PAWS OF FIREFIGHTERS

THE DOGS & OTHER ANIMALS OF NEW YORK FIREHOUSES

EMMY PARK

SCHIFFER PUBLISHING

4880 Lower Valley Road • Atglen, PA 19310

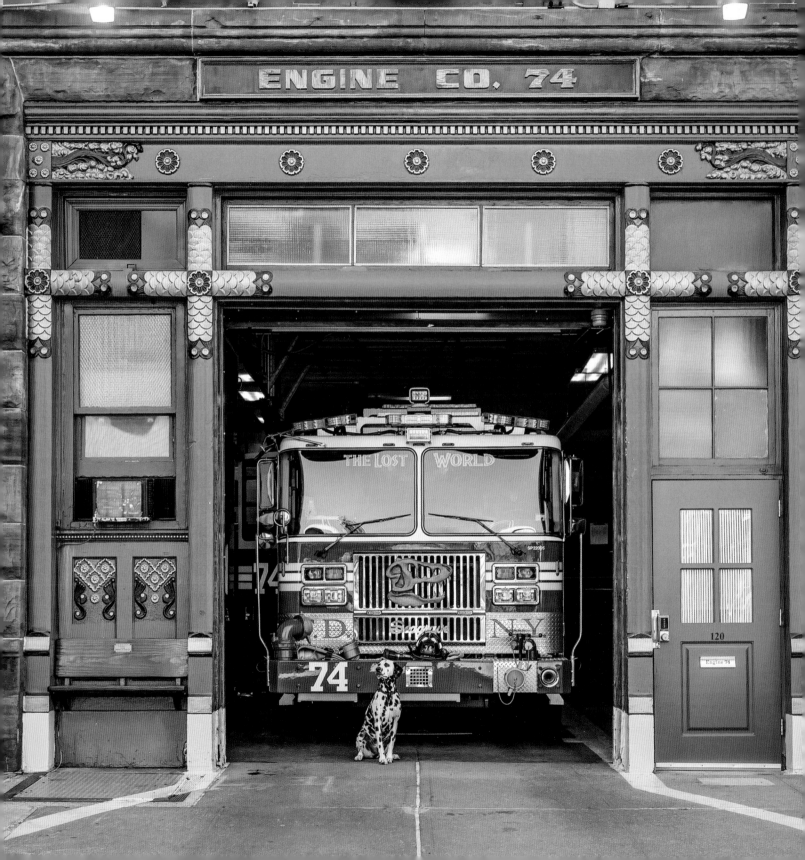

INTRODUCTION

As a lover of dogs and a resident of New York City, it is not surprising how this project came about; firehouse dogs have a long tradition of companionship with firefighters, and that could not be any more apparent than in New York City. I was inspired by this idea from my fostering days and my time in Cuba, working on my now-published books, *The Dogs of Cuba* and *The Cats of Cuba*, by Schiffer Publishing. While in Cuba, I was lucky to cross paths with a firehouse dog and took photographs of the dog with the firefighters on several occasions. The bond that the dog shared with the firefighters was heartwarming and touching. Back home, while fostering dogs, I'd often walk by my neighborhood firehouse and sometimes photograph the members as they showered the pups with love and treats. That was the beginning of this project.

Through covering these stories, I was able to build friendships with members of different firehouses, many of whom I may not have met if it weren't for the special connection between the members and their animals. Through these photographs, I am able to experience a part of the comfort that these beloved animals bring to the members, because they brought the same joy to me.

The stories accompanying these photographs are written in the voices of the resident dogs and cats as expressed by the firefighters who love them. Some have funny stories, some go on runs with the crew, and some stay behind, patrolling the kitchen for food left behind while the members are out. No matter the mischievous behavior the firehouse animals may get into, it is clear that there is a dedicated bond between them and the members. Both are beings of selfless service, dedicated to helping others in their time of need.

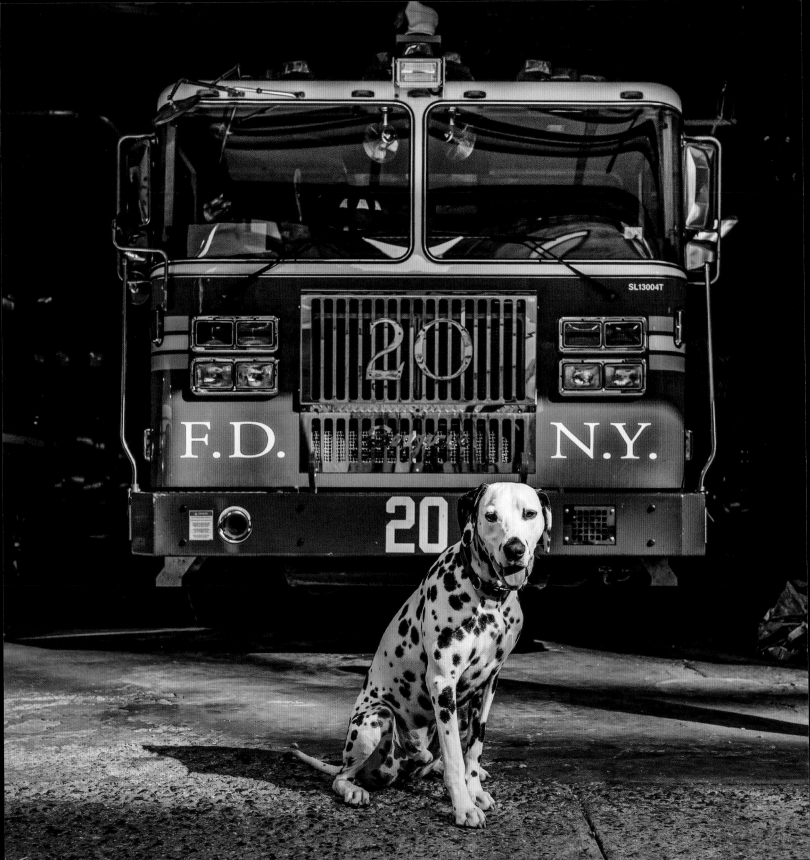

Dalmatians hold a very special place with firefighters due to the integral roles they played in the history of the fire service. I am no different in carrying on that tradition. My name is Tank, and I am a dedicated member of Ladder 20 in SoHo, Lower Manhattan. I do not run alongside the fire engines to clear the way for the horse-drawn carriages as in the early days, but I have duties that are just as important. When the North Tower came down on September 11, 2001, Ladder 20 lost seven firefighters that day. The dalmatian that came before me was named "Twenty." She provided much comfort and companionship to the firefighters during the years that followed that tragic loss. When Twenty passed, the Rochester Sheriff's Department arranged for my delivery to Ladder 20, just as they did in 2001 when they donated Twenty.

I have the honor and privilege of being named after one of Ladder 20's Bravest, Mike Toal. Mike was dedicated to serving others out of our firehouse on Lafayette Street for thirty years, and his nickname was "Tank." Although I never got to meet the real Tank, I feel the love he had for Twenty and the other members of the house while bringing smiles to everyone at the house and in the neighborhood.

When the firefighters first arrive on duty for the tour, I greet them with wiggles, tail wags, and kisses. It is an exciting time because I never know what each tour will bring, other than the guarantee of going on runs, playing tug of war, and other assigned house duties. I get to visit some of SoHo's finest shops and restaurants. Sometimes, I like to just lounge on the couch and watch training videos with the firefighters, and I get to learn how they stay safe by learning from previous runs. You may see me out to get pizza with the firefighters or waiting for the latest Supreme drop at a fashionable neighborhood retail shop. Next time you are in SoHo, know that you are in good hands with the members of Ladder 20 and me. Always on duty and always ready.

TANK
L20
MANHATTAN

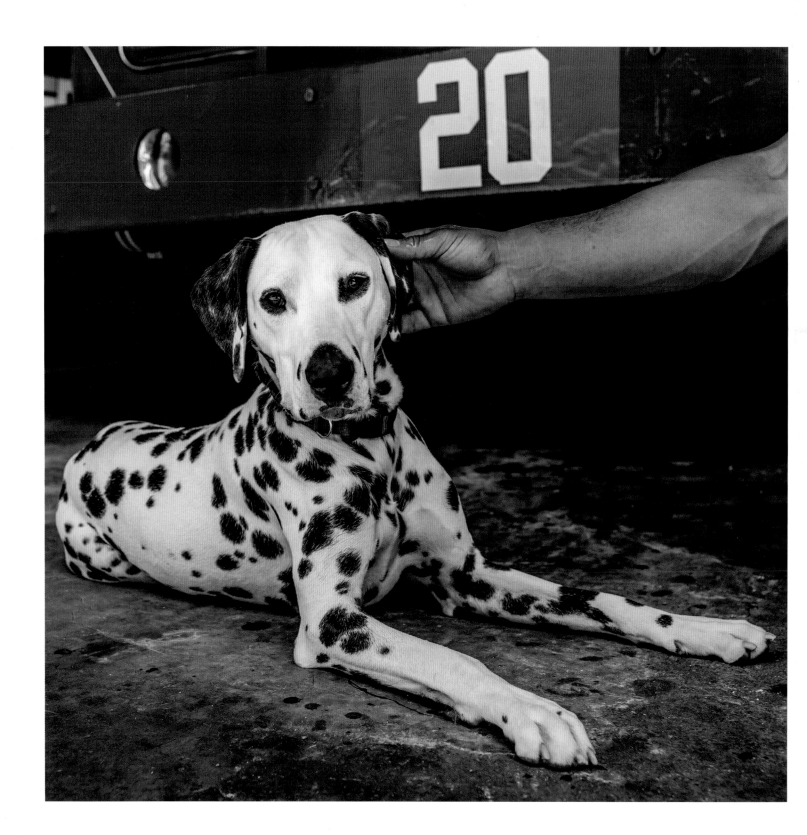

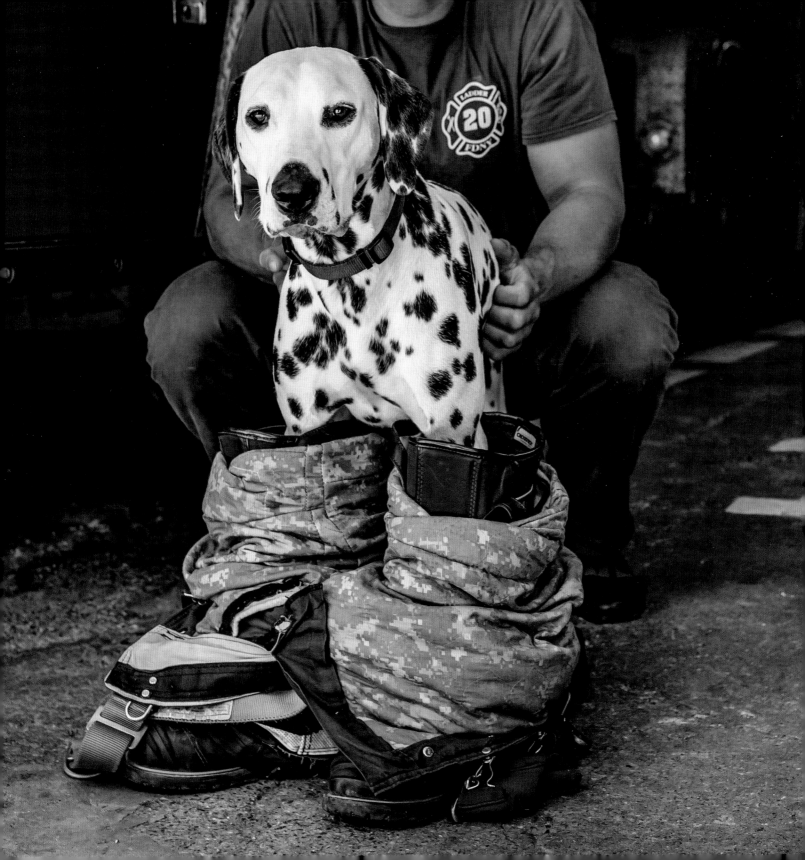

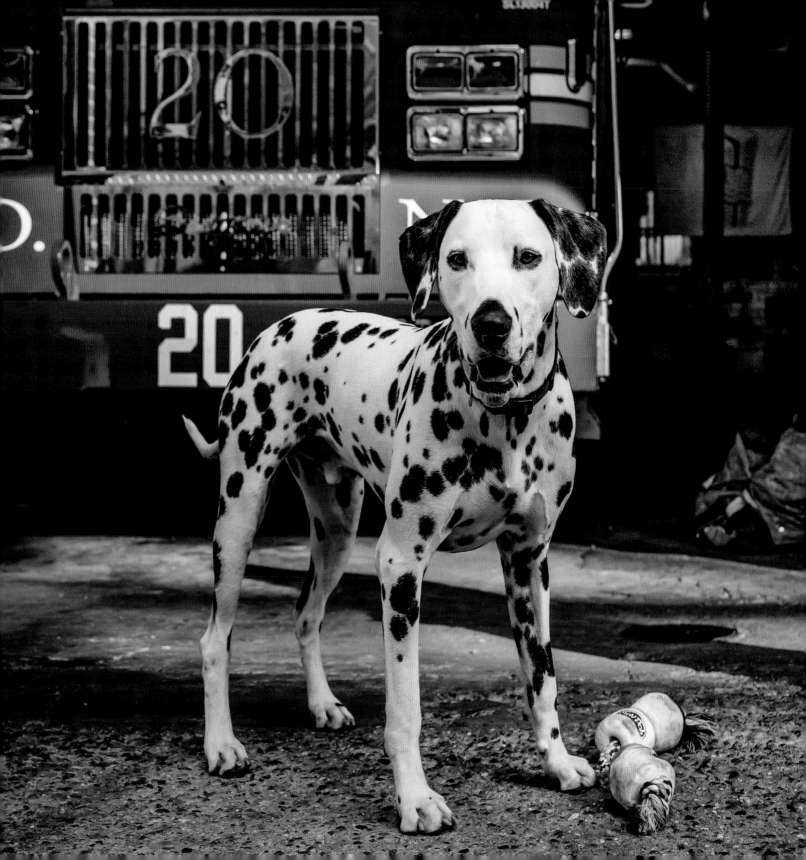

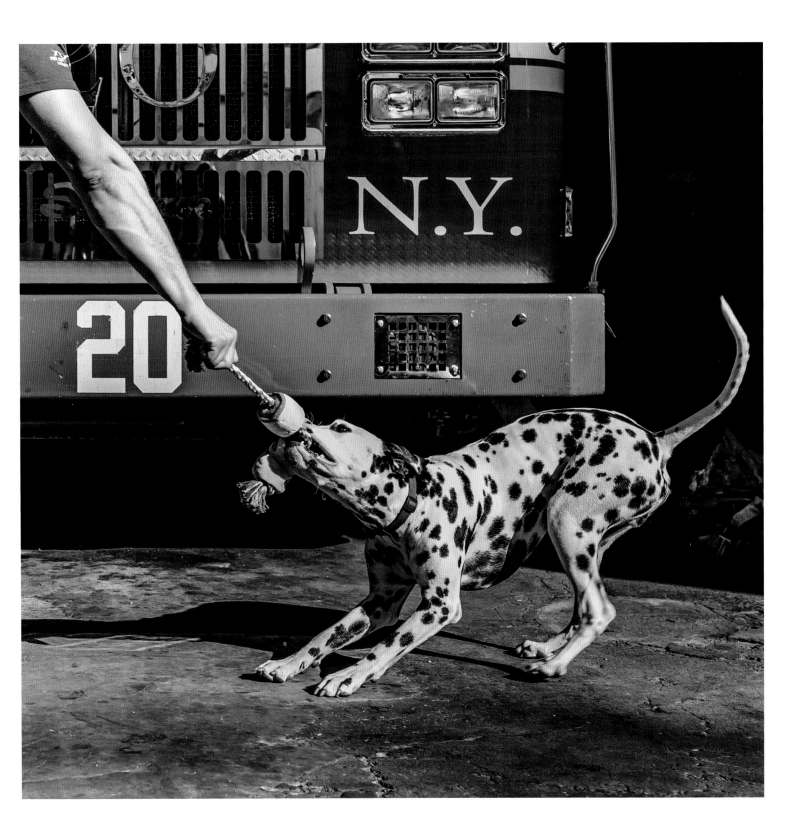

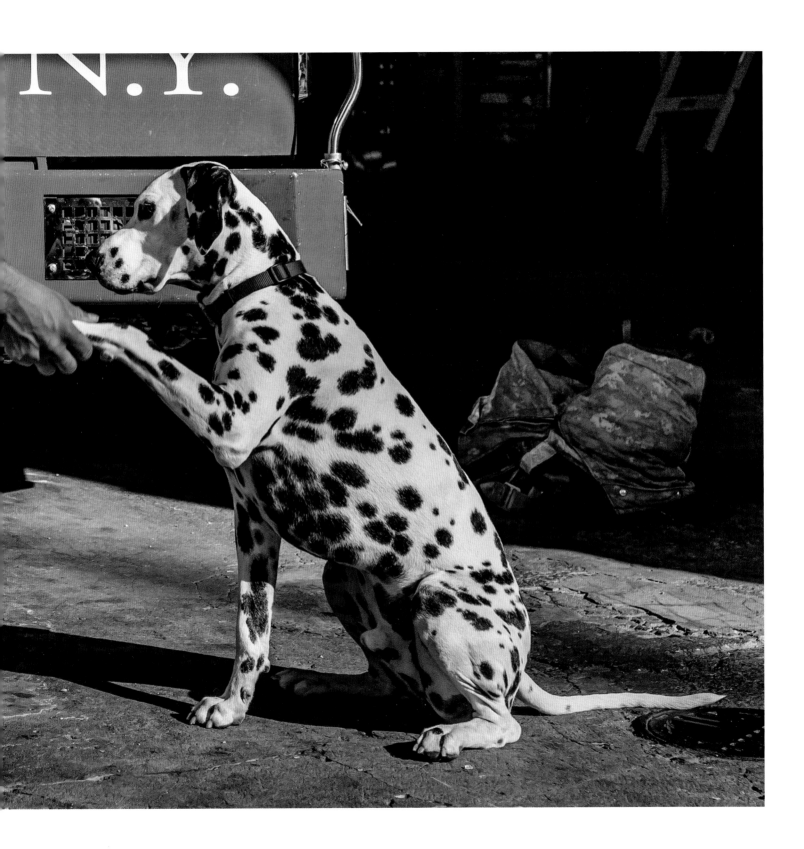

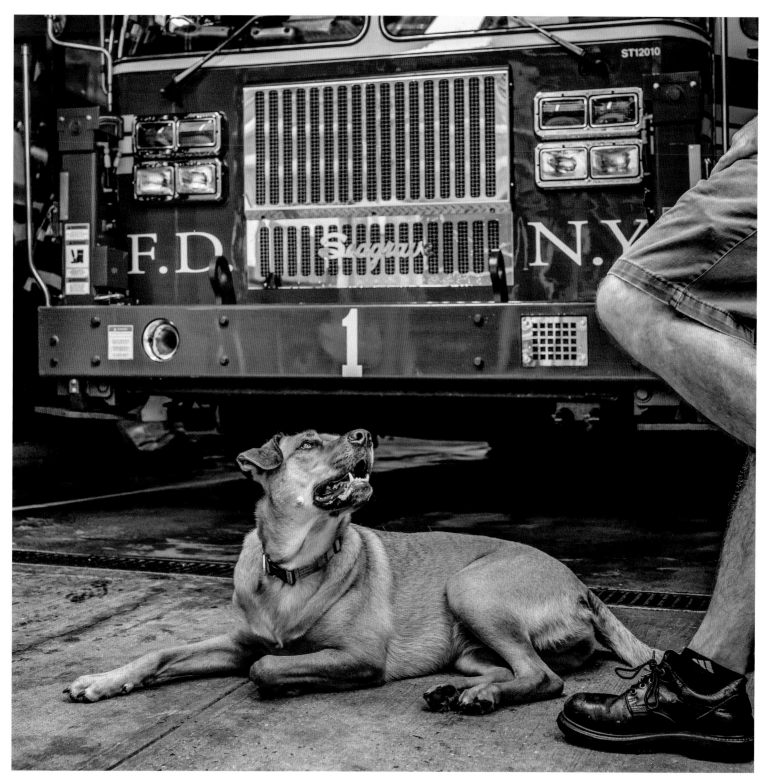

OLIVE + WINNIE, L1, MANHATTAN

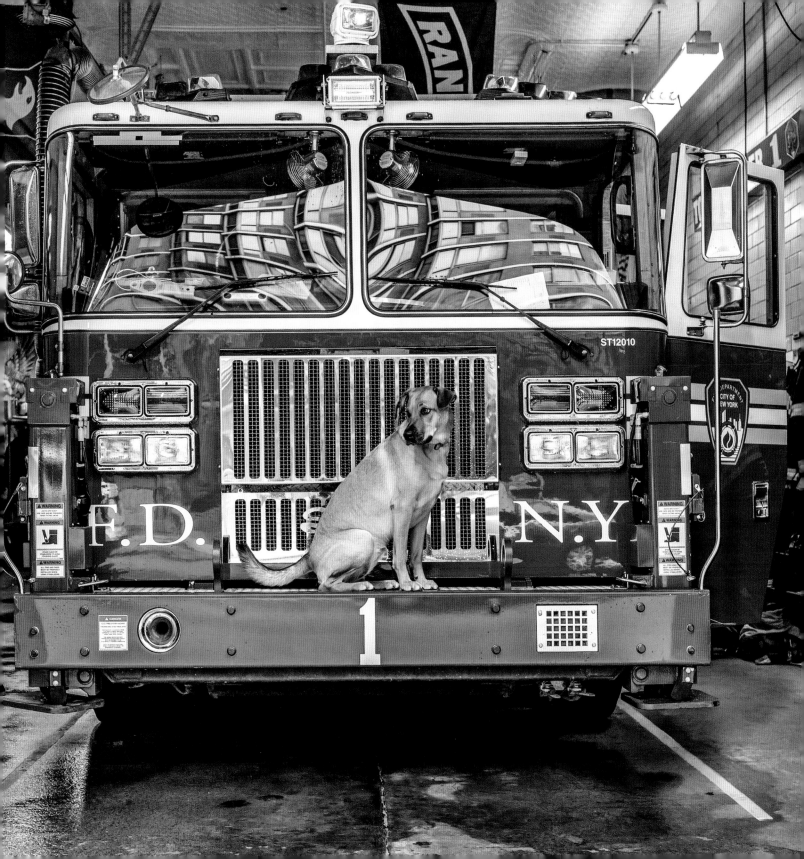

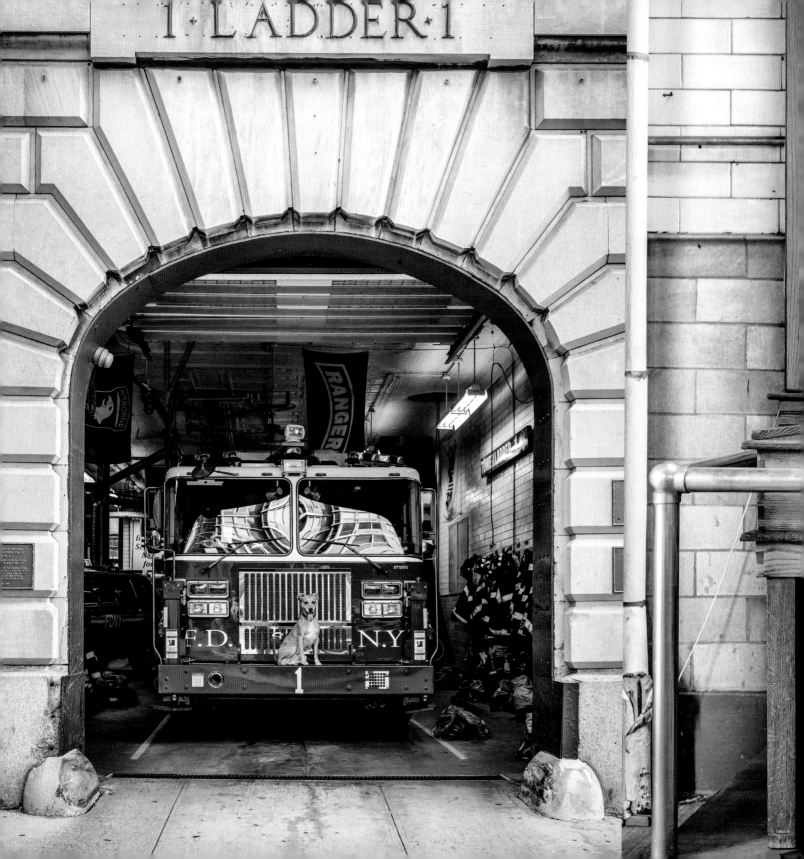

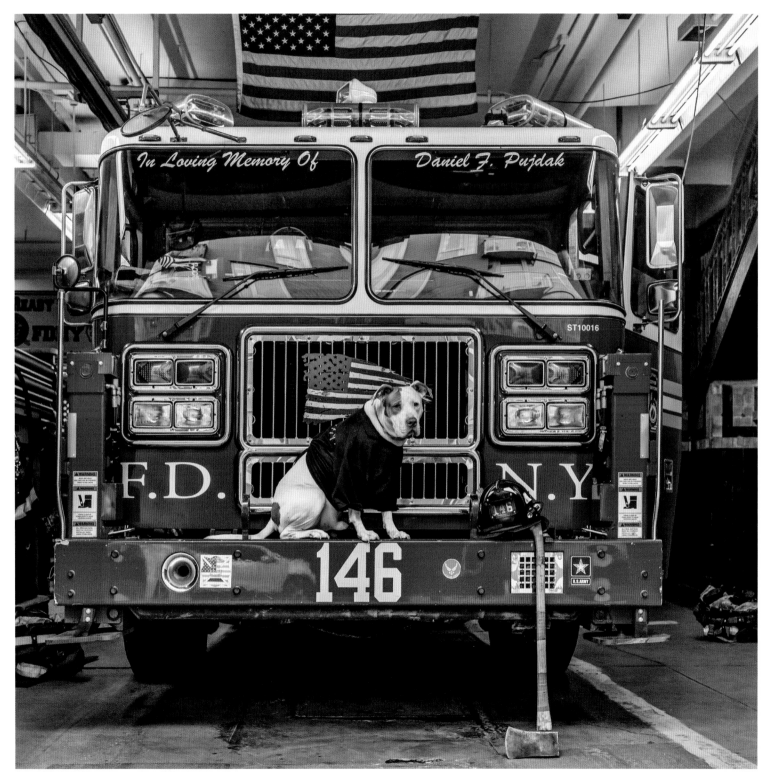

BRODY, L146, BROOKLYN

If you were looking for the Chief of 18th Avenue in Brooklyn, you found him. My name is Benson, and I am a member of Ladder 168 and Engine 243. I was named after the neighborhood that my firehouse helps keep safe, Bensonhurst! When I was a puppy, I was donated to the firehouse by my previous owner, and I have been a fire dog ever since.

Although I like all the tools on the ladder truck, I consider myself more of an engine dog. That is because the engines carry water. And I love water! When the hose starts spraying water, you can always find me at the end of it, chasing the stream. I would chase the hose line right into the fire with the firefighters if they would get me my own set of bunker gear, which I obviously deserve. But for now, I will have to settle for the job of helping wash the trucks.

I have a couple of spots in the firehouse where you will find me spending my time. Mostly, I am in my seat at the kitchen table, waiting for the firefighters to send some chow my way. You will also find me acting like I am a lapdog, and sitting on the laps of the members just about anywhere they are. I like to think of it as my way of providing comfort to them while also keeping myself comfortable. Sometimes I fall asleep on the couch with my beloved tennis balls and my plush bunny. Whenever a run comes in, I go to the house watch area and keep the watch while the companies respond to an emergency.

I love all the members of my firehouse, but I also love meeting the citizens of our great city. Next time you are on 18th Avenue, come by and say hello!

BENSON
E243/L168
BROOKLYN

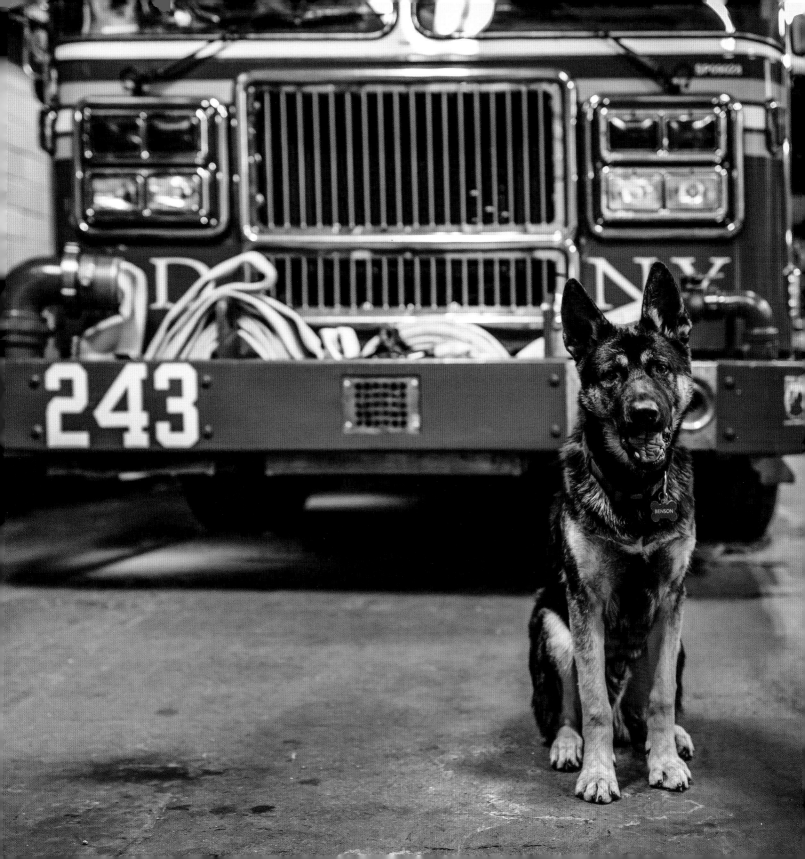

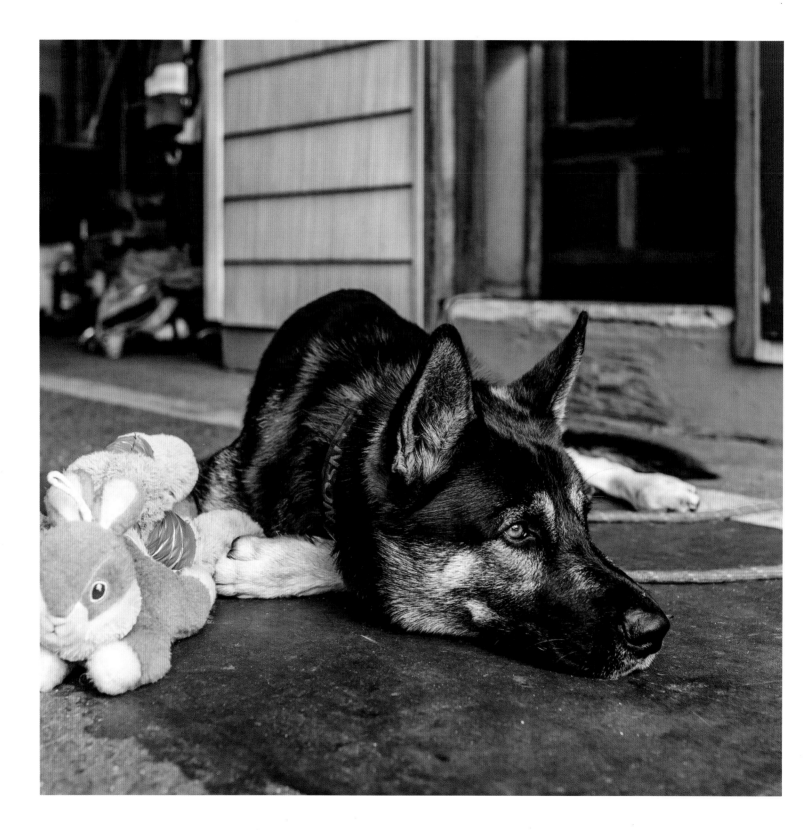

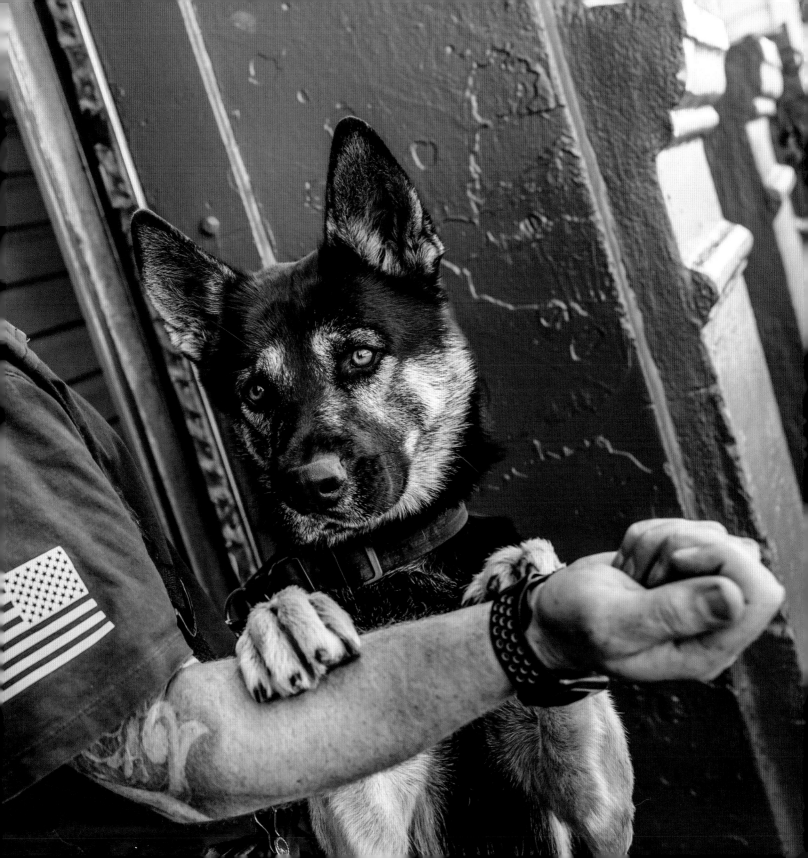

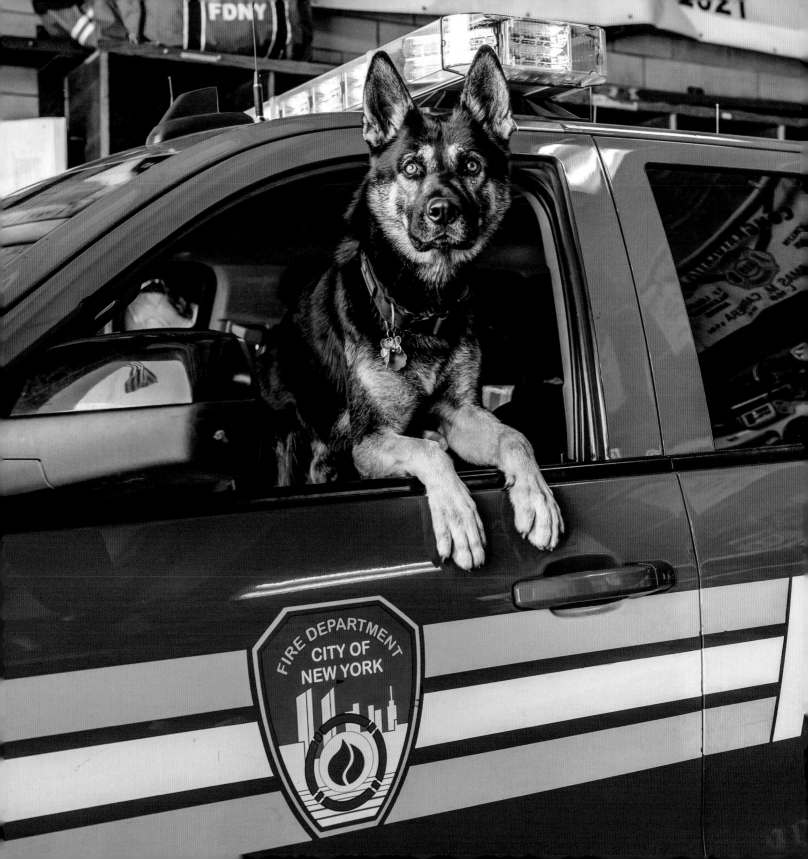

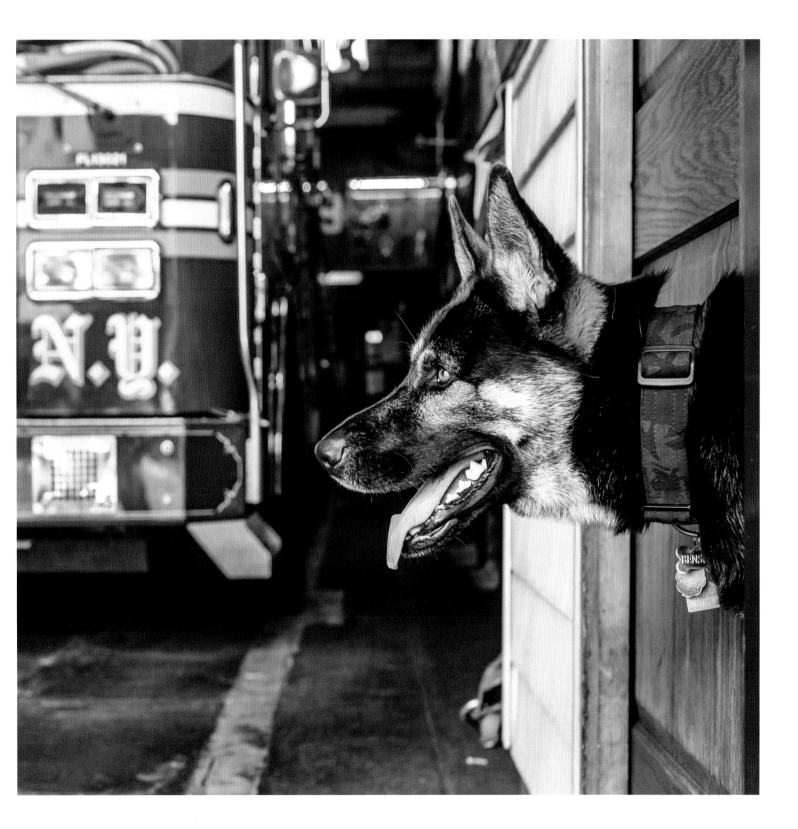

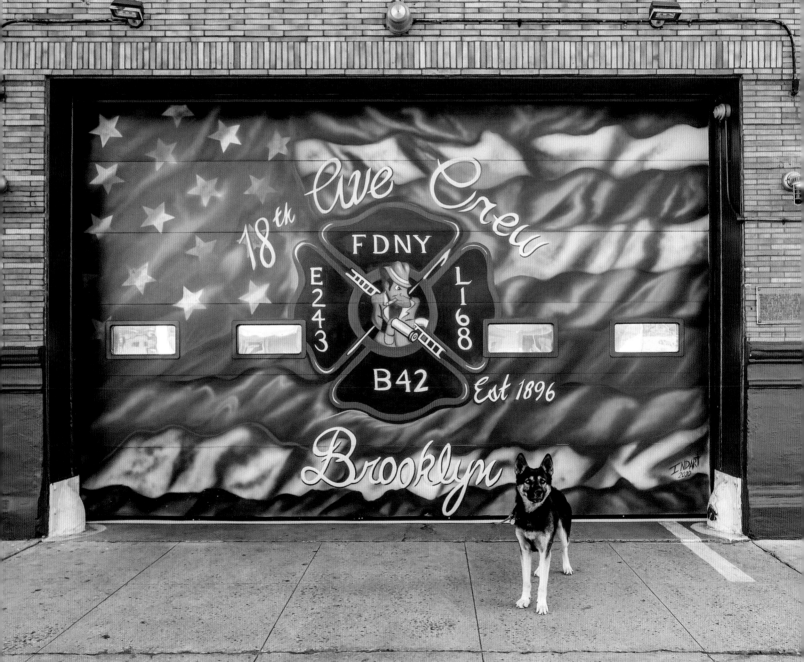

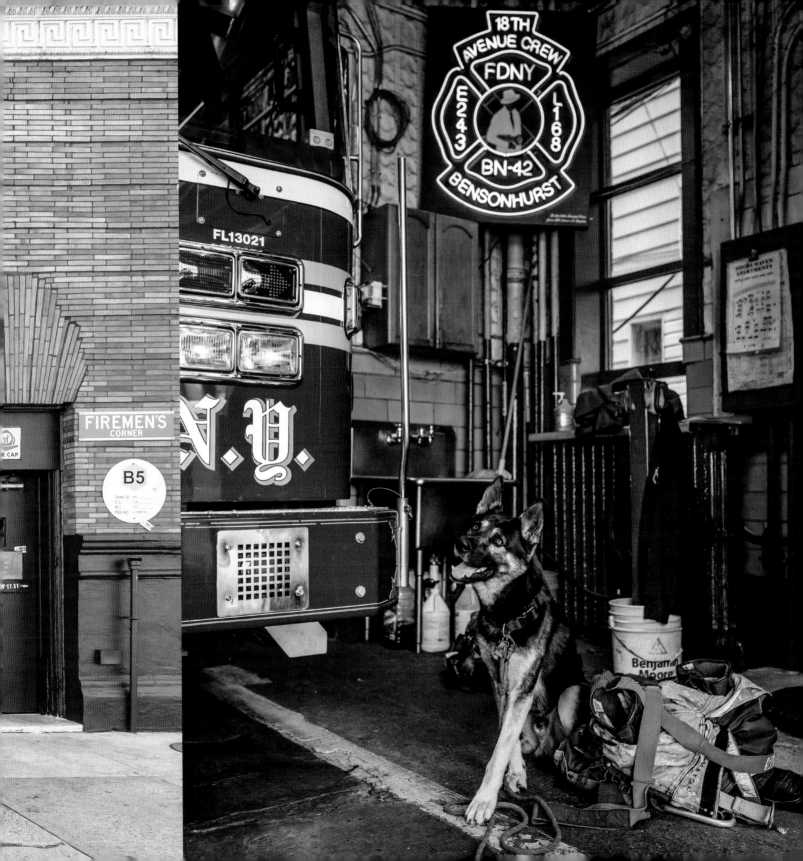

My name is Boots, and I am the resident firehouse cat of the "Chinatown Dragon Fighters." One of the firefighters brought me to this firehouse after their former house cat, Blaze, was stolen from the house. When I was a kitten, the firefighters found me several times inside the boots on the apparatus floor—my favorite place to hide. My hiding spot is partly how I got my name. The other reason for my name is that, as you can see, I have four matching boots: all four of my paws are white! As for my age, it's typically not polite to ask a lady how old she is, so my firefighters do not know my exact age. I will only admit that I am young and beautiful.

When my firefighters are out fighting the dragon, more commonly known as going on runs, I have been trained by the firehouse members to go to the basement. I stay safe down there until they return to the house. When the firefighters are cooking, I quickly come out of my hiding places and pop into the kitchen to see what is for chow. I know that no matter how tasty the meal may be, I am always happiest when I get my wet food. Sometimes I can trick the newer members into feeding me more than my usual portions by giving them a sweet stare and a soft pawing with my boots. My firefighters like to keep me looking sharp, in accordance with the department grooming policy, which is great because I do like to be combed, though I'm not a fan of being touched. Other than in the kitchen or hiding in the basement, I can be found on the staircase landing. When the tones go off and the firefighters rush down the stairs to a run, I swat at their feet and refuse to move. I definitely keep them on their toes!

My firefighters fill the big shoes of the Bravest and I fill the boots!

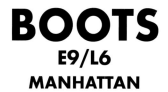

BOOTS
E9/L6
MANHATTAN

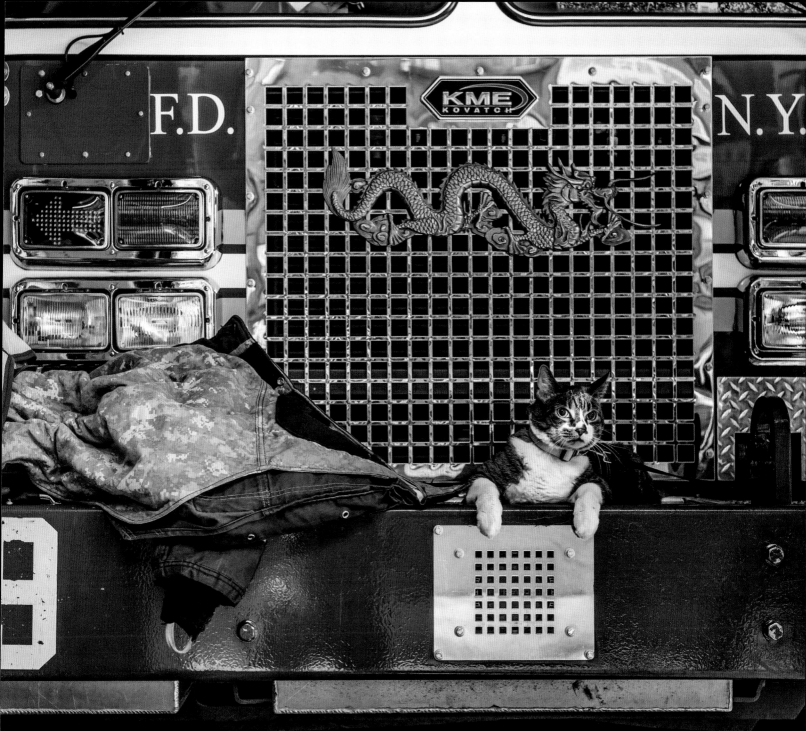

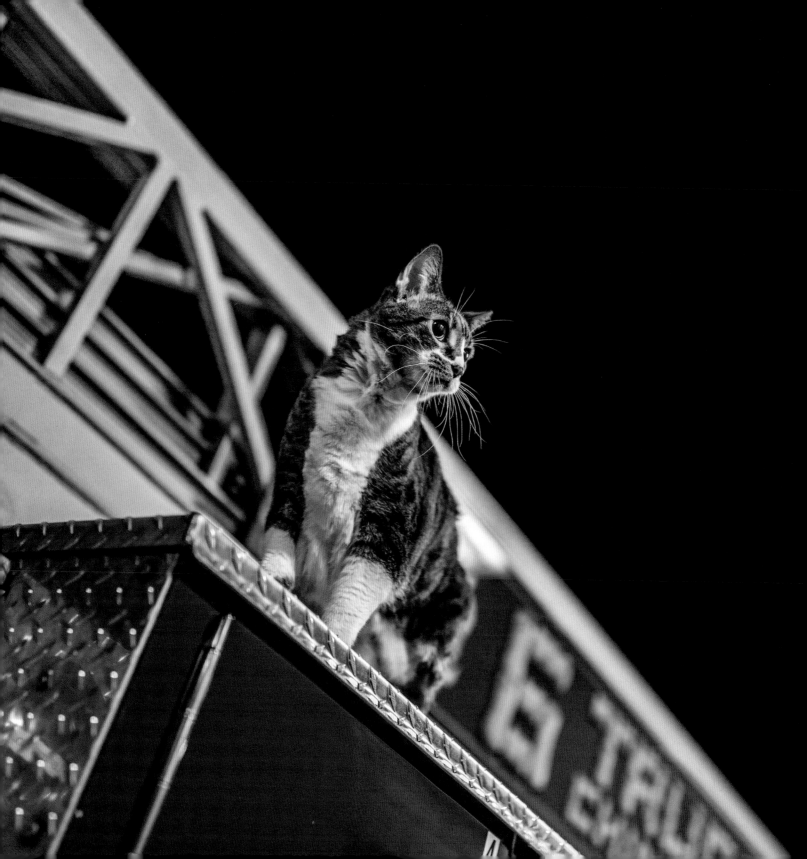

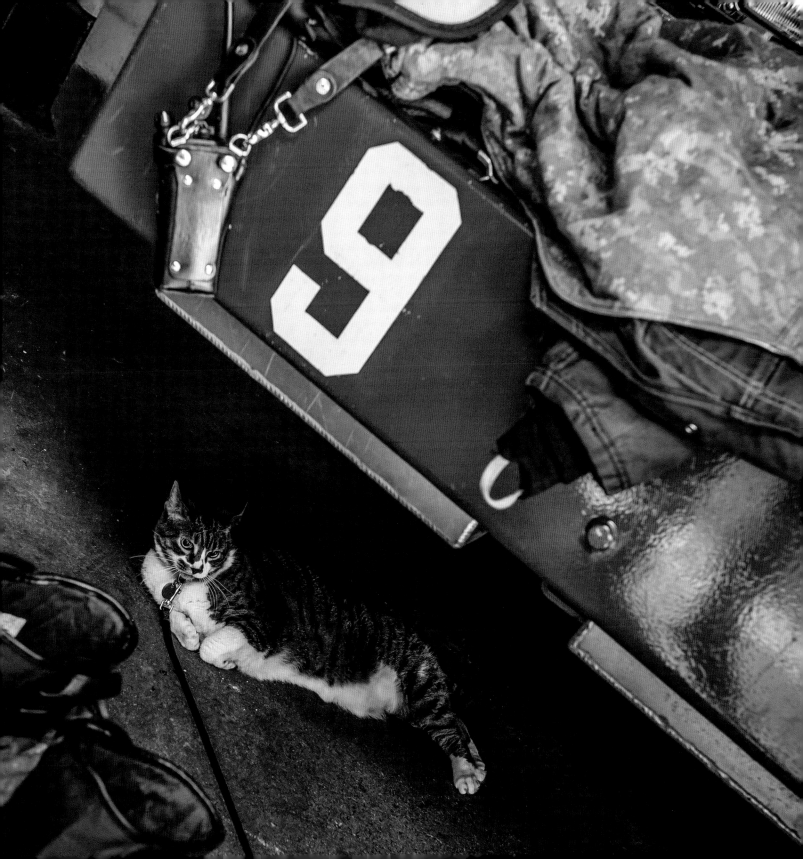

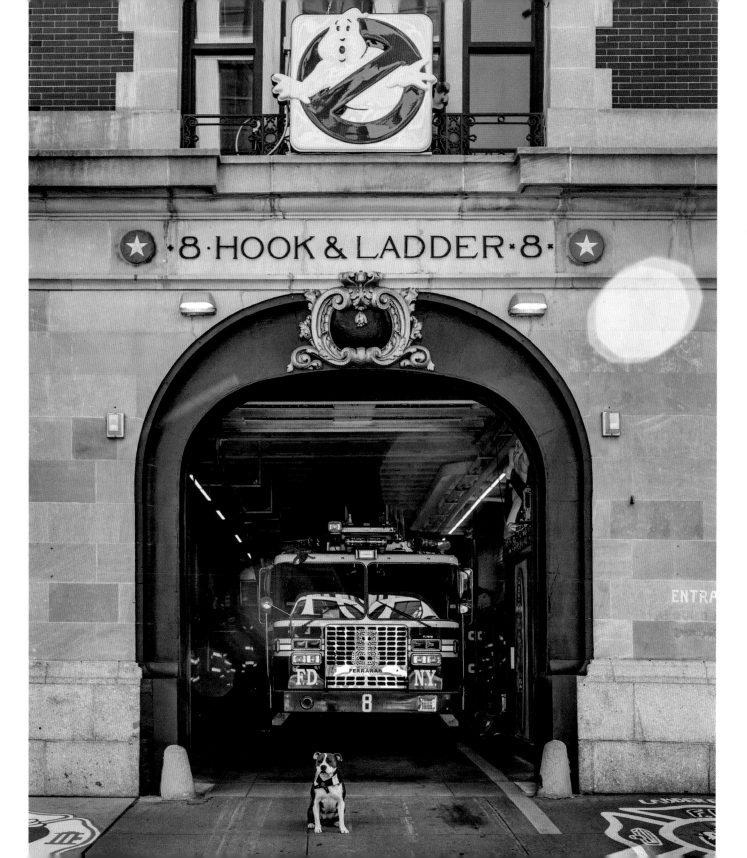

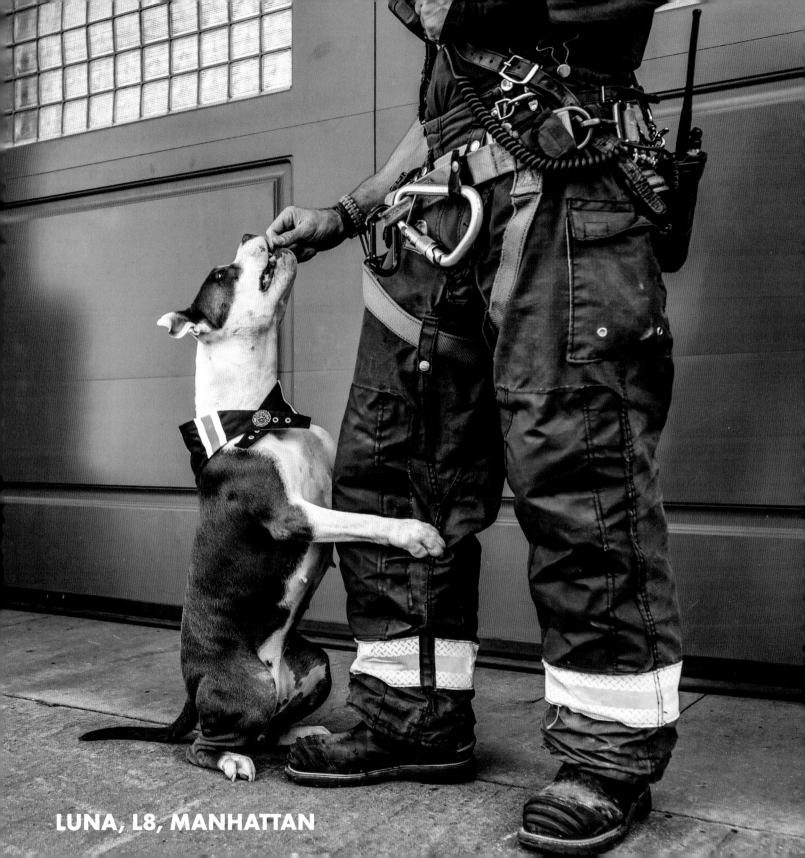

LUNA, L8, MANHATTAN

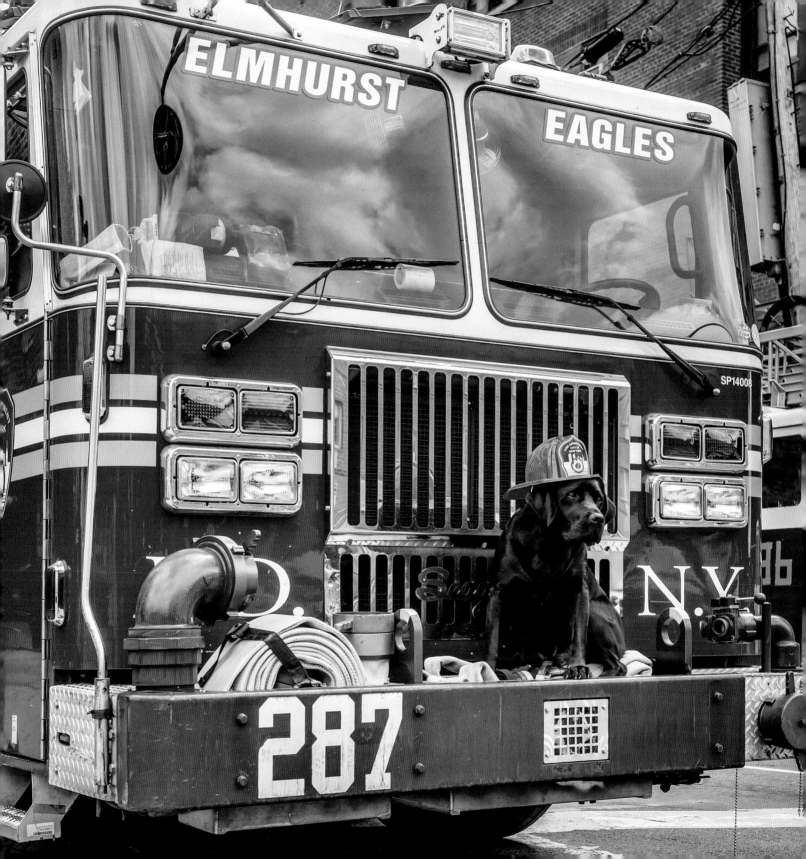

Firefighters have long been known as "jacks of all trades" because of the many talents required of them to perform their duties in addition to fighting fires. My name is Jax, short for Jackson, and I am no different from them. I have many trades I am quite good at, but mostly my talents include posing on the front bumper of Engine 287, inspecting the hose bundles and the forcible-entry tools, and catching frisbees. I arrived at Ladder 136 and Engine 287, home of the "Elmhurst Eagles" in Queens, when I was two years of age. Prior to that, I was part of an organization that provides dogs for veterans. I am named after a courageous veteran named Jackson.

I don't go on runs with the firefighters, but I eagerly await their return in my crate. I am trained to stay in my crate when the tones go off, because it provides me with a safe space to monitor the radio and keep my ears on the firefighters' activities to ensure that they are safe while they are out on a run.

Catching frisbees is my favorite trade, because my acrobatic moves are quite athletic, and I am often rewarded with treats. I find the most scrumptious treats to be blueberries, carrots, strawberries, and bananas. Fruits are given to me in moderation because I must watch my figure. My main staple is dry food, full of protein to keep me on my toes for frisbee catching.

I am a skilled swimmer. I often train at the lake with the members so I can be of assistance during water rescues. One time at the lake with some of the members, I found a big stick close to the shore. I tried my hardest to pull it out and take it for a swim with me, but my efforts were drowned out by laughter from the members. They kept encouraging me, and I was working so very hard to impress them, until I realized why they were laughing. As it turns out, I was trying to pull an entire tree out of the ground! Since then, when they need a good pull and digging, they call me first.

JAX
E287/L136
QUEENS

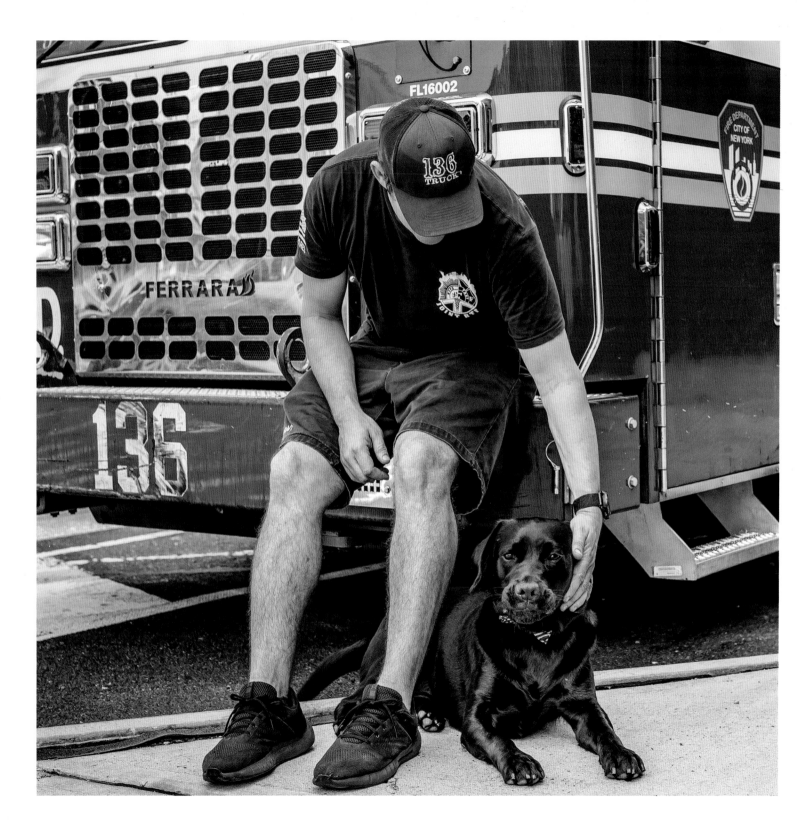

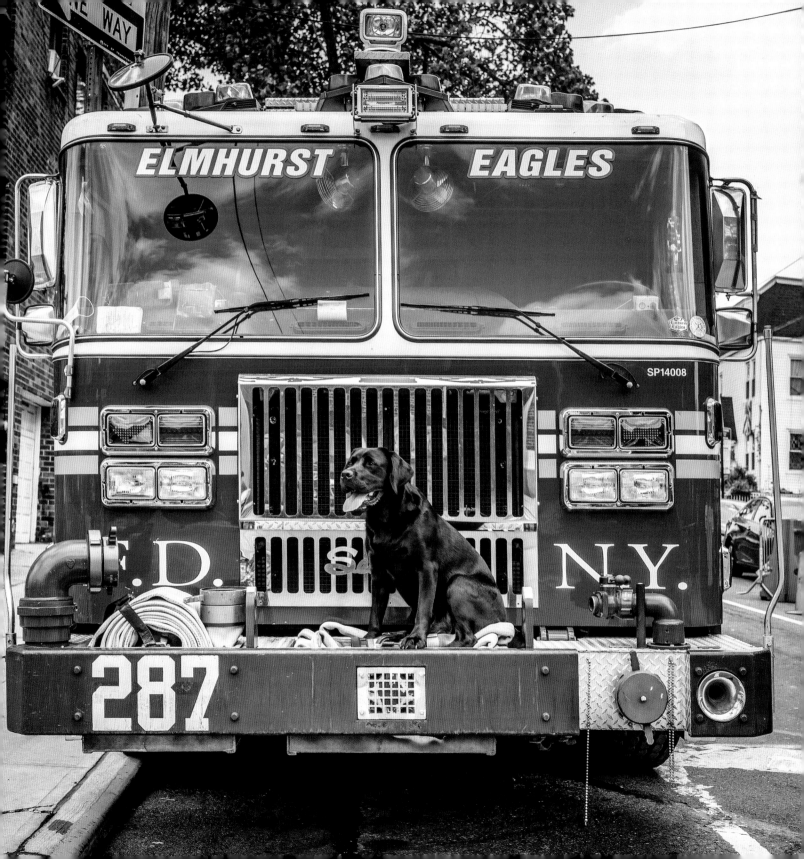

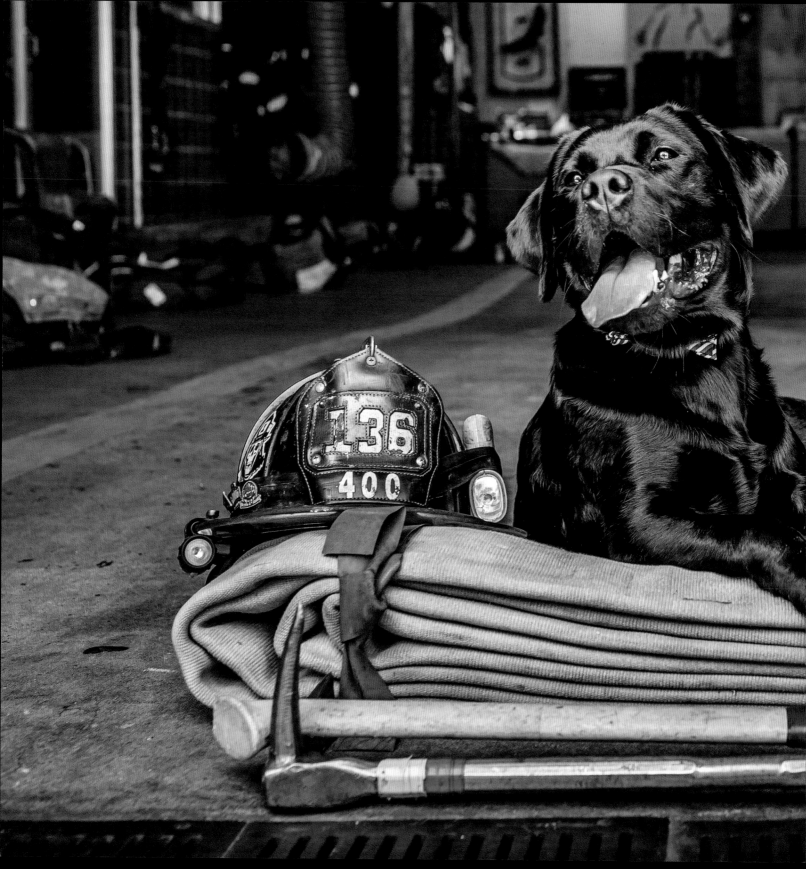

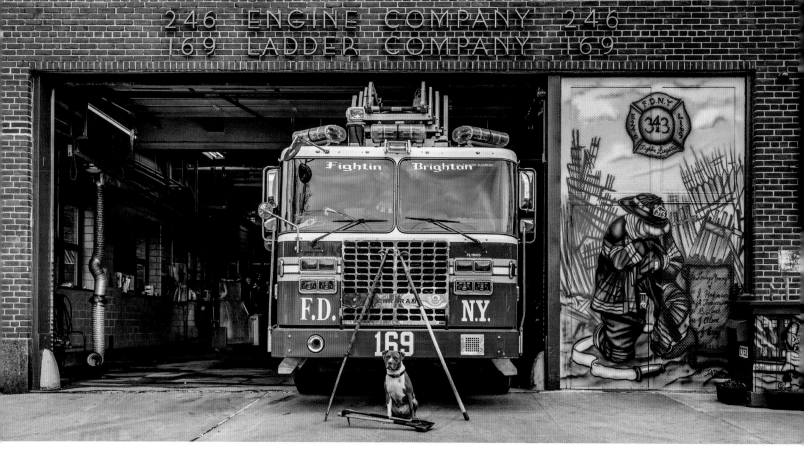

Hi, my name is Blaze, the Jewel of Brighton Beach. I'm currently retired, but let me tell you a bit about my story. I was tied to the fence adjacent to the firehouse and abandoned by my previous owner. I was lucky to be rescued by the members of Engine 246 and Ladder 169. To ensure that I had the proper training to perform my firehouse duties, they sent me off to an amazing rescue, Pitbulls and Addicts, and the rescue helped me with rehabilitation and being comfortable around people. I returned to the firehouse a new boy, and wow, did I have a few good months there! The members of "Fightin' Brighton" gave me not only love, toys, treats, and belly rubs, but most of all, a second chance at life.

I loved my life at the firehouse, but after all, life at the bustling firehouse just wasn't for me. My firefighters recognized this, and, despite the difficulty of letting me go, they knew in their hearts that I needed a quiet environment to fully thrive. I will forever be grateful to my first family, the members of Fightin' Brighton on East 11th Street in Brooklyn.

BLAZE (retired)
E246/L169
BROOKLYN

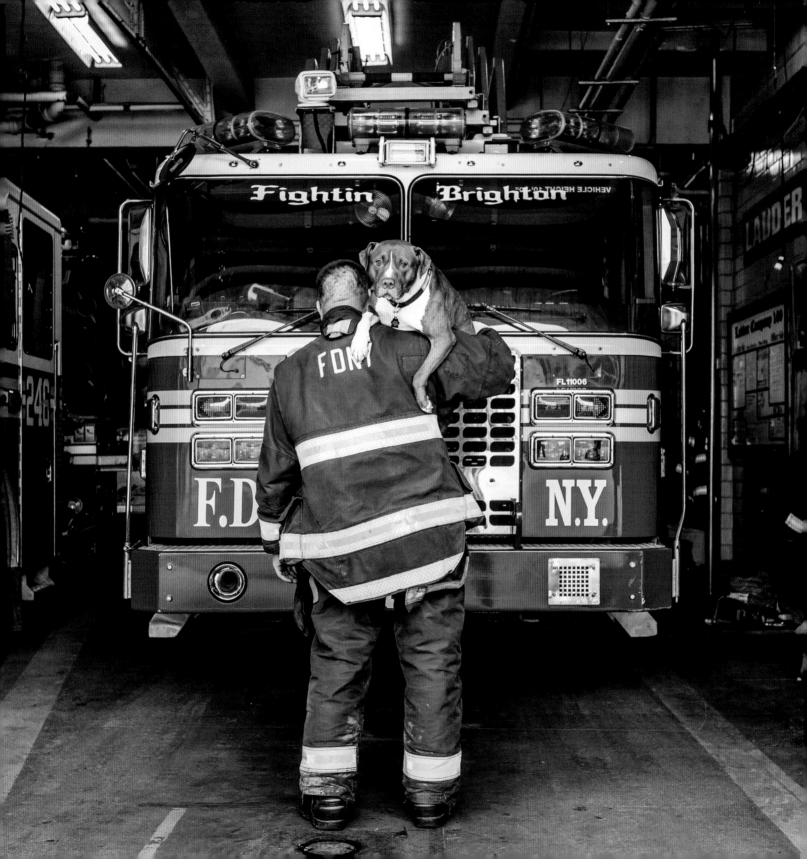

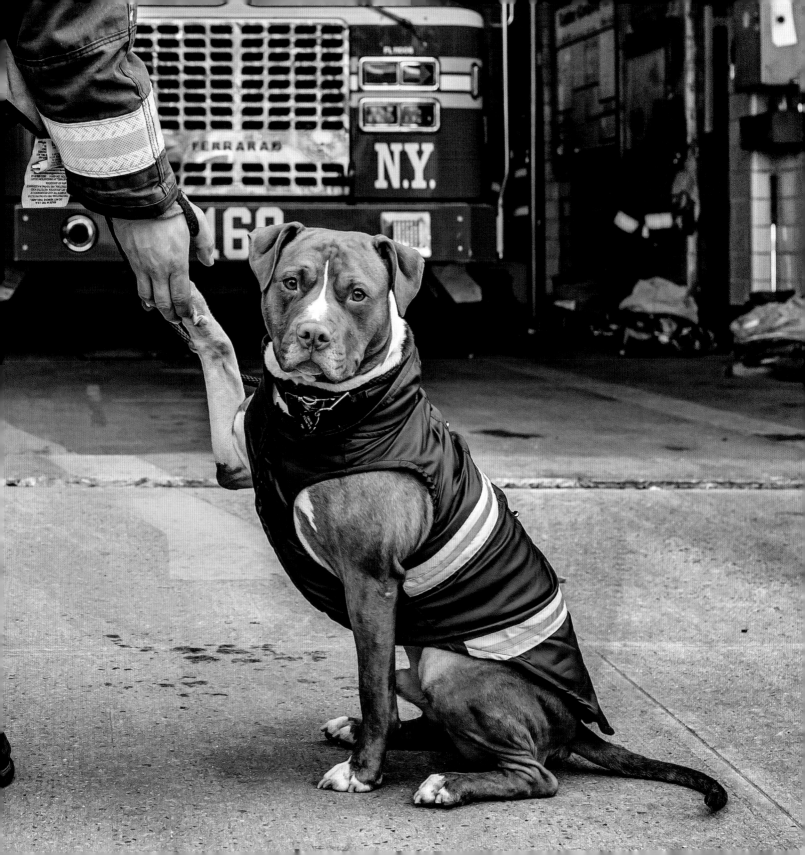

It was early 2020, and I was a young, rambunctious pup from the Rockaways. Unfortunately, my previous owners were not so nice and abandoned me tied up outside. Luckily, some nice NYPD officers from the 101 Precinct found me and brought me back to their station house. Through a network of friends, I soon found myself traveling to Freeport, Long Island, to a volunteer firehouse. I was told they had recently lost their previous dog mascot, Primo, to cancer. He was a staple to Engine 216, and I knew I had big paws to fill, but I was up to the task.

I walked into company quarters shy and timid but soon realized that the firefighters were here to pamper and spoil me like I had never experienced before. I needed special food and shots for my bad allergies, but the guys were happy to comply. Now I'm eating salmon every day! They even named me Rocco so I wouldn't forget my roots and where I came from. I settled into my new role of being a firehouse dog pretty easily. I watch the firefighters run out the door for alarms at all hours, and patiently wait for their return.

One day, to my surprise, after the tones dropped, one firefighter said to me, "Well, are you coming?" I couldn't pass up the opportunity to ride the rig to my first official fire run. Smiling ear to ear and probably drooling on the firefighters as I hung my head out the window, I was hooked! It hit home for me when I got my own picture on the wall of members of the company. There is nowhere on earth I'd rather be than here with my family in the firehouse. As we train to stay sharp and wait for the big fire to come in, someone is always playing with me, training me, or sometimes just napping with me. I'm thankful to the NYPD for rescuing me and to my forever home in Long Island with Engine 216 of the Freeport Fire Department.

ROCCO
E216
FREEPORT, LONG ISLAND

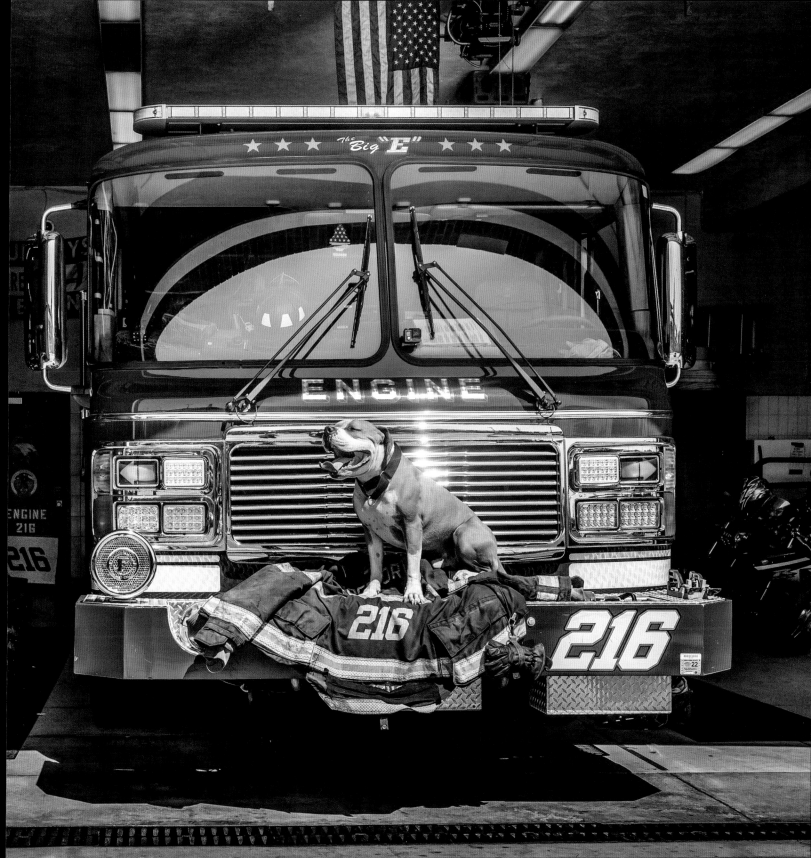

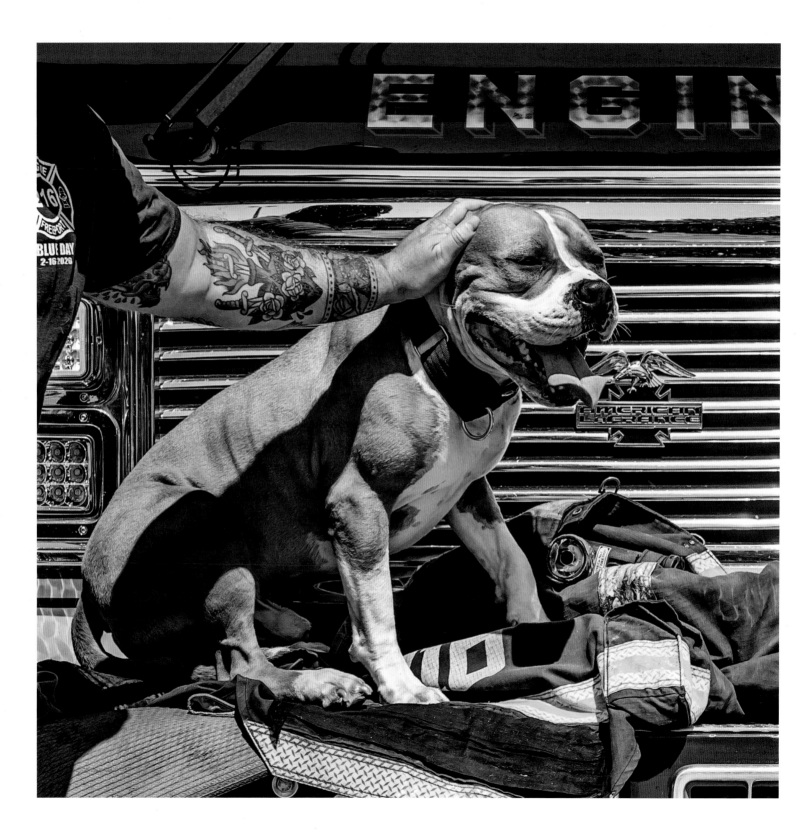

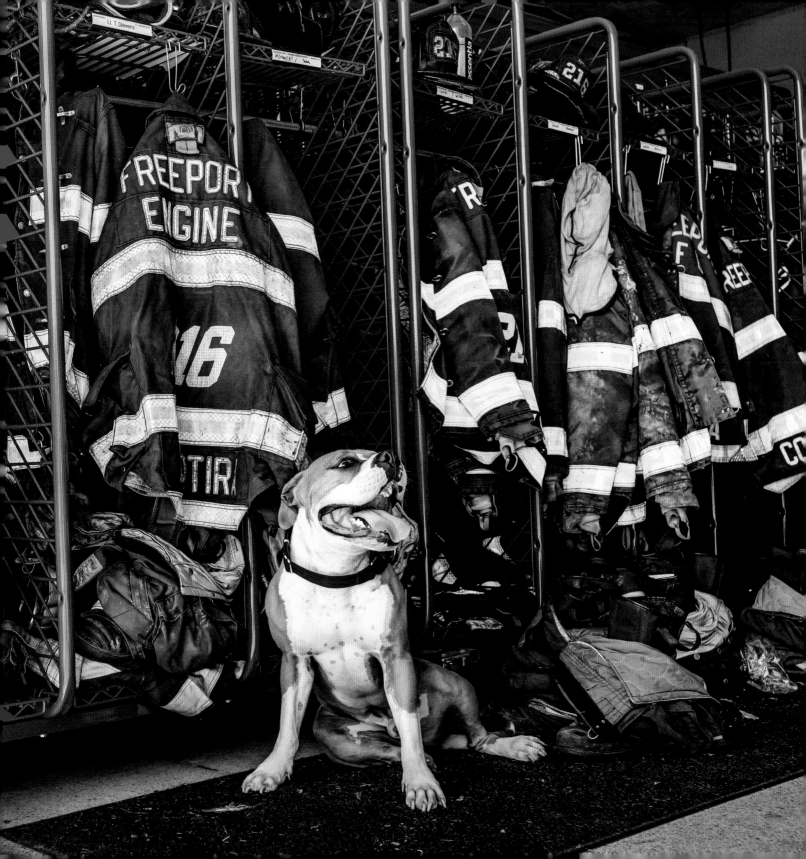

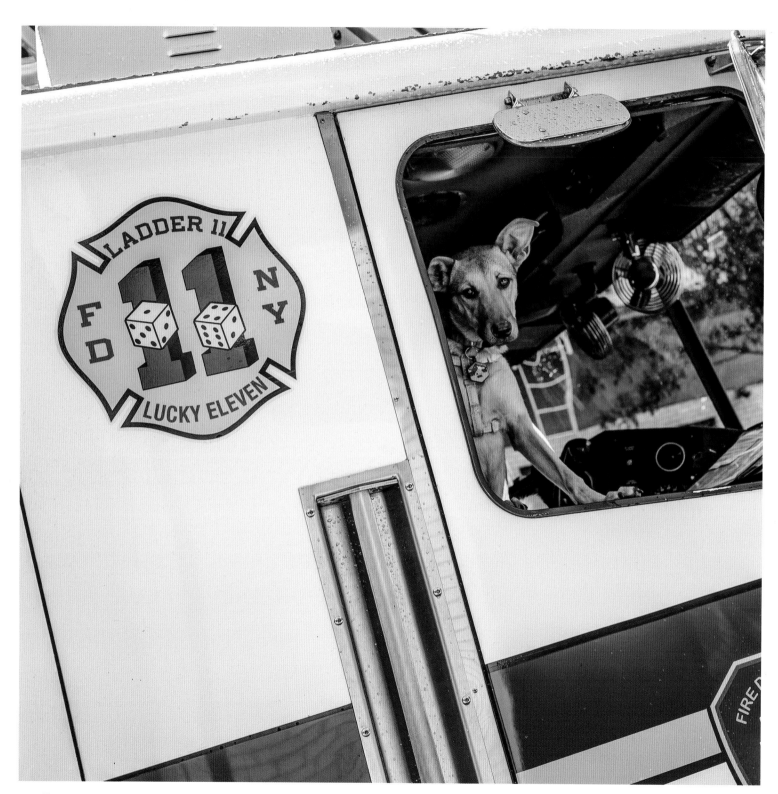

NORI, L11, MANHATTAN

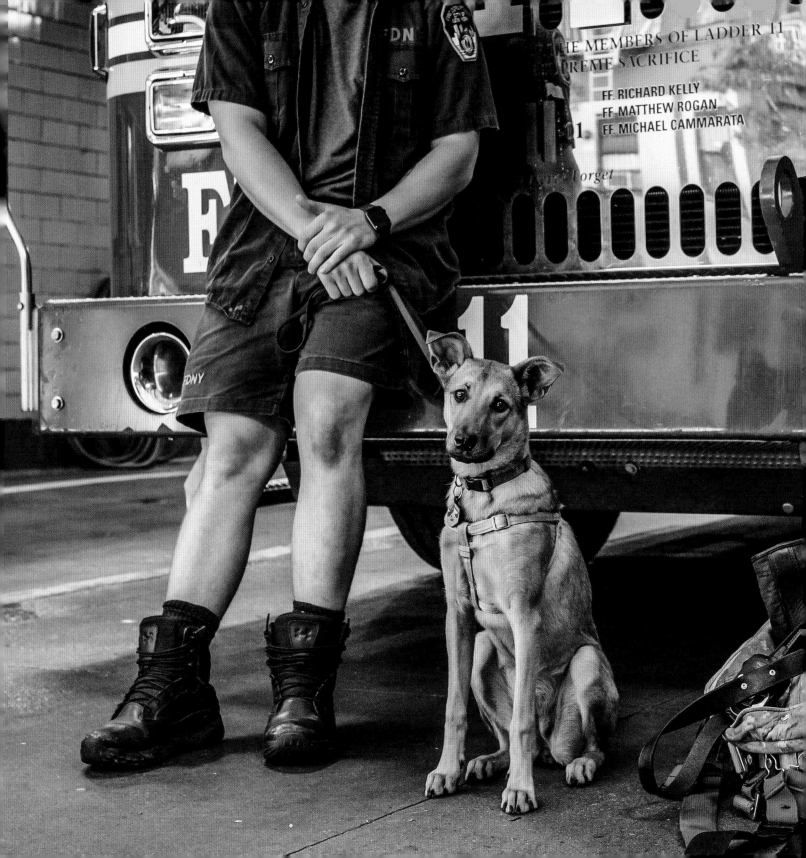

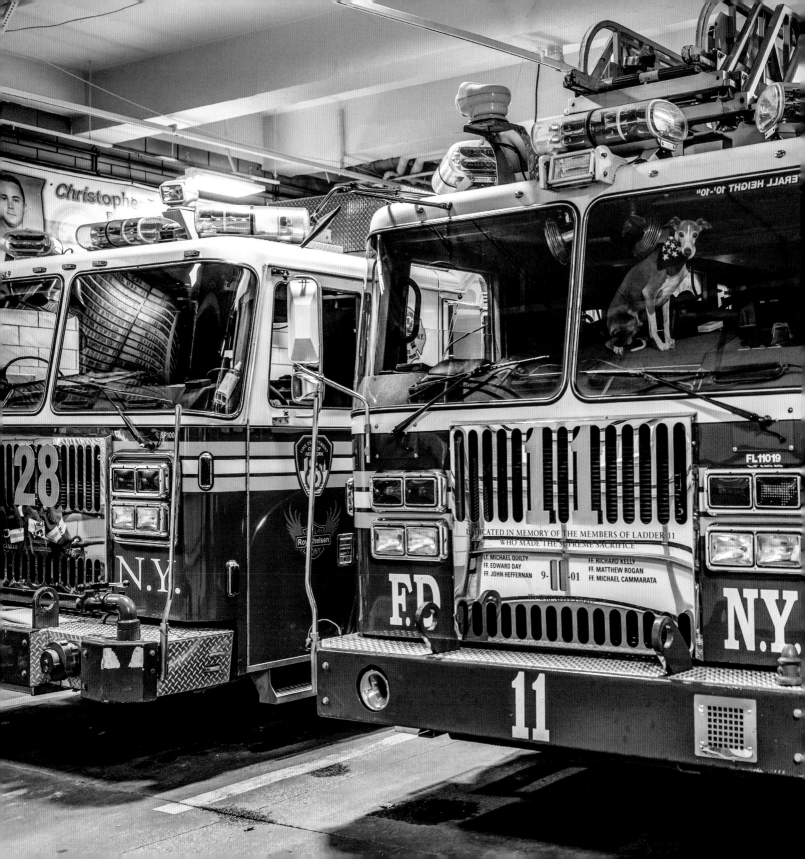

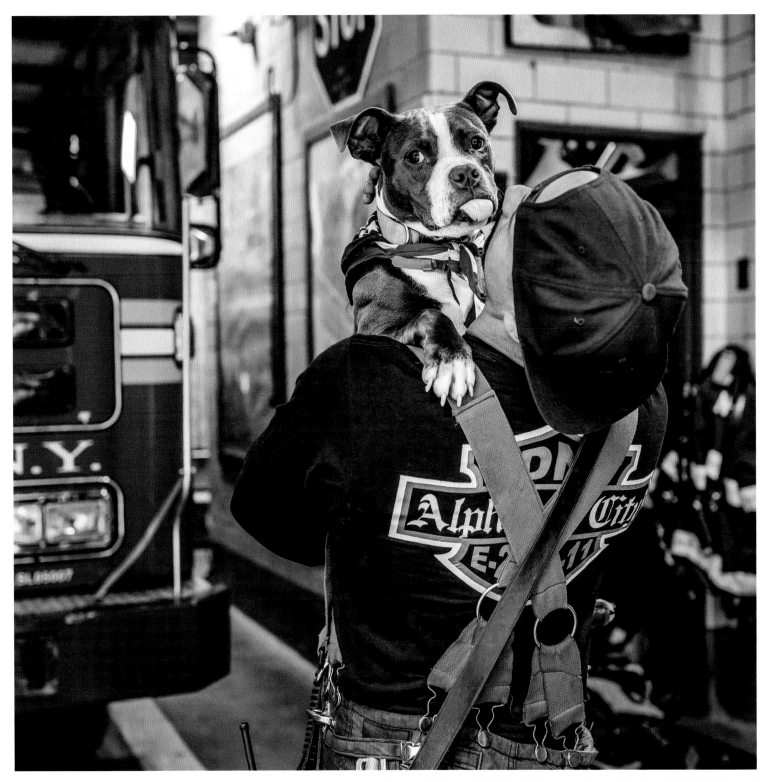

BULLET + CHAMP, L11, MANHATTAN

Hi, I'm Lola. Lola is short for "Lady of Liberty Avenue." Just in case I get lost, I'll know where to start. I live in a busy firehouse in Brooklyn with my firefighter family. Life is pretty busy in a busy shop. You may wonder how I got to Engine 236. I have heard through the grapevine that the members of the firehouse held a vote to adopt me from the Animal Care Center of NYC in Brooklyn. I won the adoption vote, so here I am!

My favorite spot to hang out is the kitchen because it smells delicious. There are definitely some good cooks here! If I'm lucky, I'll get a few scraps. But I can be picky . . . meat only. I absolutely love to play. Here at E236 we have a side parking lot, which is quite big, so I can roam and see what's going on outside. Occasionally, a squirrel or bird lands in the lot and provides me with a good chase. My favorite playtime game is grabbing a good hold on my toy rope. I challenge you to try to take it from me, because it is impossible! I always make sure to get a case of the zoomies inside the firehouse too. I'll get a few laps in and around to get some laughs. Speaking of toys, for some reason I have this obsession with biting the cap off plastic bottles. Let me be clear that plastic caps are not a challenge for me.

You may be wondering what I do when the tones go off. Ugh! It is loud and scary, but I know the firefighters are running to the rig to get dressed, and I'm running to the couch. It didn't take me long to figure it out. I'm not quite a fan of riding the fire truck, especially hearing the siren. It is too fast and loud and not for me. I keep a good watch on the firehouse when the firefighters are gone. I've learned to take care of myself, and I know they can't always be here. But I know they will be back soon, and, I hope, with something good from the supermarket!

LOLA
E236
BROOKLYN

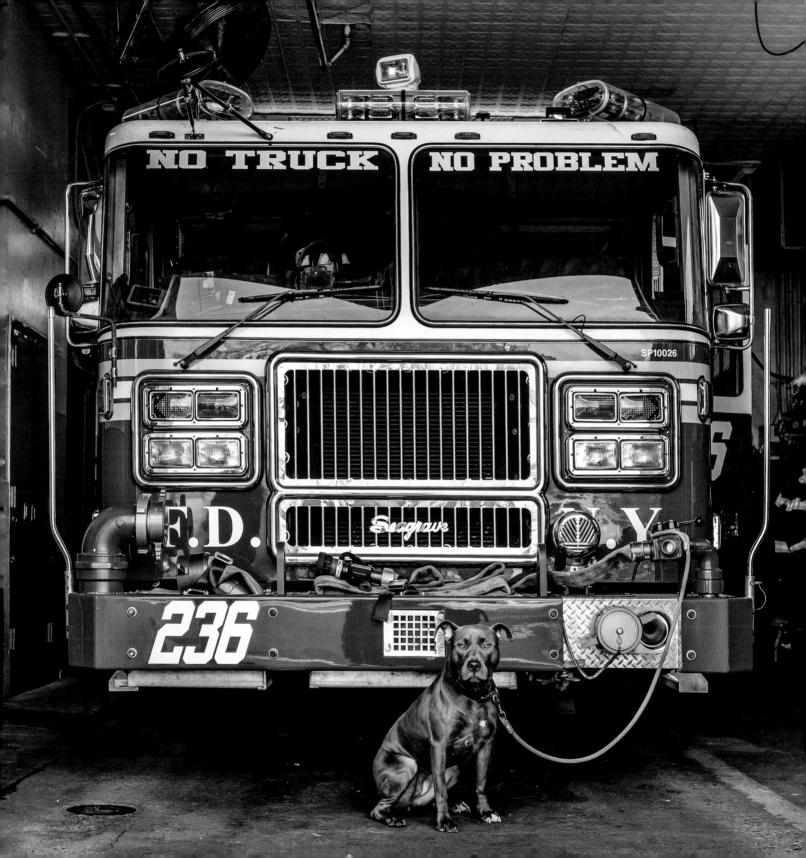

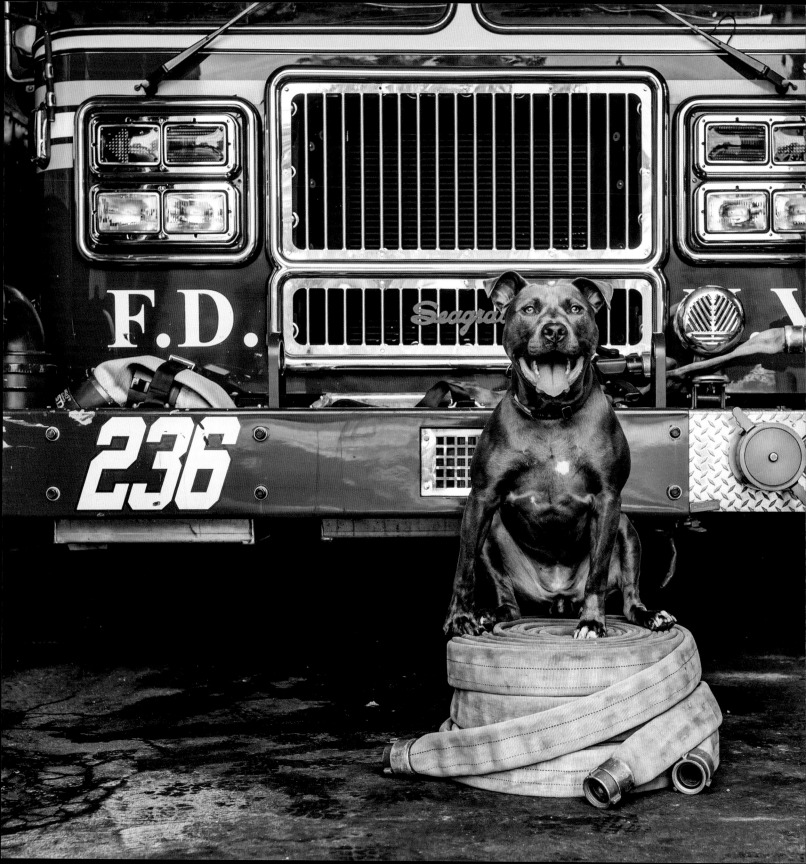

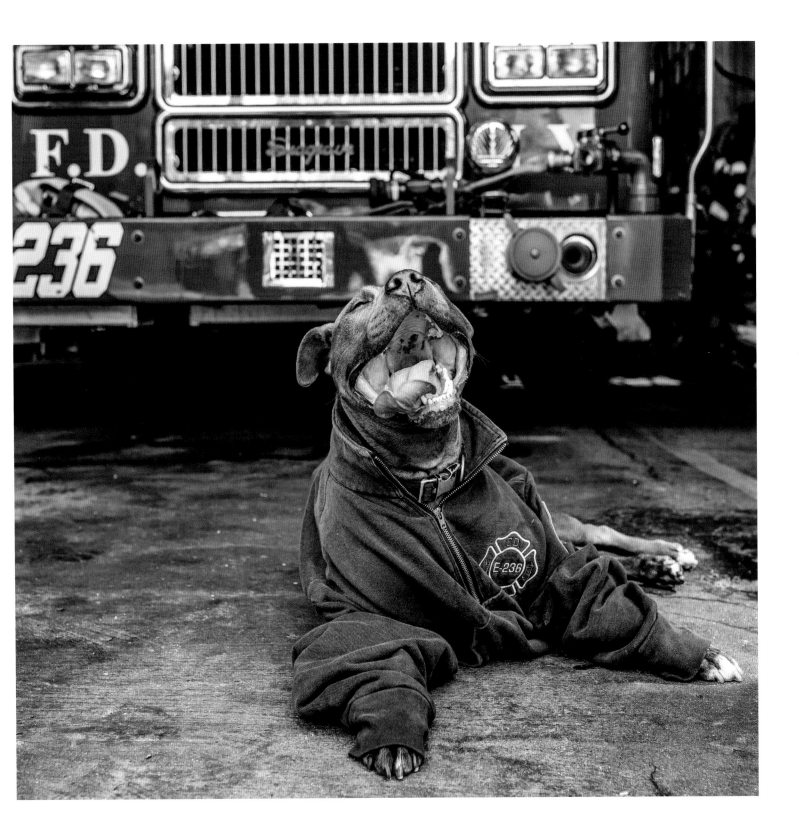

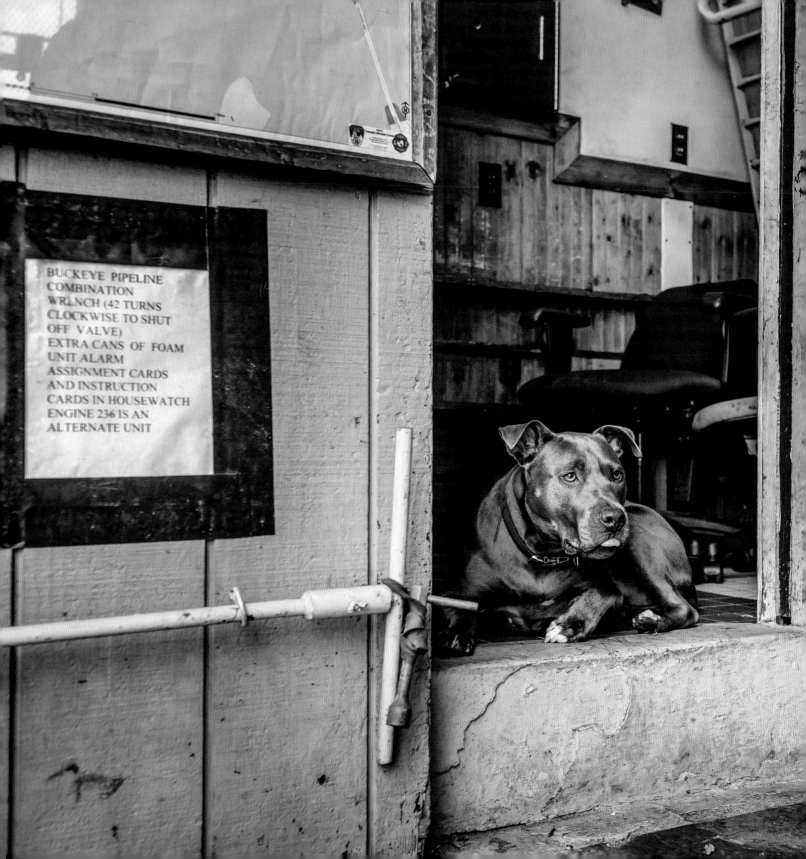

BUCKEYE PIPELINE
COMBINATION
WRENCH (42 TURNS
CLOCKWISE TO SHUT
OFF VALVE)
EXTRA CANS OF FOAM
UNIT ALARM
ASSIGNMENT CARDS
AND INSTRUCTION
CARDS IN HOUSEWATCH
ENGINE 236 IS AN
ALTERNATE UNIT

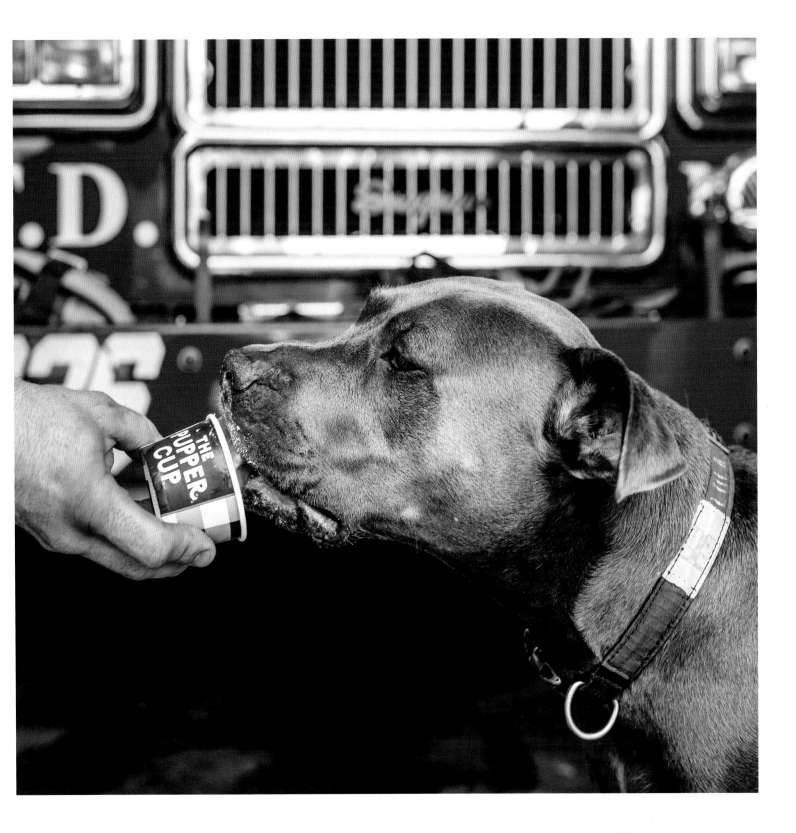

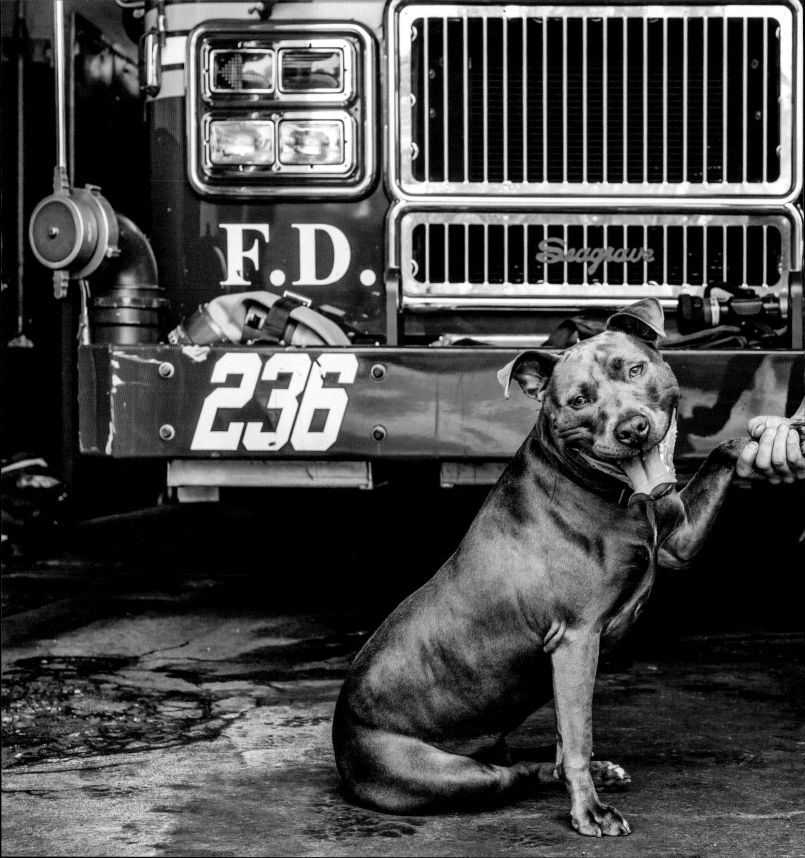

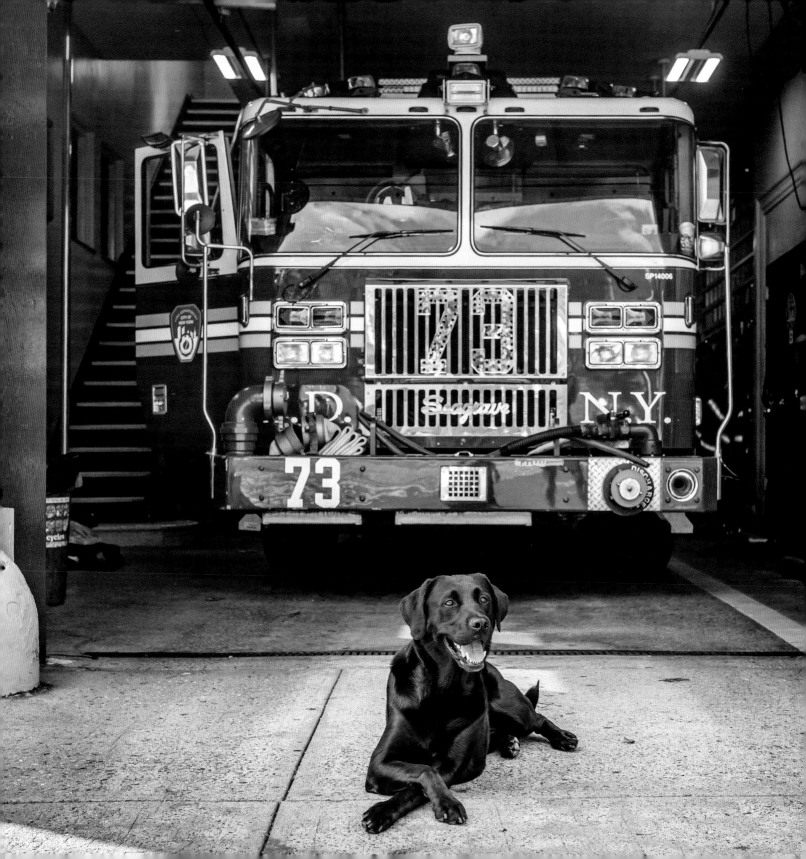

Jamo. Jameson. The goodest boy. No matter what the members of Engine 73 and Ladder 42 call me, I am the most loved member of the firehouse known as "La Casa Caca" (E73) and "La Casa del Elefante" (L42). Since I arrived here one and a half years ago with one of the members, the firehouse became known as "La Casa de Jameson." My house! Being the goodest boy that I am, I easily acclimated to the firehouse way of life and quickly found my favorite spot in the sun in front of the apparatus bay door. This spot puts me in the prime position to greet all who pass by the firehouse. I welcome everyone to the house, and I am especially great with the neighborhood kids and neighborhood dogs. I am even great with the stray cats who pass by. Since I am so friendly, there are zero guard dog duties assigned to me.

I don't join the firefighters on runs, but I do listen to the best dispatchers, the Bronx dispatch, to keep accountability on the firefighters while they are gone. I came to the firehouse already trained, so it is no problem for me to go to my safe place in my crate when the tones go off. Sometimes I get lucky and a firefighter will leave my door unlocked, and then all food is fair game. If the firefighters get a run in the middle of cooking chow, it is highly likely that the cheeseburgers will be gone when they return from their run if my crate door is left unlocked. I will leave them just the buns. The meat is mine. In the hot New York summers, I love a good bath. I don't particularly enjoy showers because the hose scares me, but fill up a decontamination tub—a tub firefighters use to scrub off any hazardous contaminants—and I will jump right in! My free time is spent playing tug, playing fetch, and seeking treats from my favorite members of the house. During long tours, I crave human touch, and I give comfort to the members by leaning up against them for a cuddle.

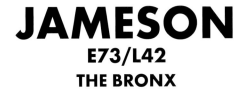

JAMESON
E73/L42
THE BRONX

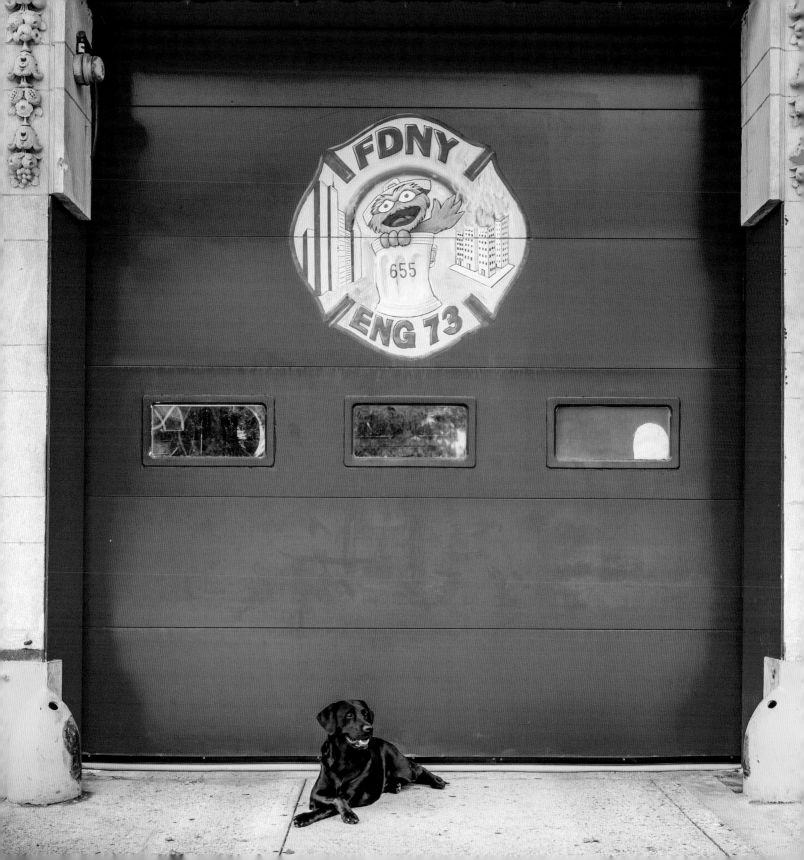

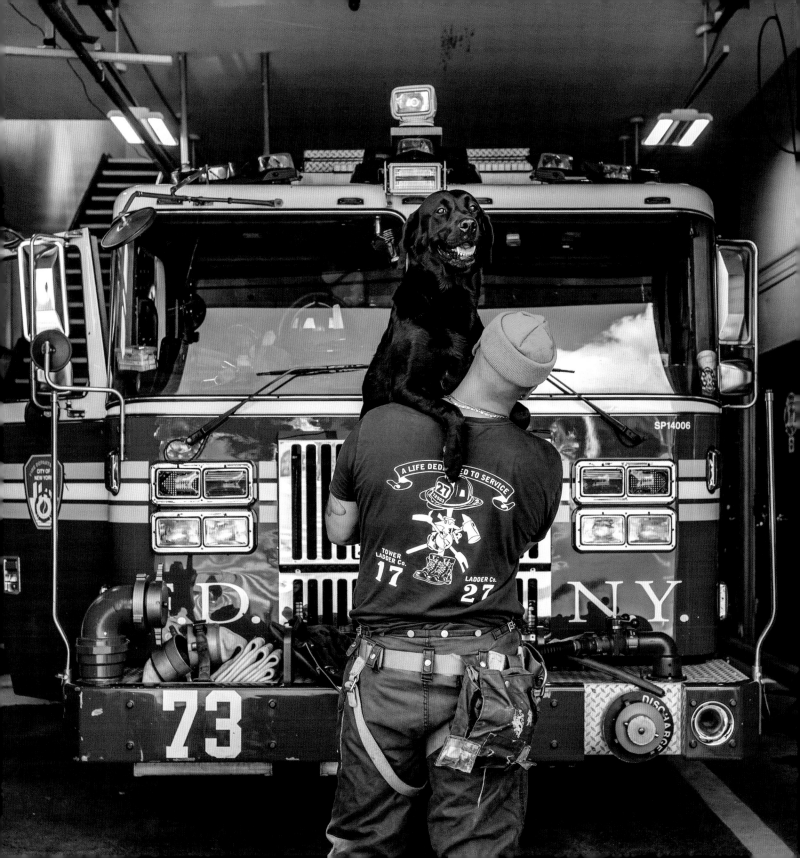

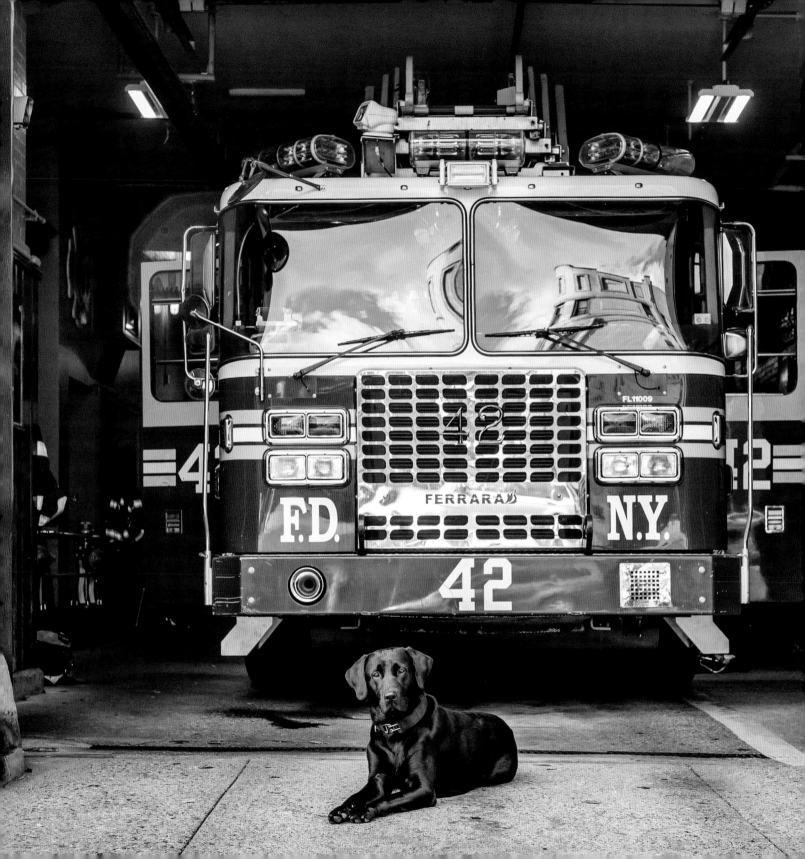

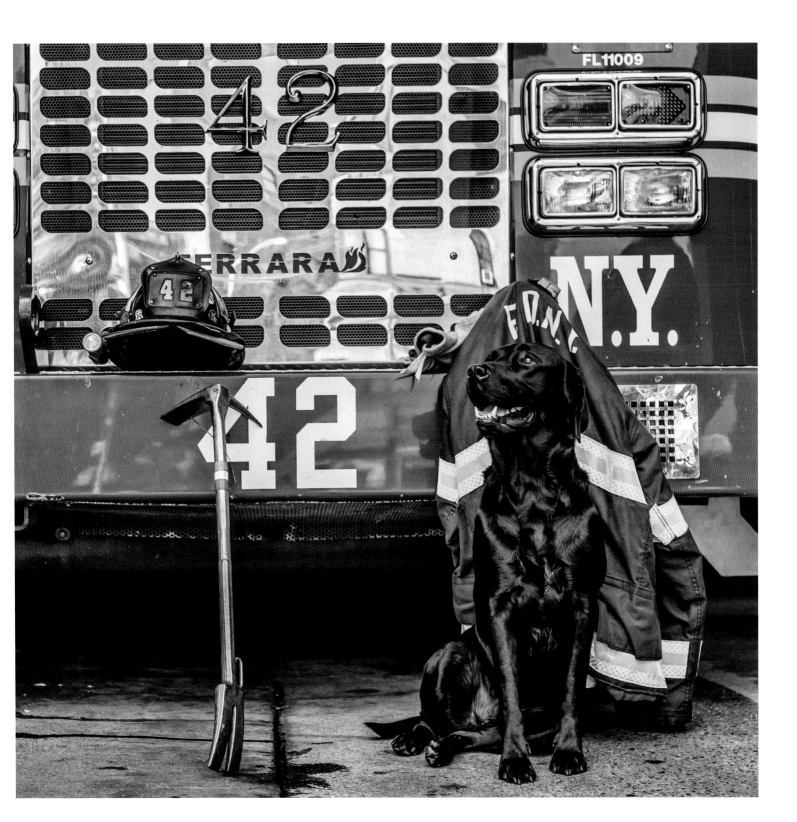

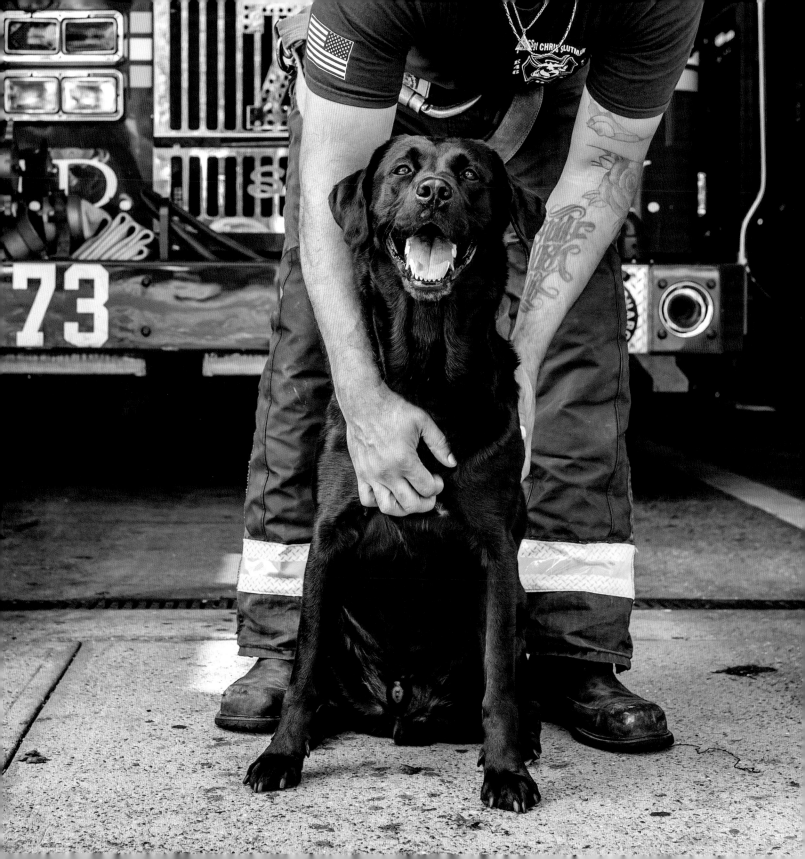

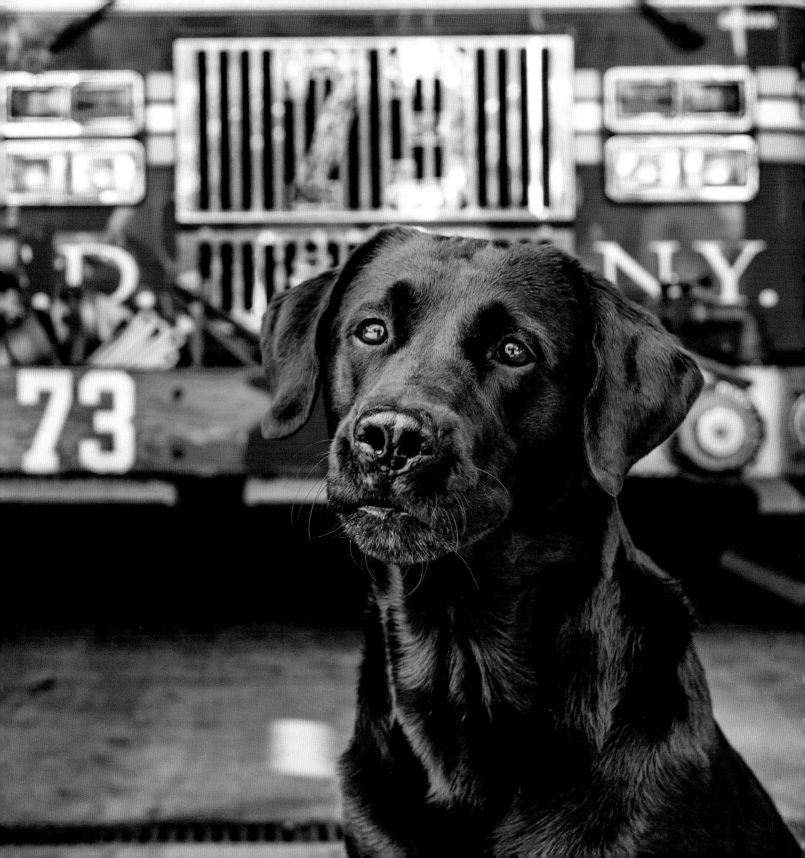

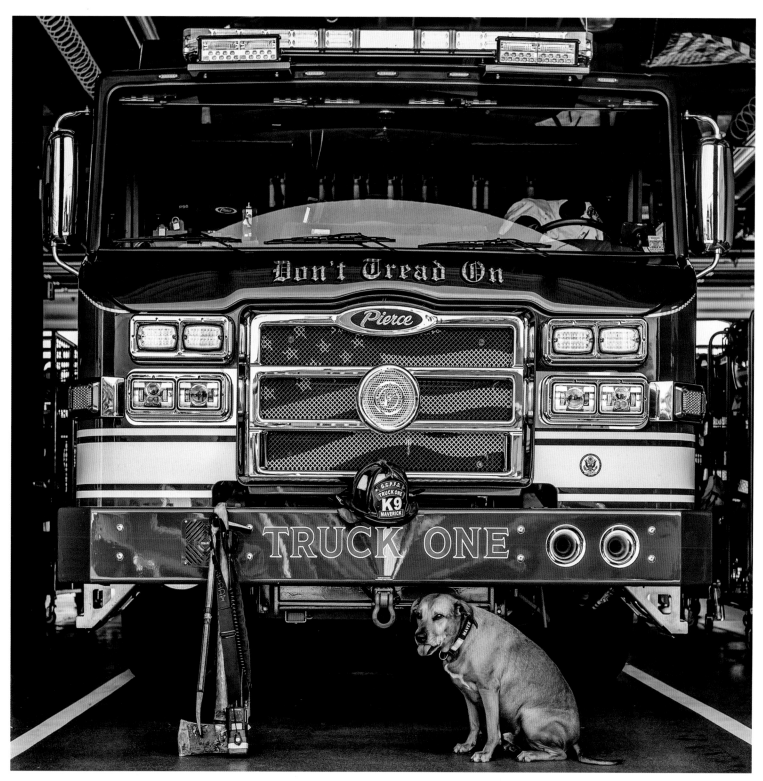

MAVERICK, TL151/E152, GARDEN CITY PARK, LONG ISLAND

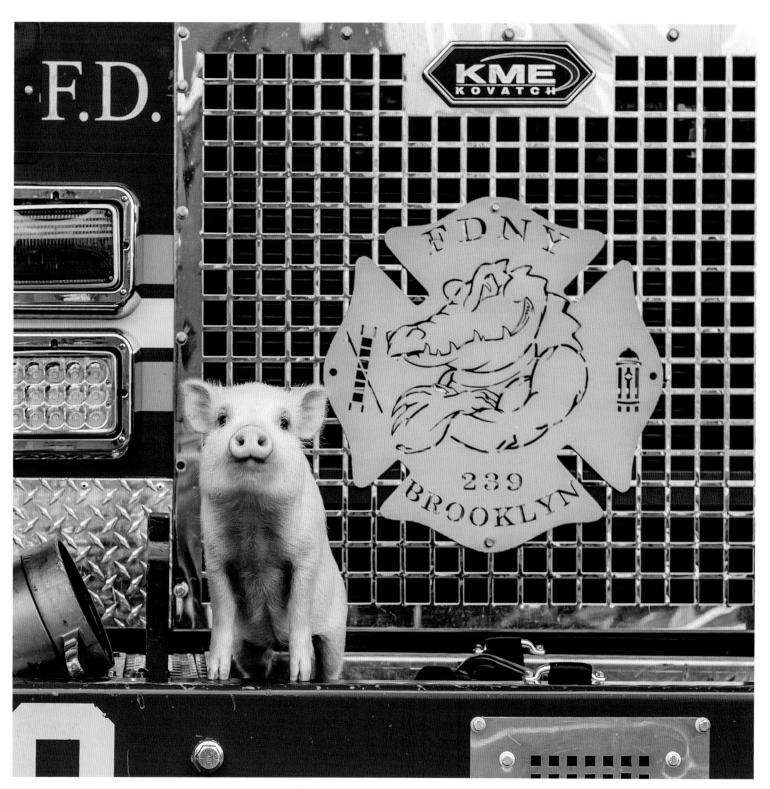

PENNY, E239, BROOKLYN

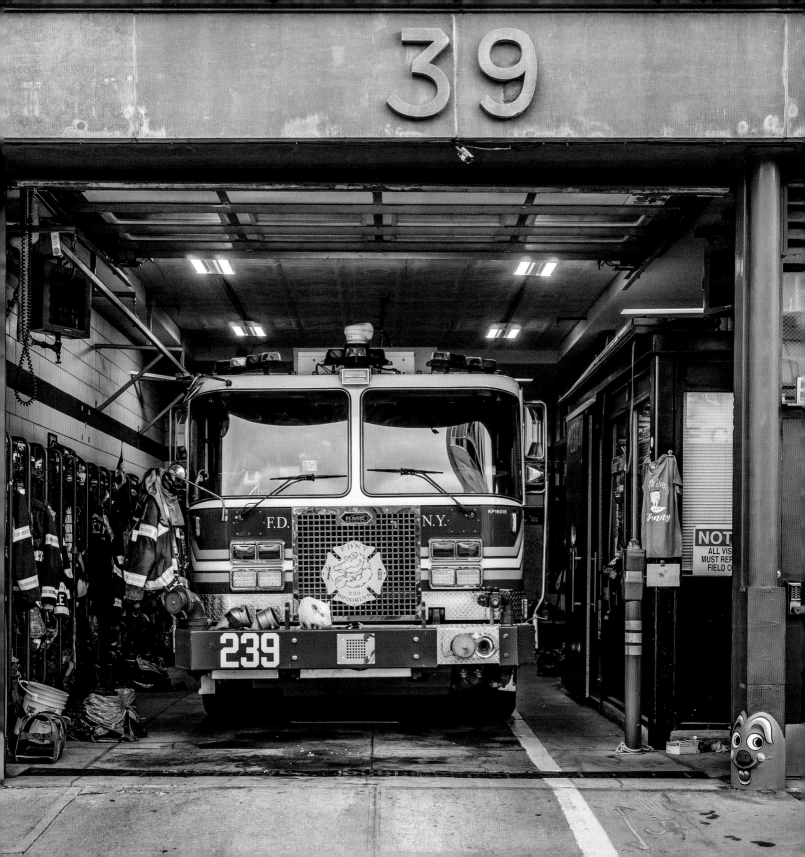

My story has a ruff beginning, but it is that story that has led me to fit in perfectly with the members of the "Fort Pitt" firehouse on the Lower East Side. I am Ashley, and I made my way to Fort Pitt through the wonderful people at No More Pain Resq. I am also lovingly called "Da Baby." You see, the first part of my life was spent malnourished, neglected, and at an abandoned house used for illegal activities in Staten Island. I know this sounds terrible, but be assured that my story only gets better. The members of Fort Pitt were contacted by No More Pain Resq, and they graciously took me in. As firefighters are brave, resilient, and strong, so am I. I am a proud and loved member of the Fort Pitt firehouse, home to Engine 15, Ladder 18, and Battalion 4.

The firefighters at this house love animals of all kinds. I share the house duties here with the other senior resident member, Daisy the cat. It is well known that Daisy and I get into disagreements, and she loves to remind me of her seniority at the house and put me in my place. My name is inspired by the department tradition of the probie and the connection of fire to ashes. Probie is short for probationary firefighter, and Ash is short for Ashley. I passed my probation years ago, but they still affectionately call me "Probie Ash."

One of my fondest memories was after I was off probation and had started to get comfortable at the firehouse kitchen table. I got so comfortable that when the firefighters went on a run, I feasted on all the cheese left on the table! I am waiting for that day to happen again, but they are more careful now. I can only watch as the cheese gets thrown in the fridge quickly when the firefighters get a run.

All the locals know me; they call my name and say hello. I feel so grateful to be home at Fort Pitt. The firefighters are always saying that I am a gift to them. I didn't come wrapped in a pretty package, but I am their beautiful pup. I know that the gifts I provide the members with are happiness, laughter, and stress relief for the members working away from home and their families. I help them manage the stress of the job much better than if they did not have me. See, I told you that my story has a happy ending!

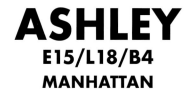

ASHLEY
E15/L18/B4
MANHATTAN

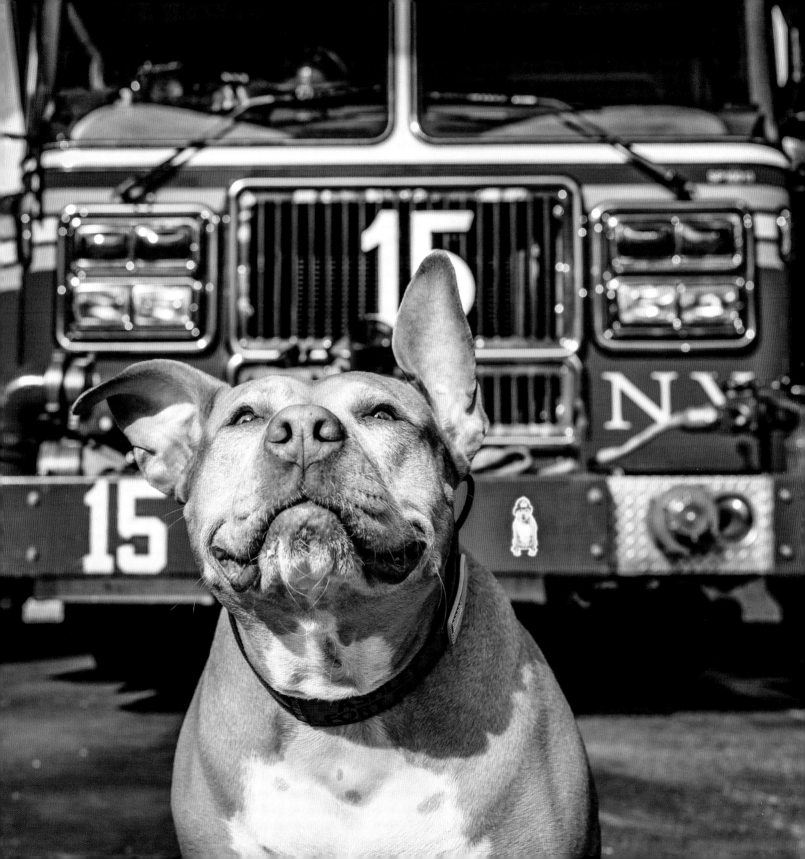

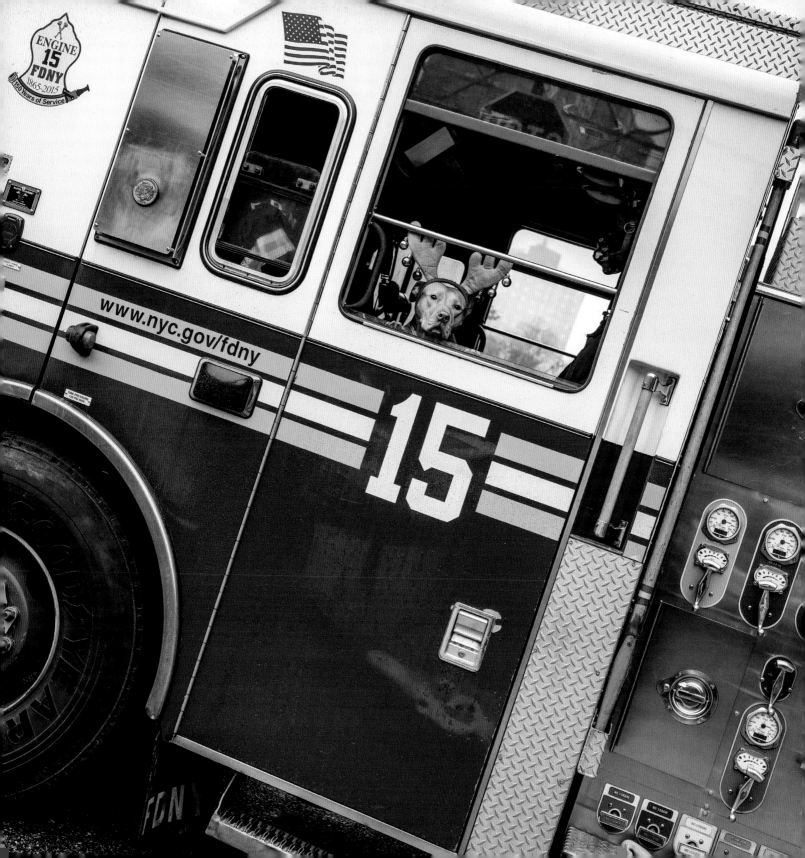

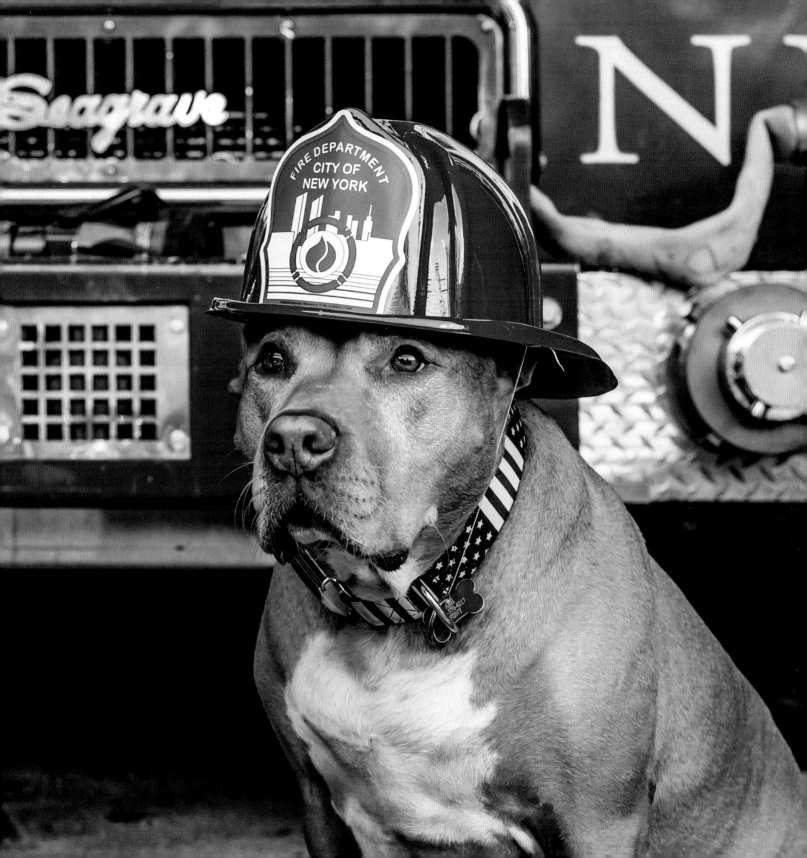

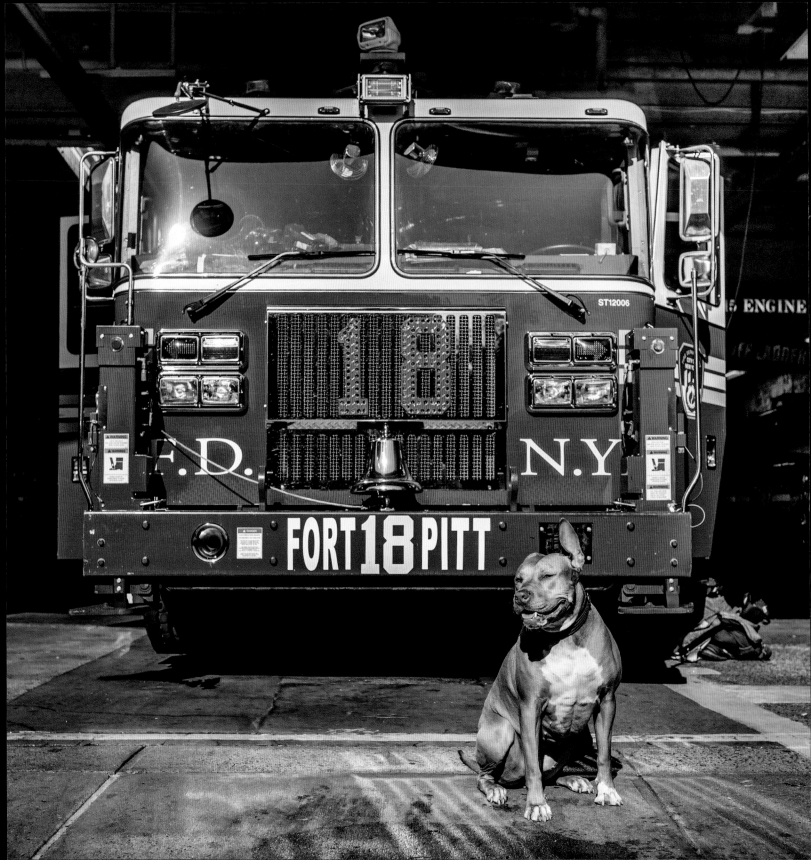

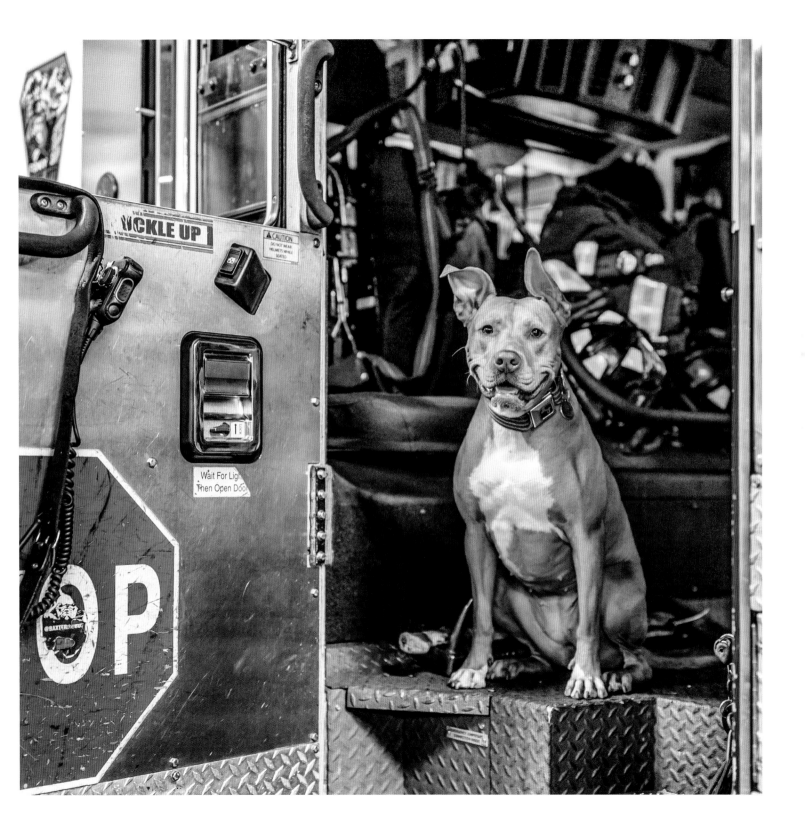

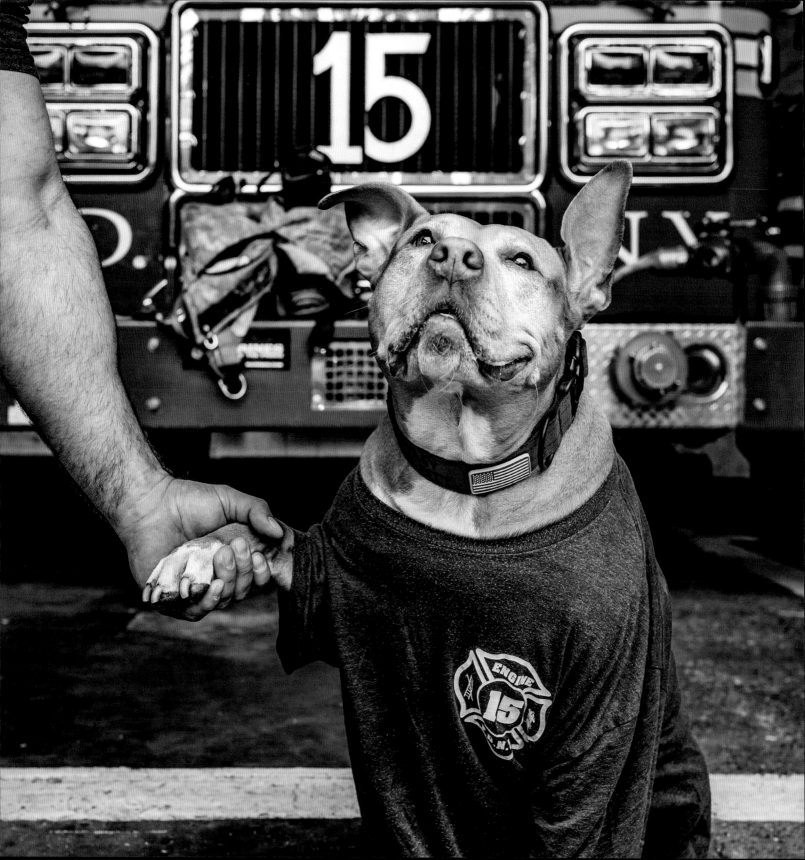

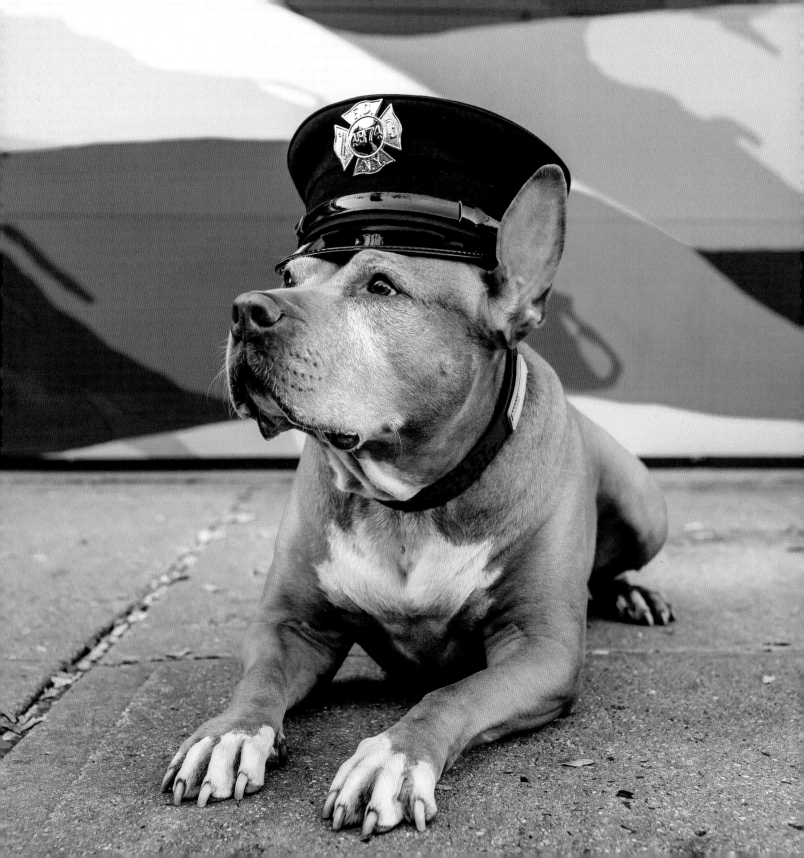

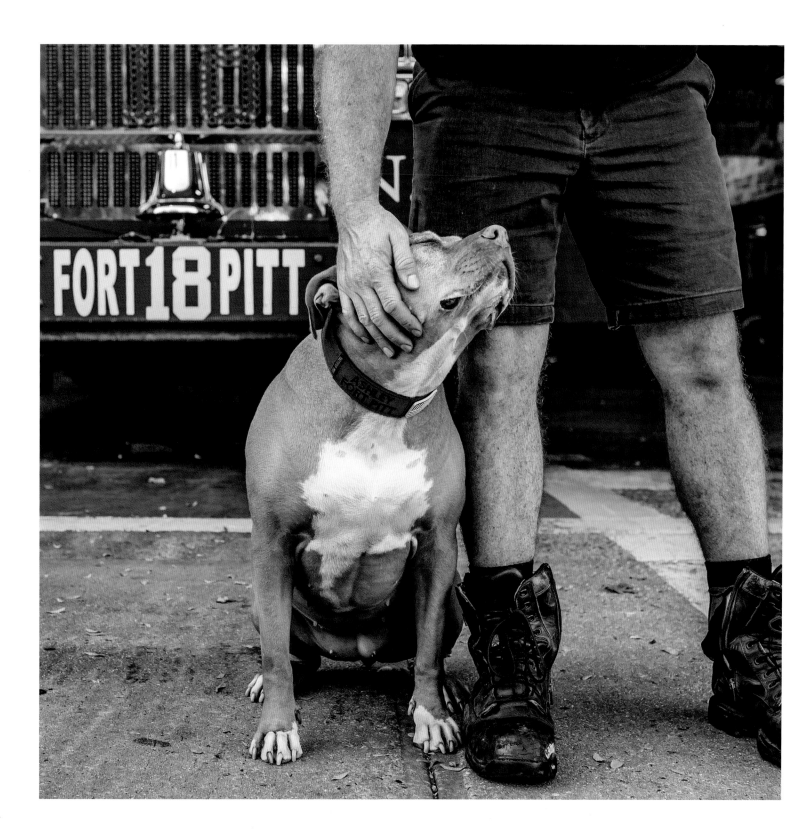

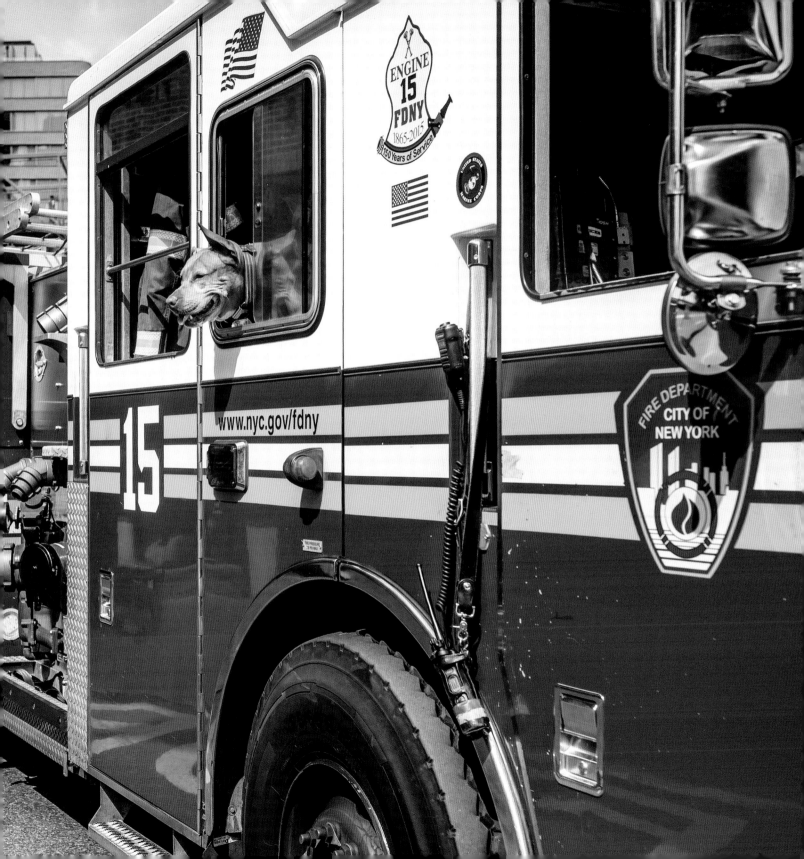

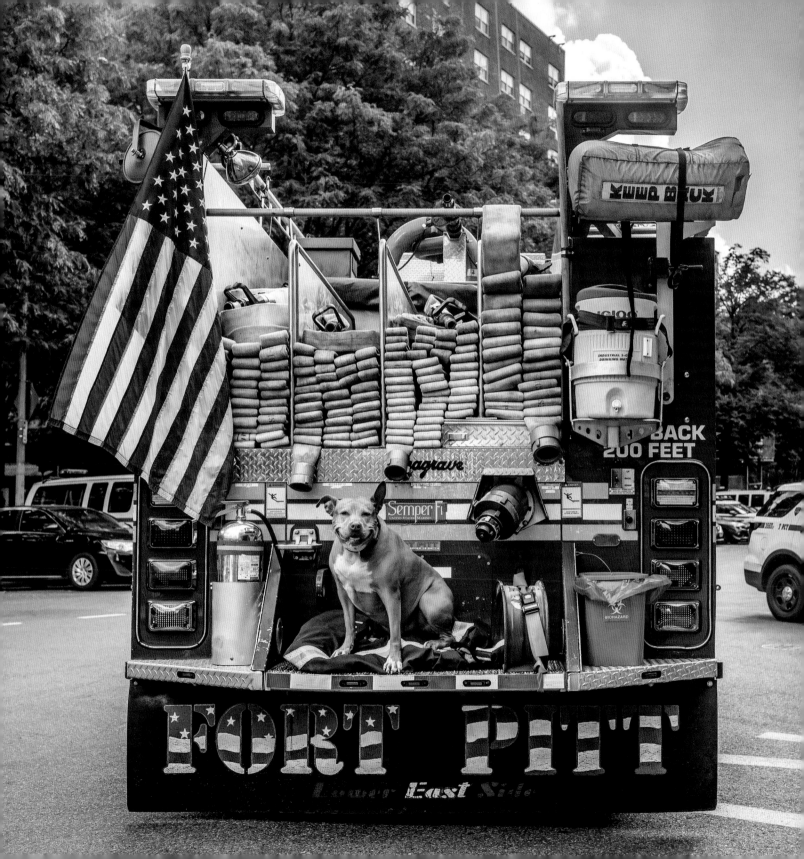

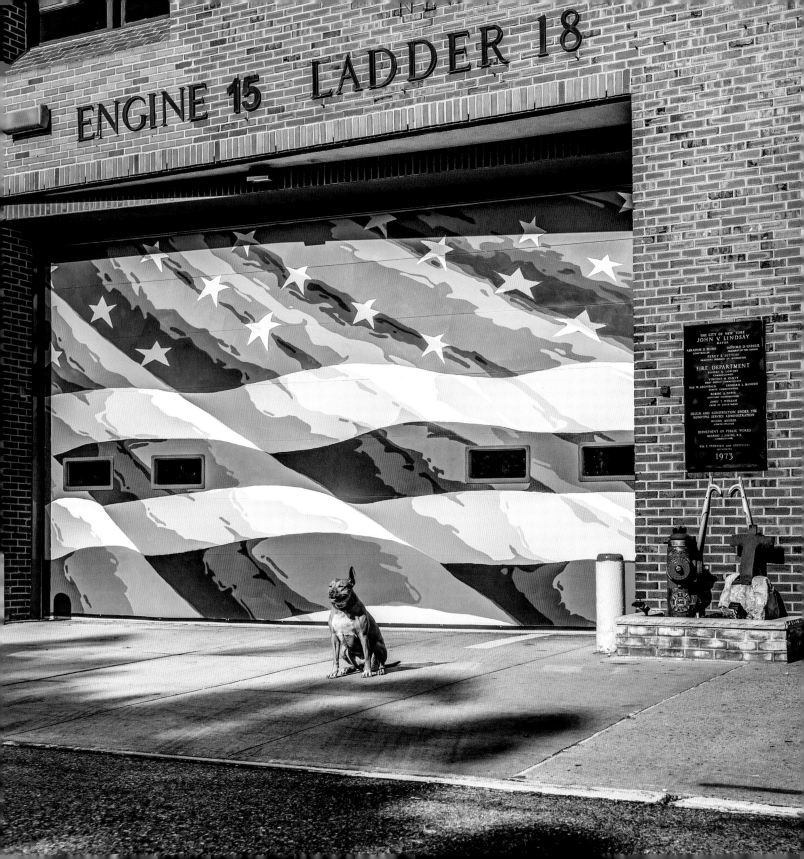

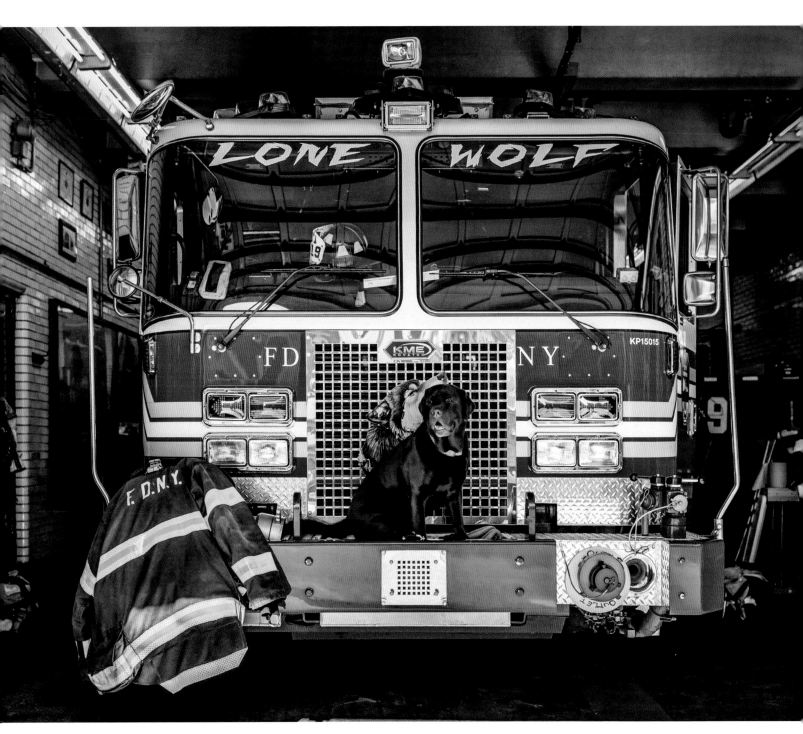

OTIS, E319, QUEENS

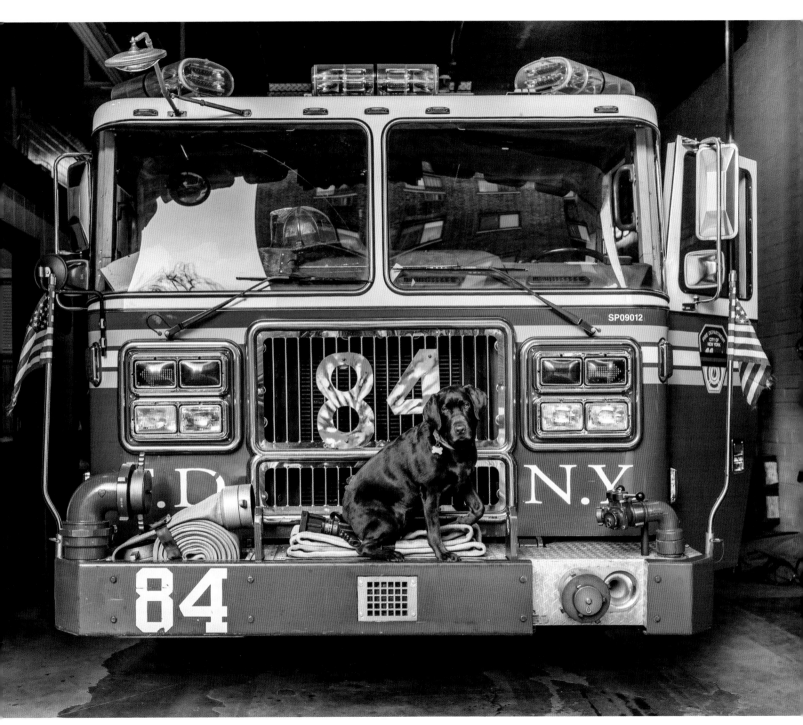

MAKO, E84, MANHATTAN

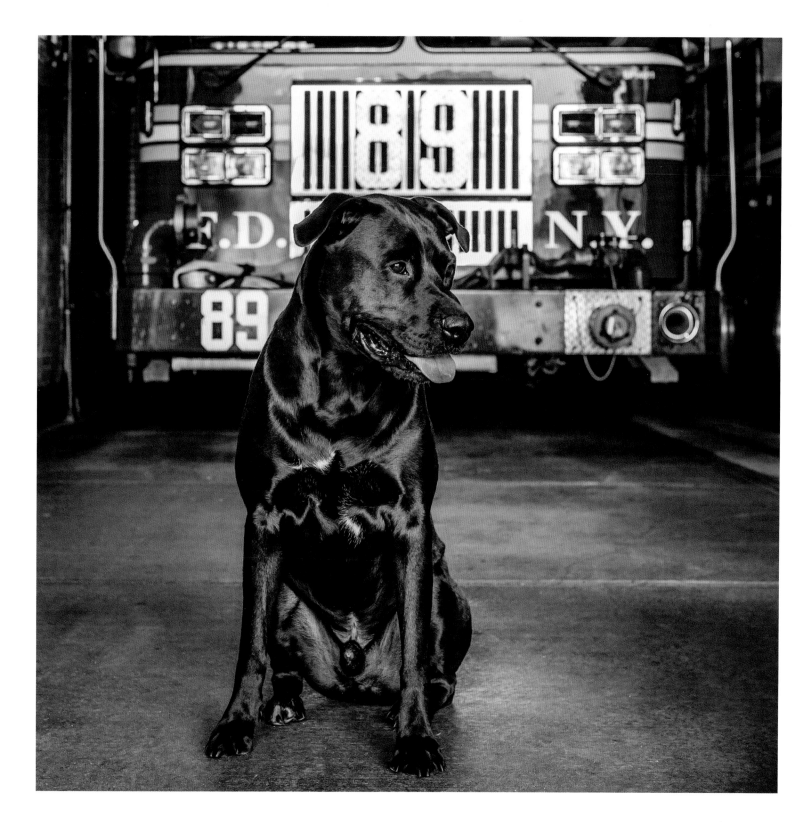

A dog named Smokey who lives in the firehouse—could it be any more perfect than that? I think not. I am Smokey, and I am a full-time resident member of "The Cuckoo's Nest" in the Bronx, home to Engine 89 and Ladder 50. I have been at the house for five years. I wear a tactical collar because I like to ride the truck the best. Especially when I can ride in the lieutenant's or chauffeur's seat. It makes me feel in charge of this nest.

I take pride in being a part of the special and tactical operations that the truck is responsible for in their duties and assignments. As part of my tactical assignments, I assist with research and development of the firefighters' personal protective equipment (PPE) and uniforms. I participate by wearing new fire hoods, job shirts, hats, and sweaters. And then I tell them which ones I like the most by refusing to take any of it off. However, there is one operation that I do not participate in: that is tactical night operations. At night, I rest on my own bed in the bunkroom. The firefighters work around the clock, so nighttime emergency response is a normal part of their tour. My nighttime response is only putting myself to bed and passing out. But first, the firefighters must take off my tactical collar, because I like to sleep comfortably through the tones going off at all hours so that my dreams of rescuing are not to be interrupted. I feel for the firefighters, since they work so hard and all I am willing to offer at night is a good lick.

It is my nature to provide love to the firefighters and locals alike. I especially like it when the local kids come by to give me pets and hugs. I am a mix of a few different breeds; however, no one is quite sure what breed it is that makes me so gorgeous. All I know is that this mutt is strong and healthy. You will most likely see me carrying my own leash. This ensures that the firefighters do not go on a run without me and that they are not delayed in their response. This way, I can easily be secured in the truck while they help others who need their expertise; after all, in my line of work, seconds do count. So next time, if you see Ladder 50 with my happy face leaning out the window, I encourage you to give me lots of love, and I will provide the same in return.

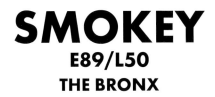

SMOKEY
E89/L50
THE BRONX

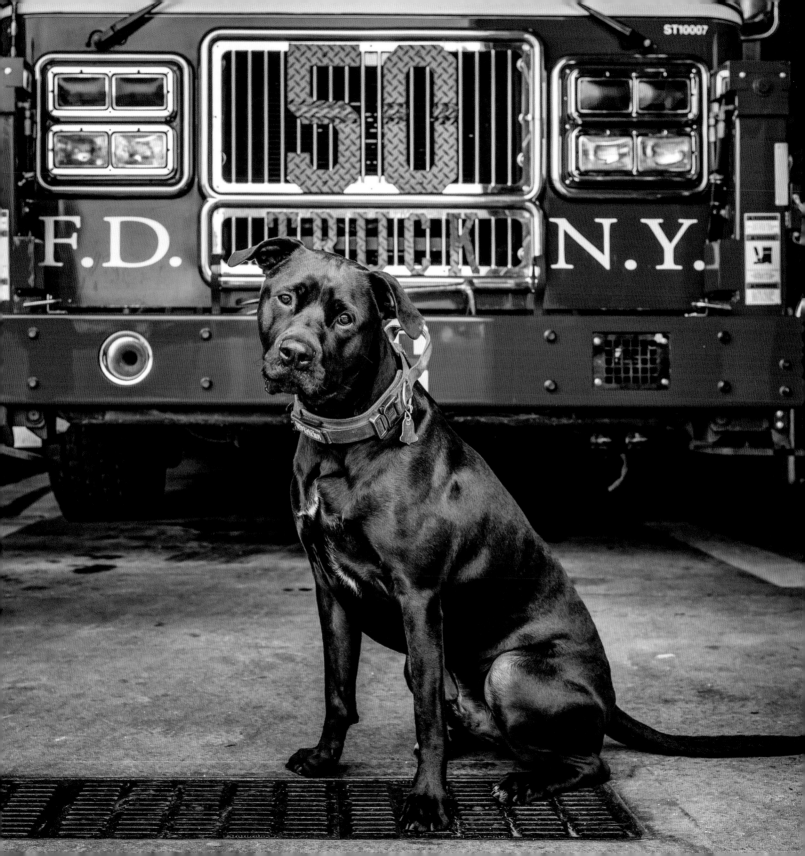

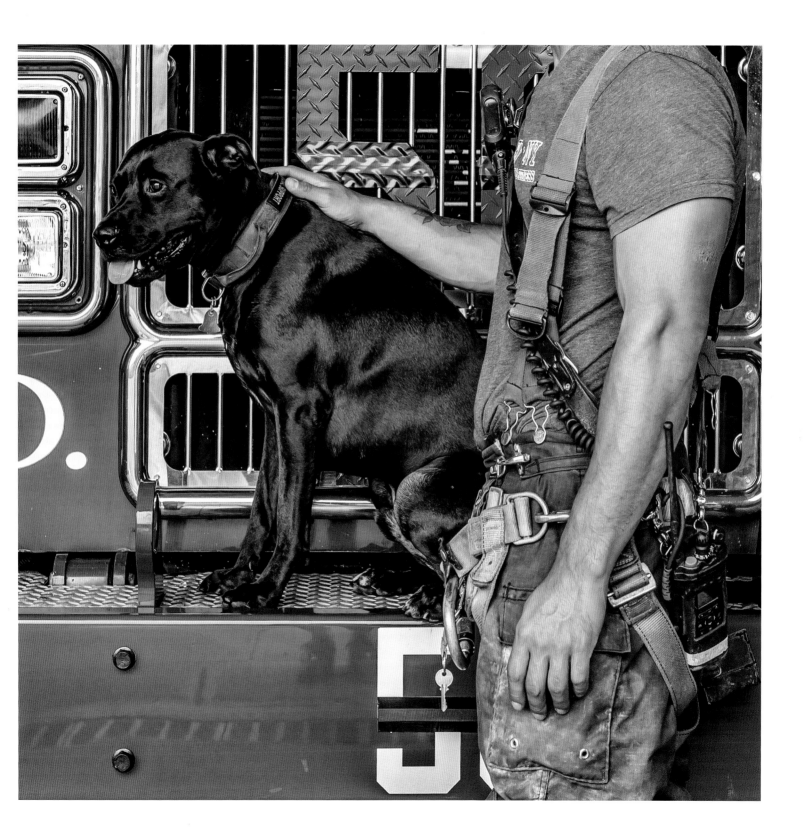

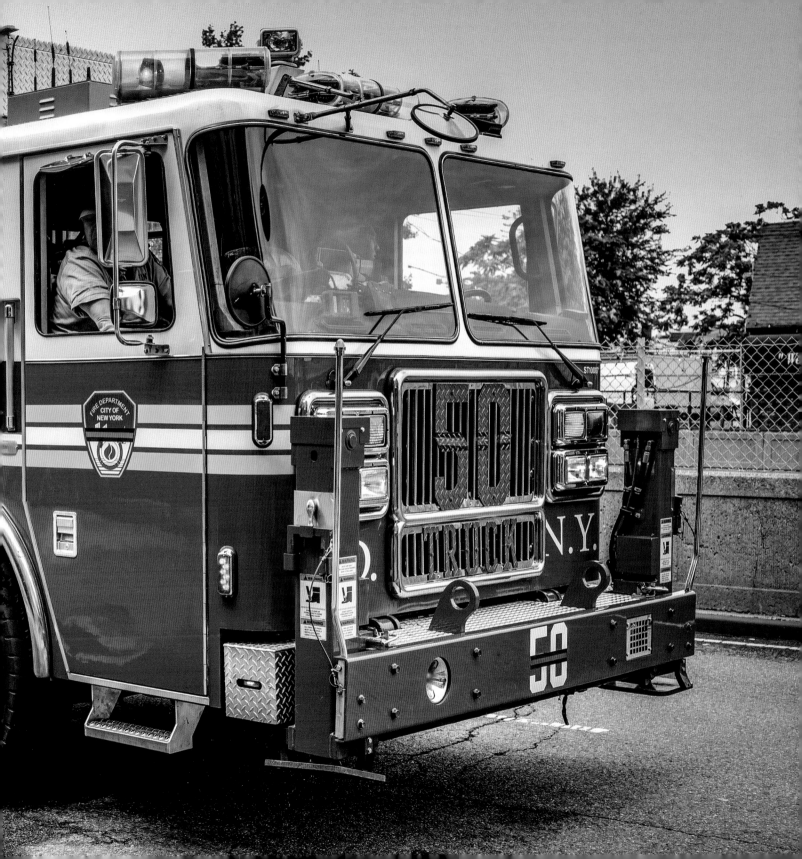

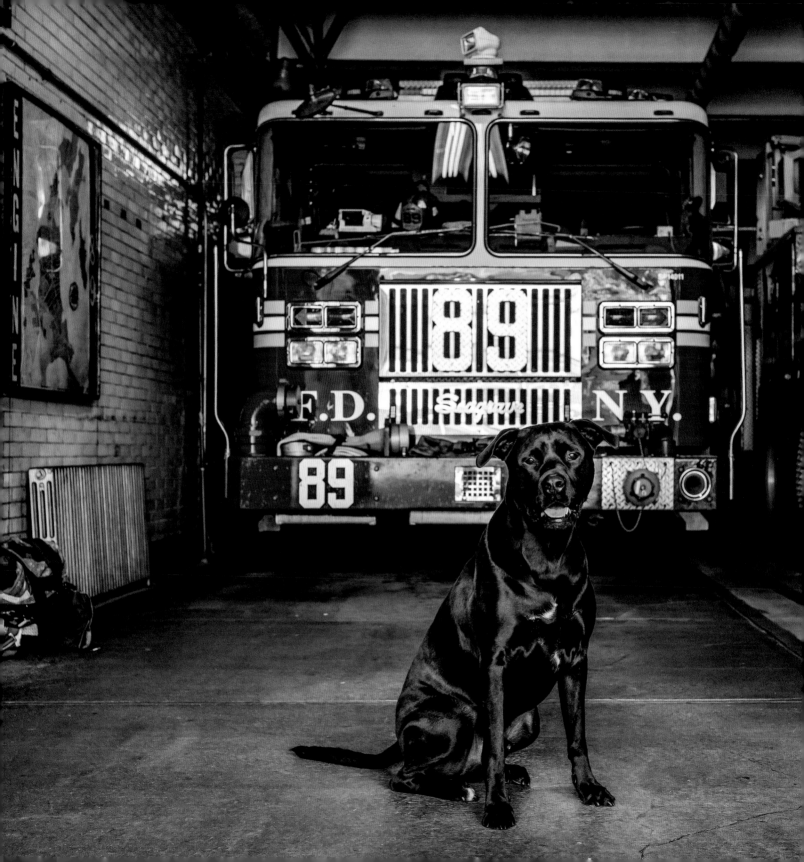

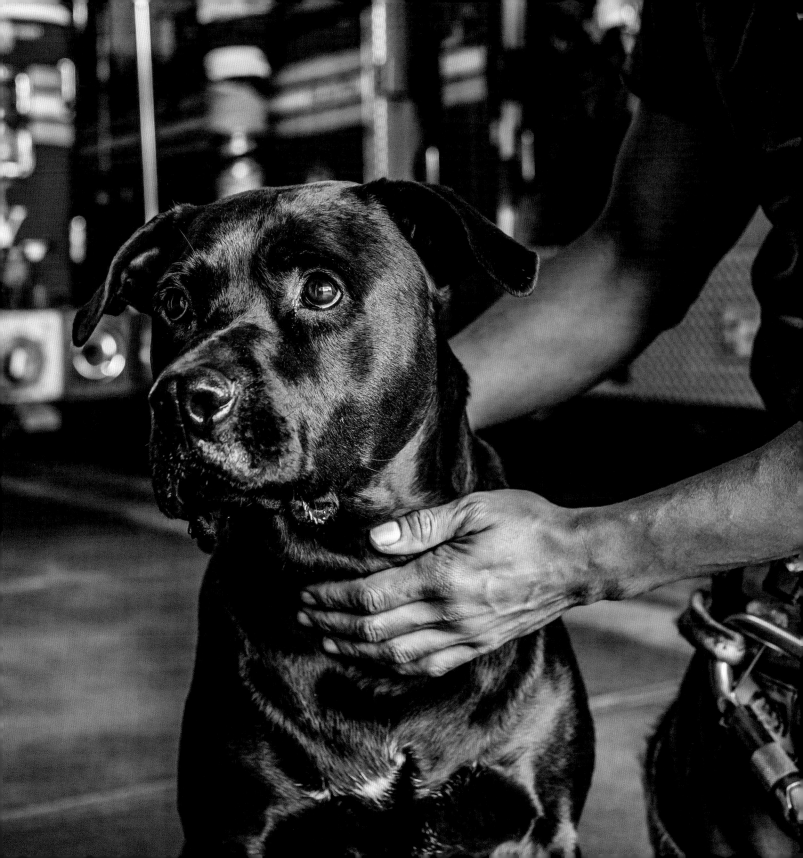

As the mascot of "The Fire Factory," home to Engine 58 and Ladder 26, I am just as important to the firehouse as the engine and truck. As a matter of fact, that is how I got my name. They call me "Riggs," which is another name for the apparatuses (engine and truck) in the firehouse. I am a six-year-old English bulldog.

Since the 1960s, the Fire Factory has been a very busy house. It had received its name from the large volume of fires constantly called in, not only by neighbors but by firefighters themselves. This led to the dispatchers asking if we were operating a "Fire Factory." Because of how busy this house is, it makes me a perfect fit! We bulldogs are known to sleep through any noise, so it allows me to perform my mascot duties to the best of my abilities. No matter when the tones go off, I will be sound asleep!

While my brothers and sisters of New York's Bravest are responding to emergencies, I am at my command post protecting the house, sleeping, and snoring the day away. That's right, I sleep and snore while I sit. That way, I can respond faster since I am already halfway up. When I do respond on runs with the firefighters, you will see me hanging out the window with my tongue out and loving life. Though I must mention, those chairs made for humans are not at all comfortable for us bulldogs!

As the company mascot, I bring positive vibes wherever I go. I like to give a warm welcome to anyone who passes by, and make new friends every day. People from different countries come to visit me! They give me treats and, if I am lucky, toys! Some of my favorite toys are my fire hydrant and pineapple. Wherever I go, they go!

I love the energy and excitement the firehouse brings. There is a constant amount of attention given to me, and I am always treated like a king. Though I must admit, during Christmas time there is an old man in a red suit that patrols the apparatus floor. My brothers and sister have comforted me, saying he is just an inflatable Santa, but the way he looks at me is off. He is an impostor, and I do not like him! My chihuahua friend named Bella helps me throughout the holiday season to get this impostor out. We bark AND bark AND bark him away to the next season!

As the Fire Factory continues to get busier serving Harlem, I will continue to carry out my mascot duties of sleeping around the clock as best I can. They say, "The best tool on the job is a well-rested firefighter," and I will make sure that I am rested and ready for the next big run!

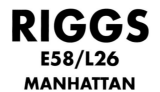

RIGGS
E58/L26
MANHATTAN

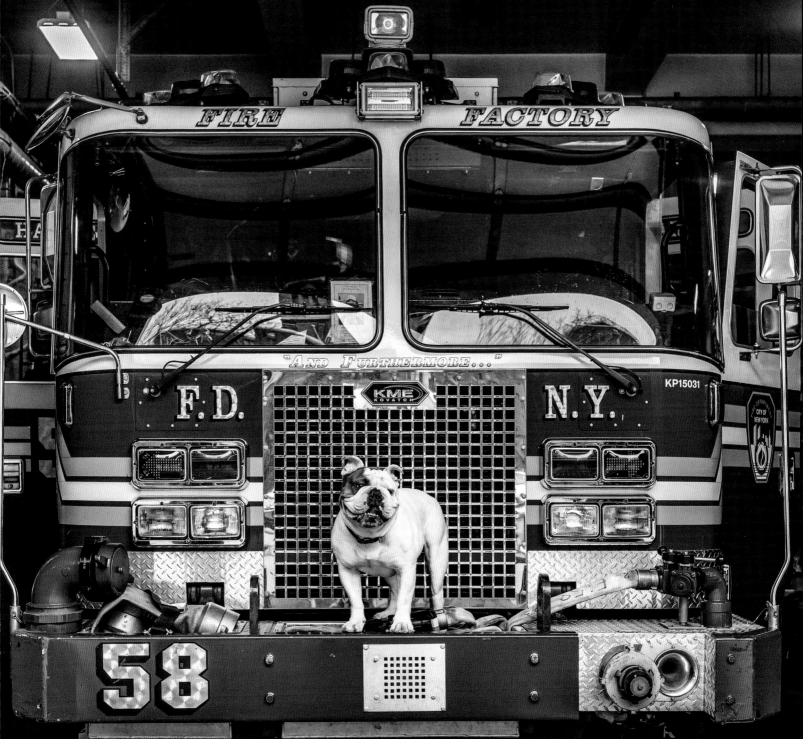

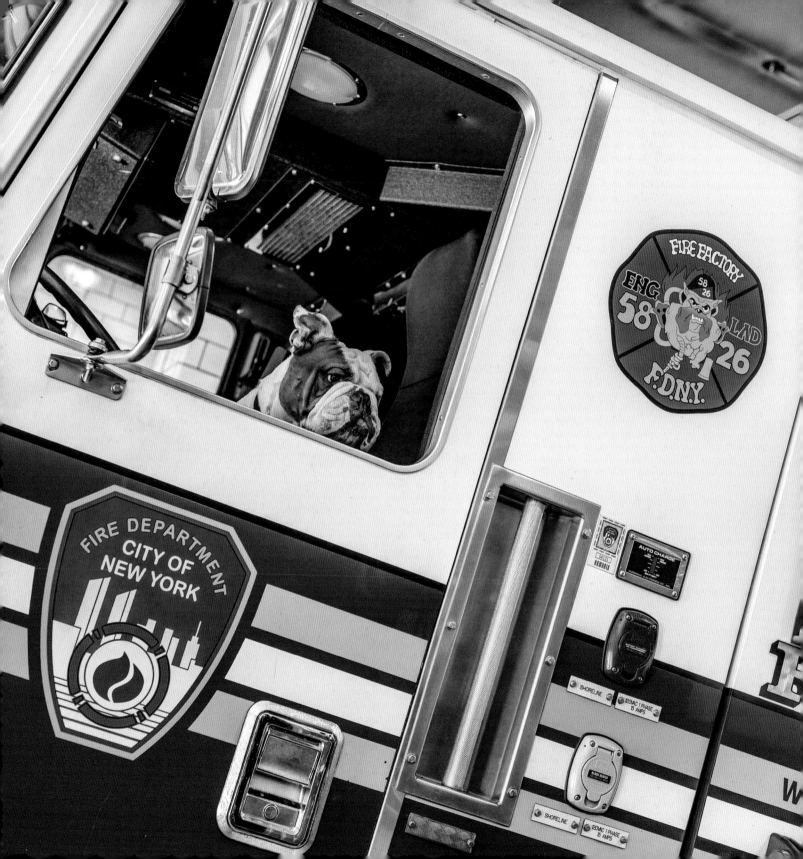

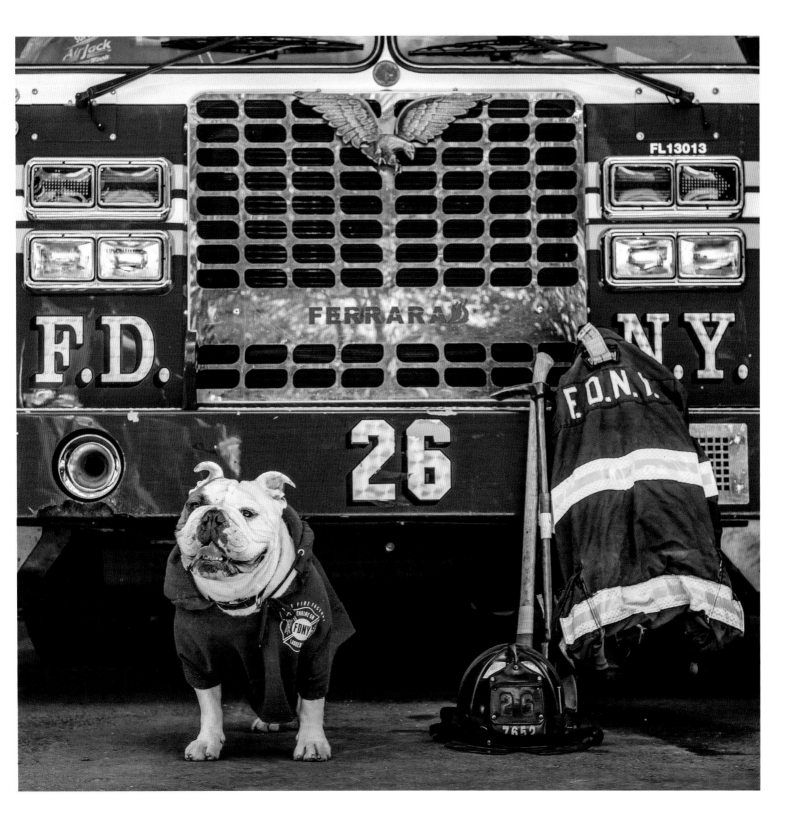

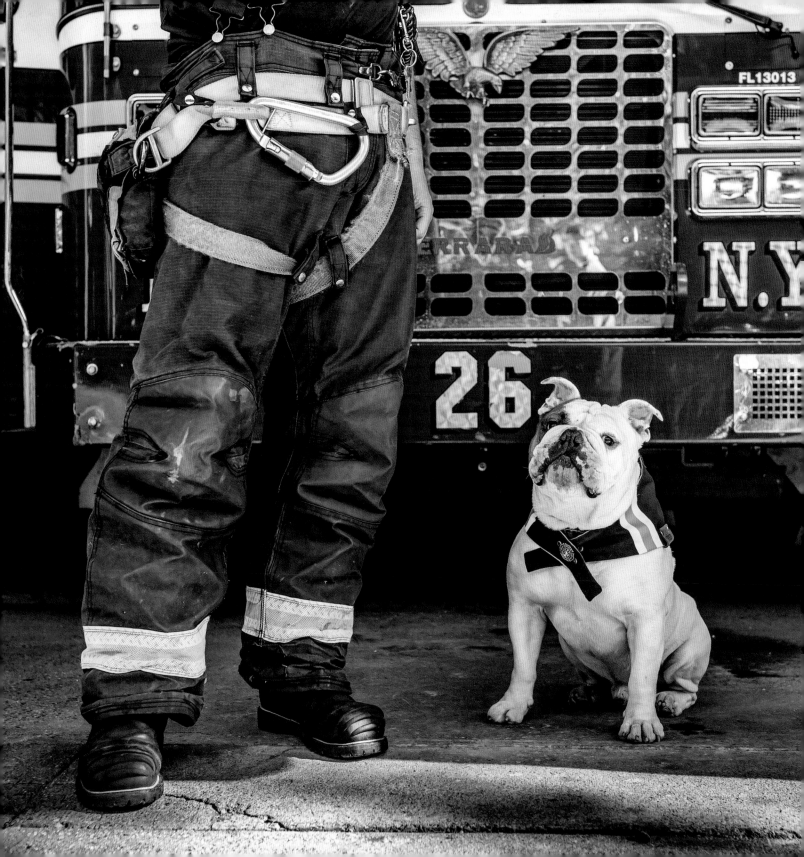

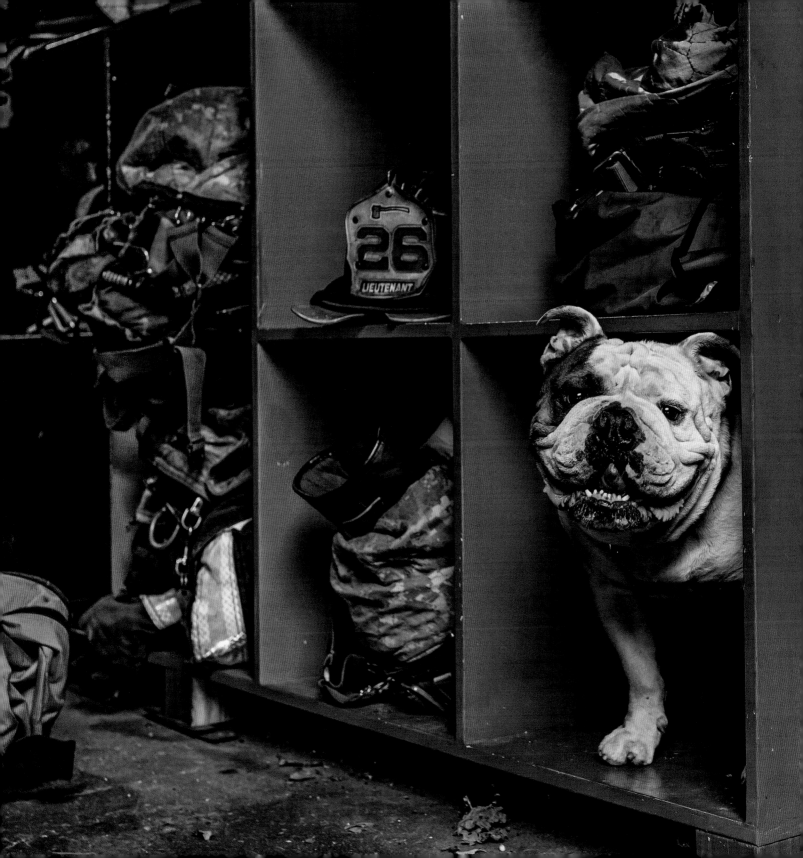

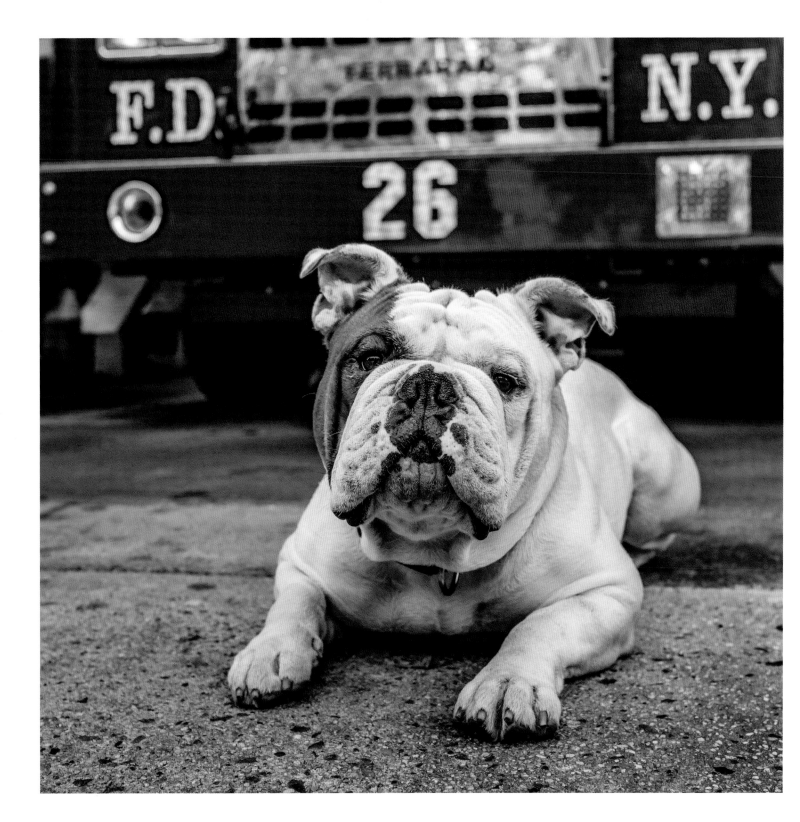

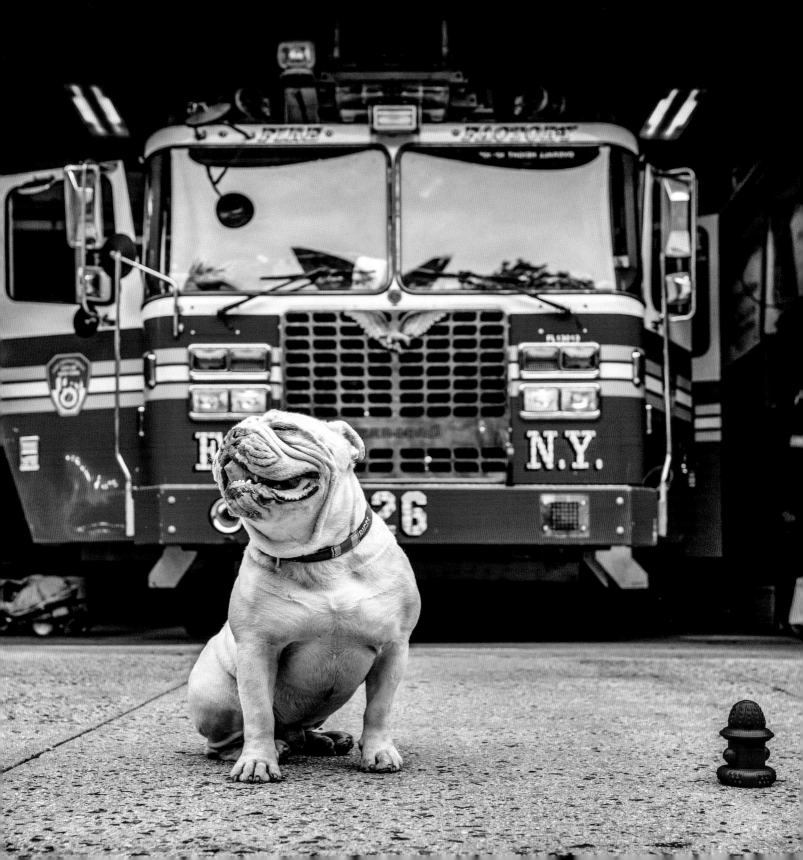

Hi, I'm Jake. I'm told I was born sometime in February 2017. That makes me about six years old. I was originally adopted by a family of four, but due to my hyper but ever-so-sweet demeanor, they thought life for an active pup like me would be better suited in the firehouse.

I'm happy to say that I am now a proud member of the "Swamp Dogs" of Engine 311 and Ladder 158, in Springfield Gardens, Queens South. When I first arrived and the tones went off, I ran with everyone else because I thought I had to protect them. I had to make sure they didn't get harmed by their loud vehicles, with all the lights and their large, scary pants with suspenders. I'm not fond of those large pants. To me, they smell funny, and it makes the firefighters look like monsters. But after seeing this a few times, I realized that I didn't have to keep an eye on them. Those pants actually protect my humans, and they are called turnout pants. So now I just stay on my comfy couch and watch the firefighters go on runs.

I go to meetings with all the firefighters, and I attend the drills too. My role at the drills is mainly supervisory and ensuring that the firefighters are safe. At high-rise drills, I get comfortable on the fire curtain. The curtain, which is deployed over high-rise windows, protects the firefighters from wind-driven fire conditions.

Some of the things I like to do in the firehouse are sleeping, digging, running to get the doorbell, watching the children passing by to go to school in the morning, walking in the park, playing in the yard, and farting on the junior guys. Sometimes the firefighters like to tease me and try to leave me in the kitchen. You may think I would like to be left there with all the treats, but no, I want to be with my firefighters at all times, so I protest and someone always lets me out. I love chewing and destroying things, such as bones and toys. It's okay, though; my firefighters take great care of me, and they always buy me new ones! Nice to meet you, and, until next time, you will find me holding down the swamp.

JAKE
E311/L158
QUEENS SOUTH

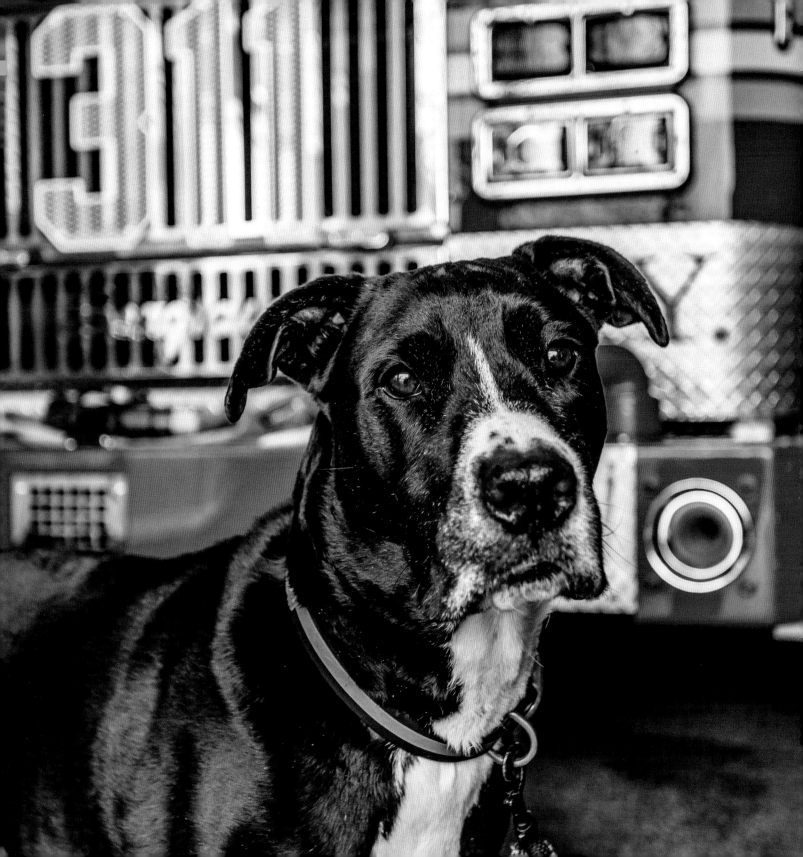

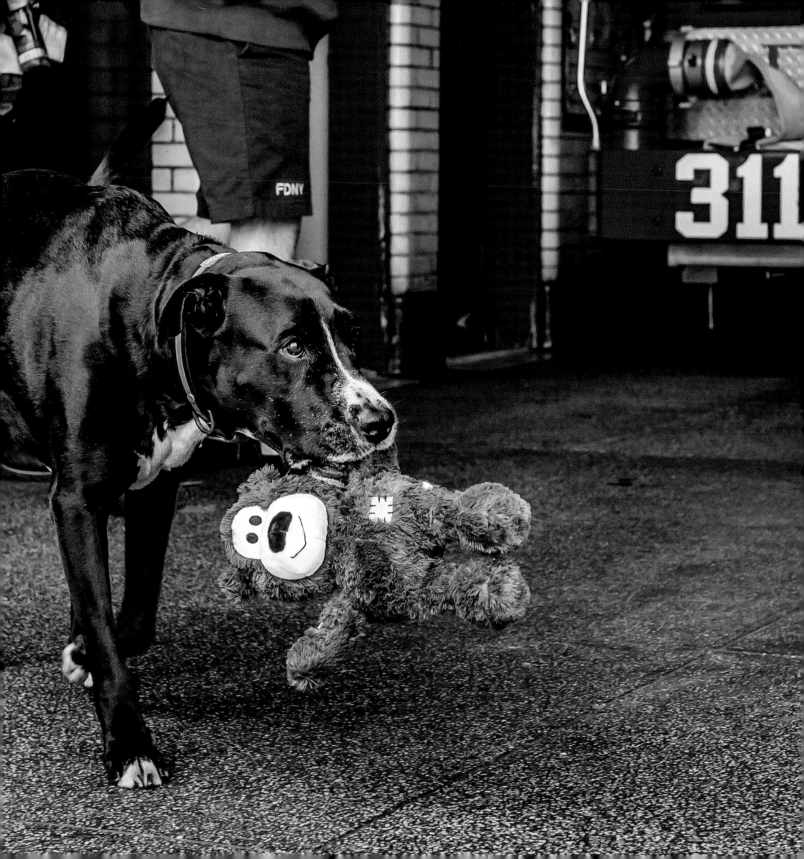

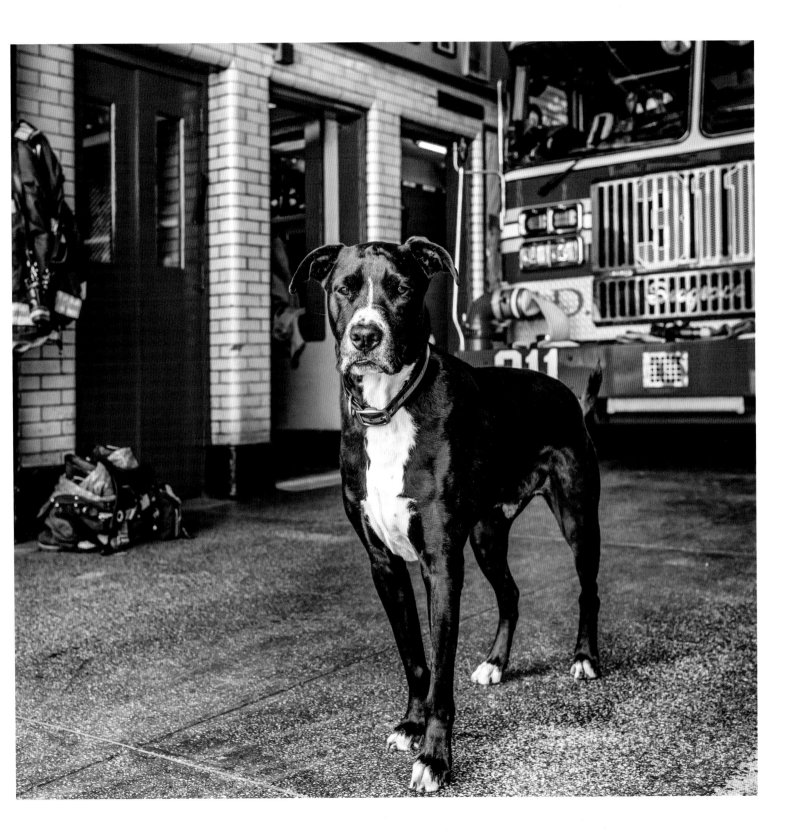

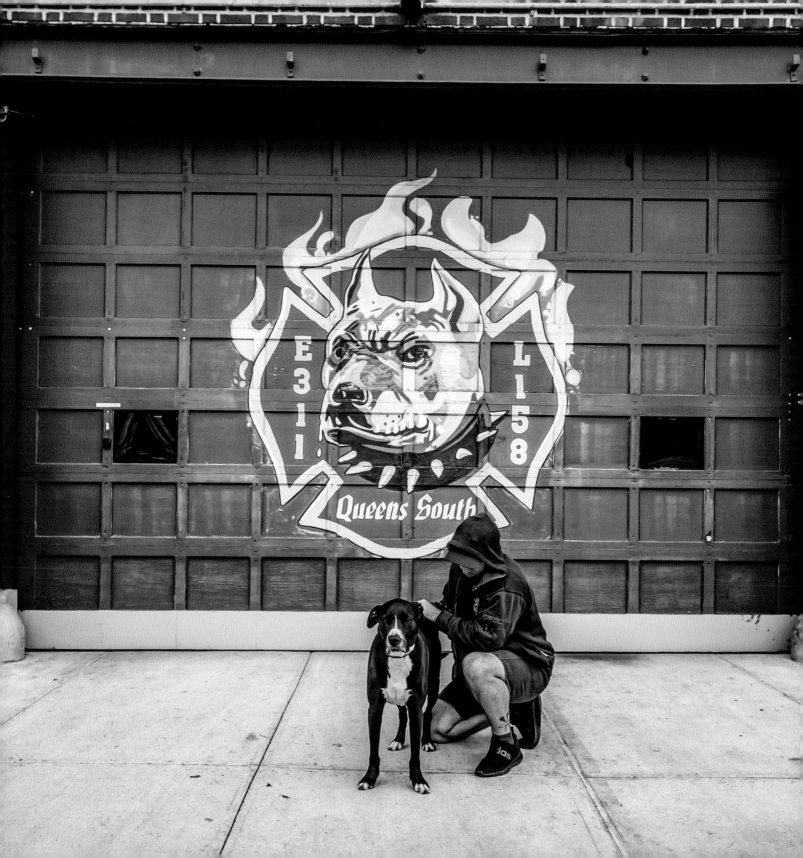

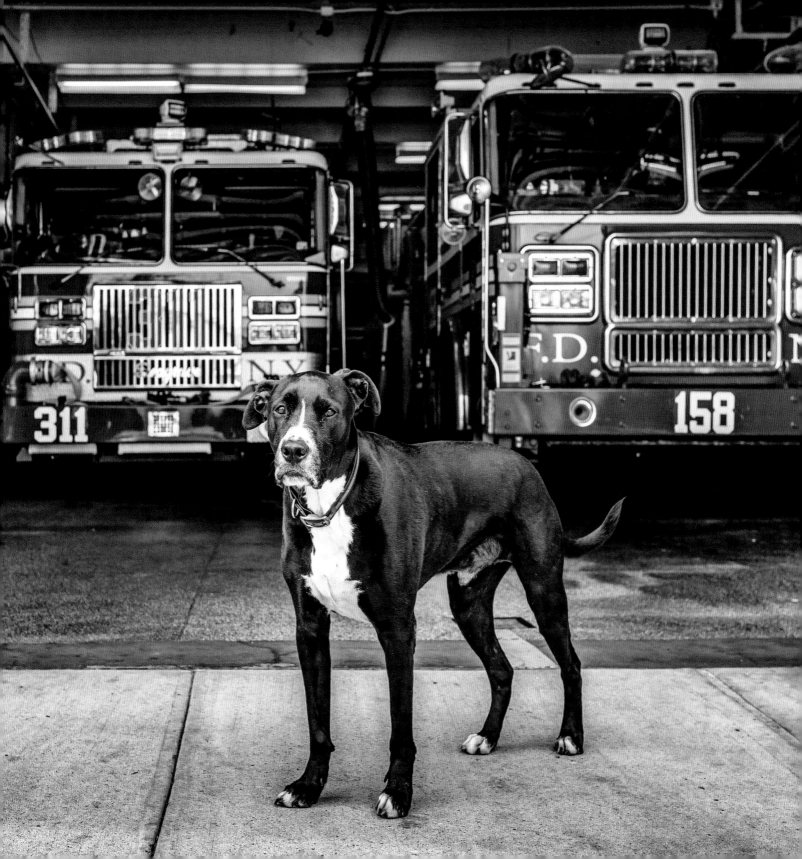

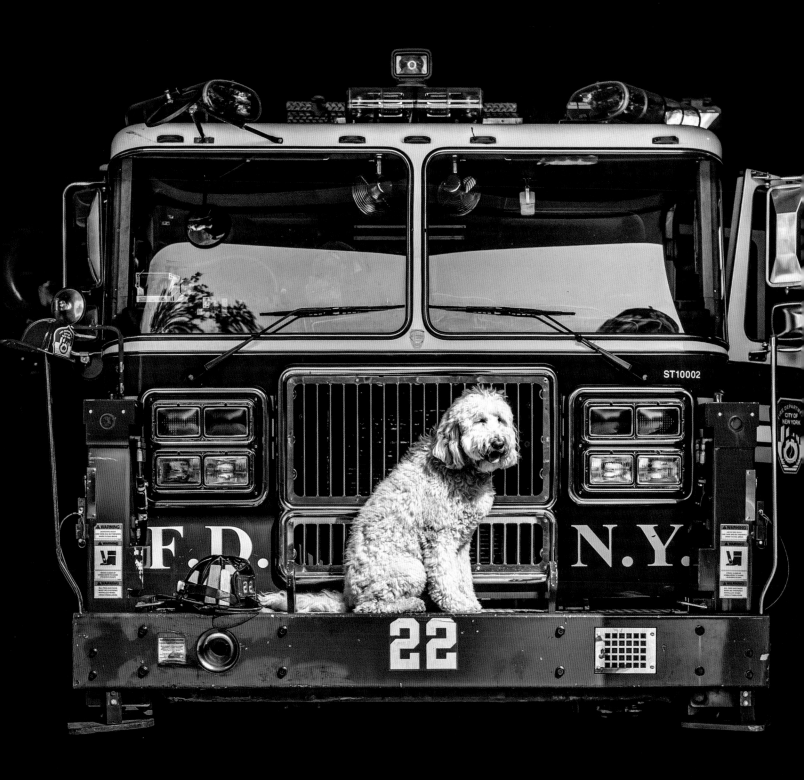

CAPTAIN, L22, MANHATTAN

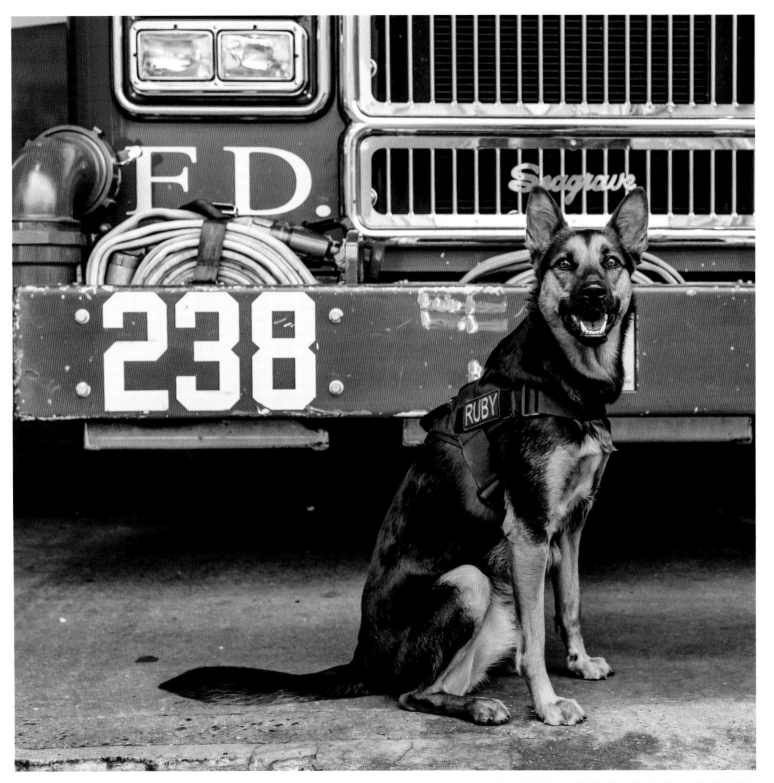

RUBY, E238, BROOKLYN

My name is Bobby. I live at the firehouse with members of Engine 55, in Manhattan's Little Italy. I arrived here when I was already an adult cat, and before that I was at an animal rescue organization. I don't remember much before that. I live in the present moment, you know?

Engine 55 used to have a dog before I got here. His name was Nickels. He sounds like a great dog, and everyone loved him, and I wish I could've met him, even though I don't like dogs very much. Or other cats, for that matter. Or large groups of small children. But I'm actually very friendly, I swear! I am a pretty laid-back cat. My passion is cat food. I love cat food. I am missing quite a few of my teeth, but it doesn't affect my adoration of kibble. Those kibble nuggets are the only thing I need, and the only thing I dream about. Each crunch of those delicious kibble nuggets is an explosion of pure happiness. I wonder if my passion for kibble has anything to do with my hypo-thyroidism. The vet gave me some medication, but I still seem to be ravenously hungry. All. The. Time.

My job in the firehouse is to patrol for rodents and large insects. I take my job seriously, and I almost always stay on the apparatus floor, in the kitchen, or in the basement. Although I have an assignment at the firehouse, I am not quite sure what the humans in the firehouse do. I know they have very important assignments to protect the life, safety, and property of the citizens of New York, and they train every day to perfect their skills in those assignments. I also know that they arrive for their shifts at the firehouse in groups and wait for a loud tone to go off. That tone is my cue to go to the back of the firehouse. When the tones go off, they all rush to the apparatus, climb in the fire engine, make a lot of noise, and leave. At some point, they return. I don't ask a lot of questions about their responses to emergencies, but I know that when they come back, I am here for them, just like they are always here for New York.

BOBBY
E55
MANHATTAN

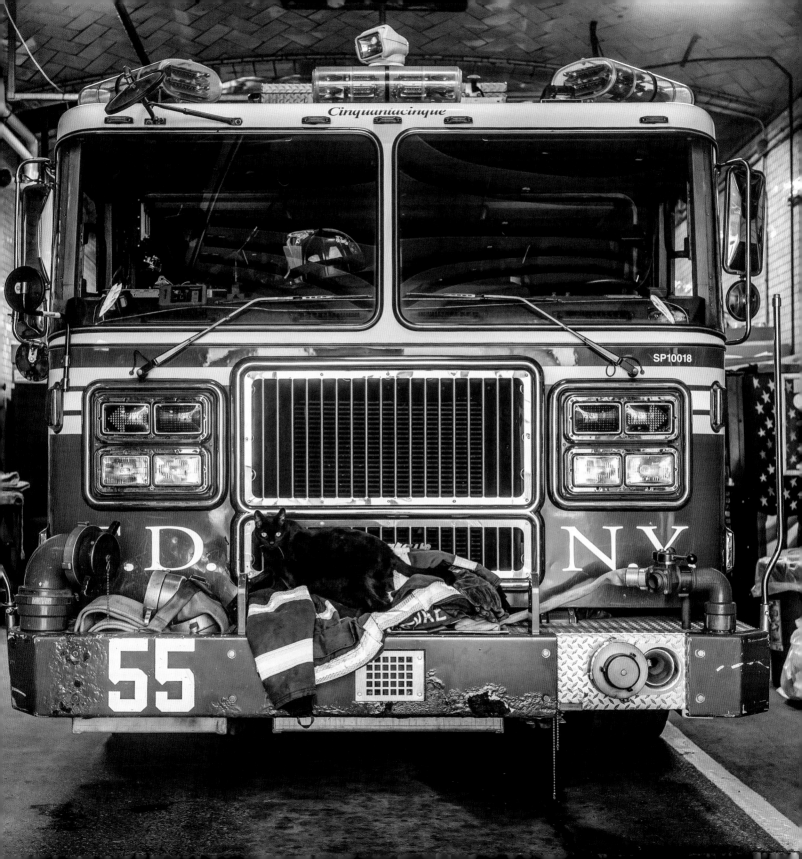

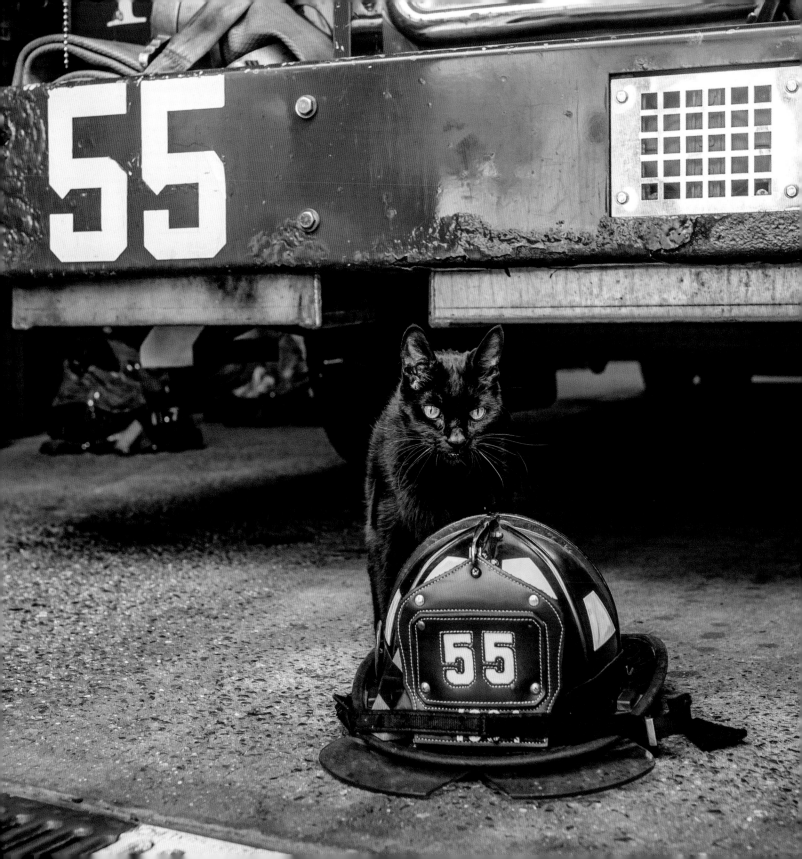

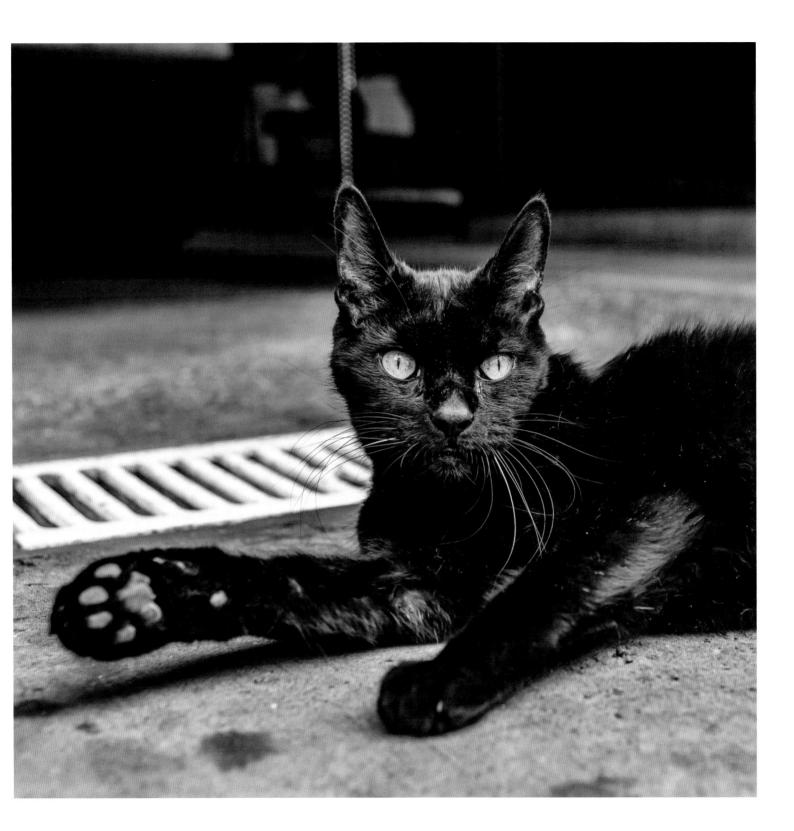

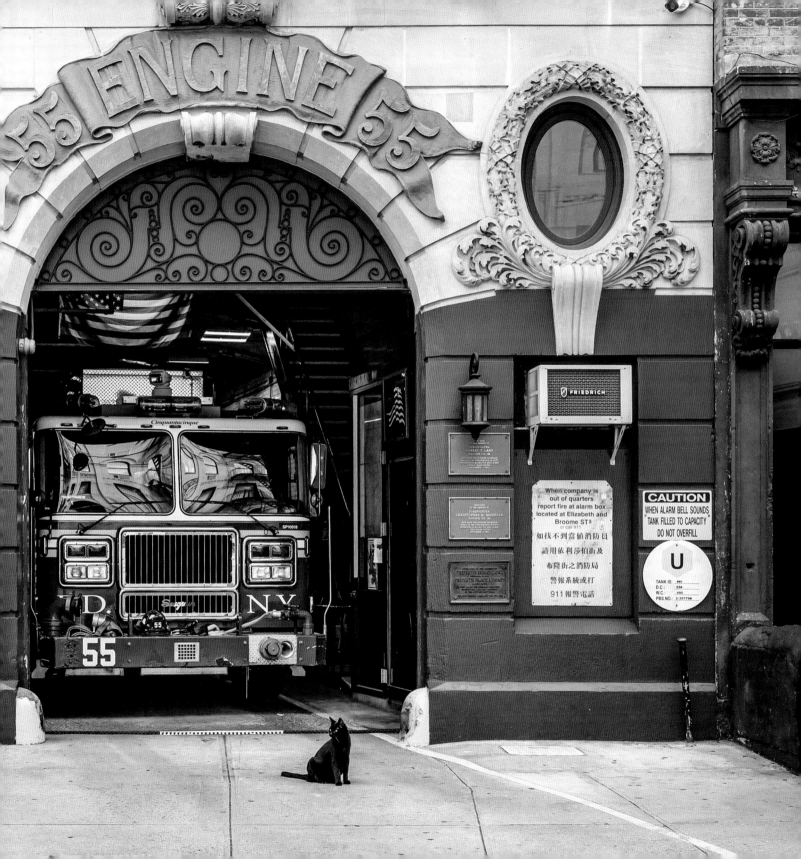

"Chapo," the name given to me by the firefighters of Engine 323, may evoke thoughts that I am a tough, fighter-type dog. However, it is quite the opposite. I am nothing but a lover! I am seven years old, and my honorary birthday is Halloween, October 31. I easily won the majority vote by the firehouse to bring me on board as an official member, and I am given lots of love daily by the firefighters. I enjoy my position of holding down the firehouse and keeping it safe while the members are out on a run. I have been known to take runs with them, and I have no problem climbing into the tall rig, since I am quite athletic. If you cannot find me anywhere in the house, then I am probably making myself at home in the cabin of the rig where the firefighters ride.

I am as friendly as can be, and as soon as I spot a new firefighter on the firehouse CCD monitor, I jump up and greet them with a big hello. The first hello, though, is more like a spontaneous siren, a combination of a howl and a bark. This may catch some off guard, since it is quite loud, but it is also my way of marking my territory and letting everyone know that I am the king of the firehouse. After I give the obligatory loud but friendly siren sounding, I am back to my throne in the kitchen, where I hold court. Sometimes, on the firefighters' days off, they take me to the beach, where I keep up my physical conditioning by running on the beach and playing in the ocean. My job as a firehouse dog requires me to be in top condition, so these training days are often supplemented with walks and visits with kids, who love to play chase. My favorite toy is one that is destroyed in ten minutes. That keeps the toys coming almost daily. I am loved and spoiled by the crew members, and I always return the love but doubled!

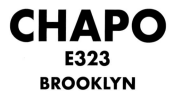

CHAPO
E323
BROOKLYN

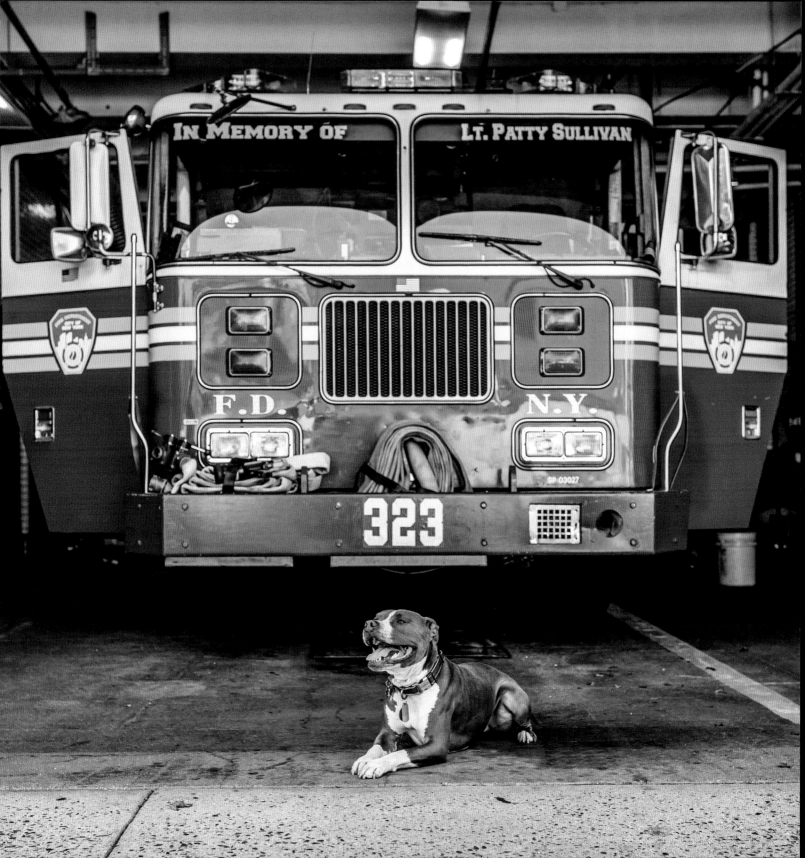

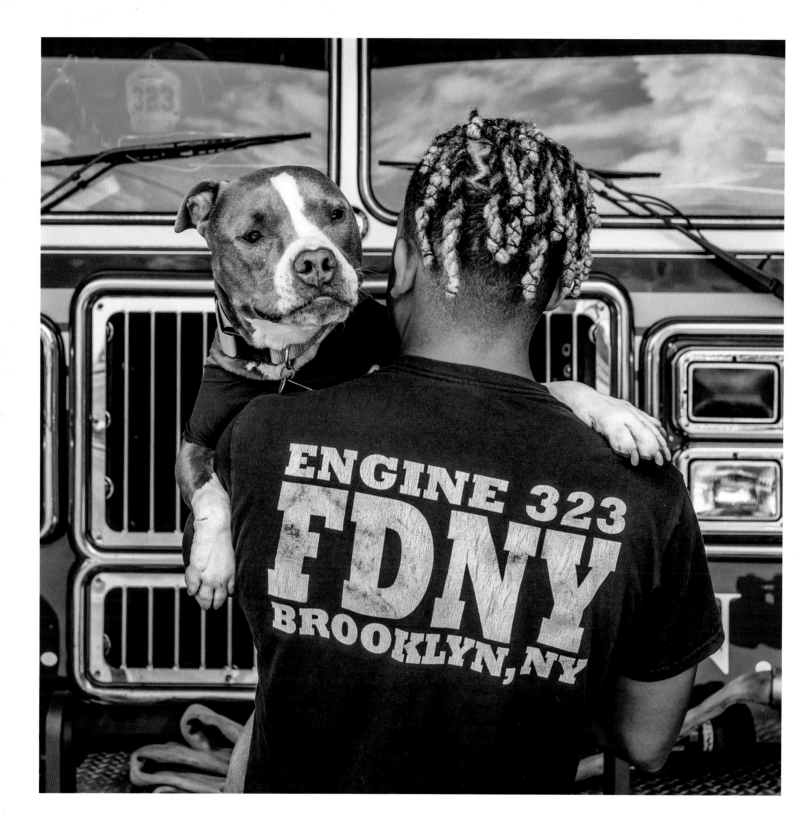

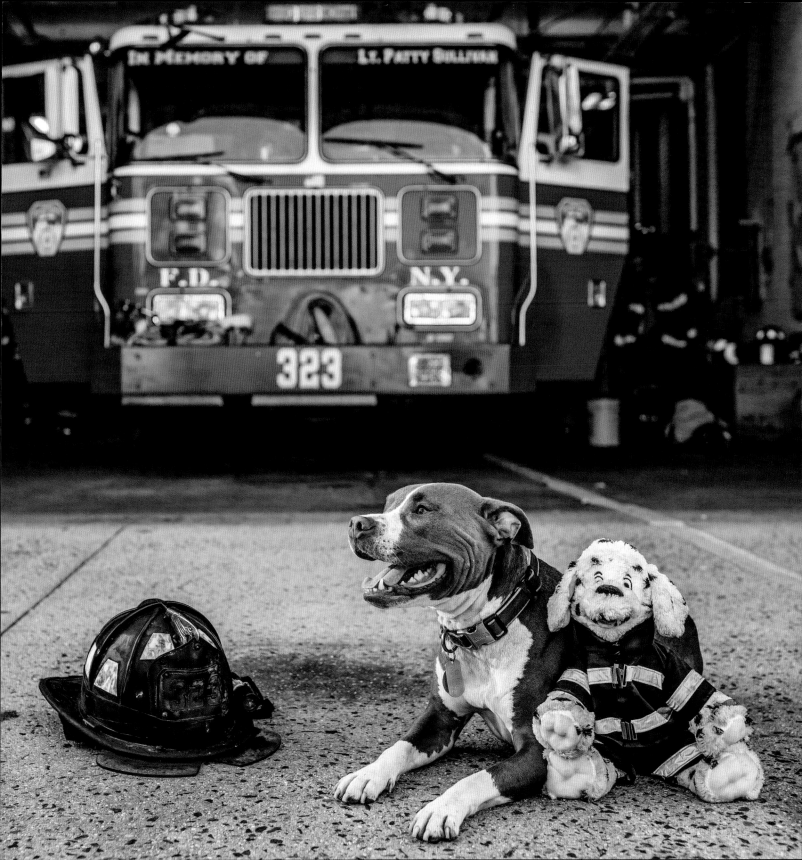

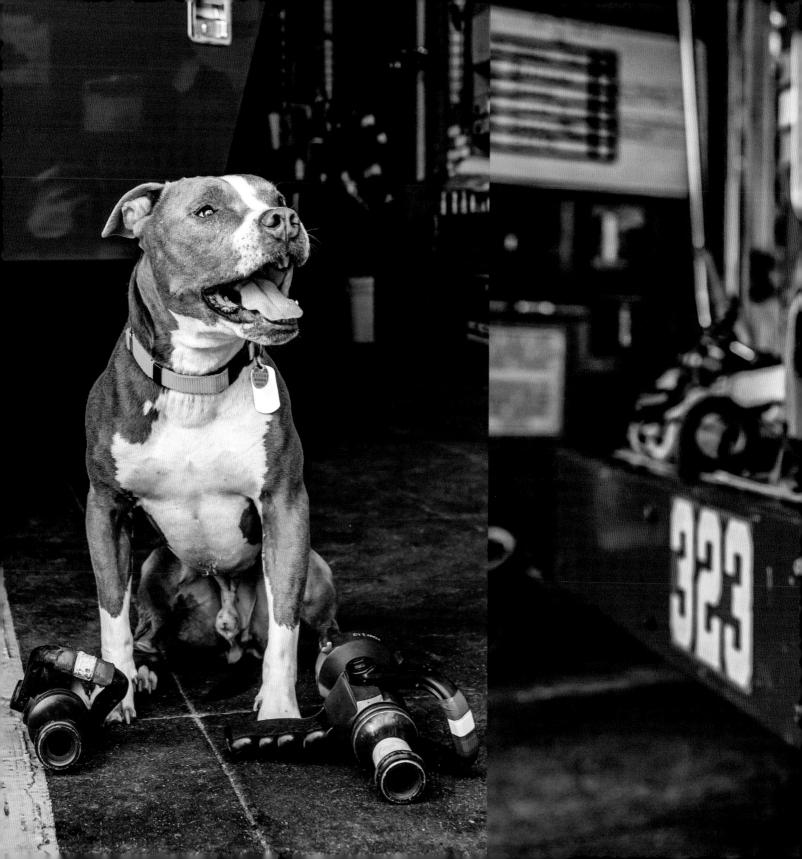

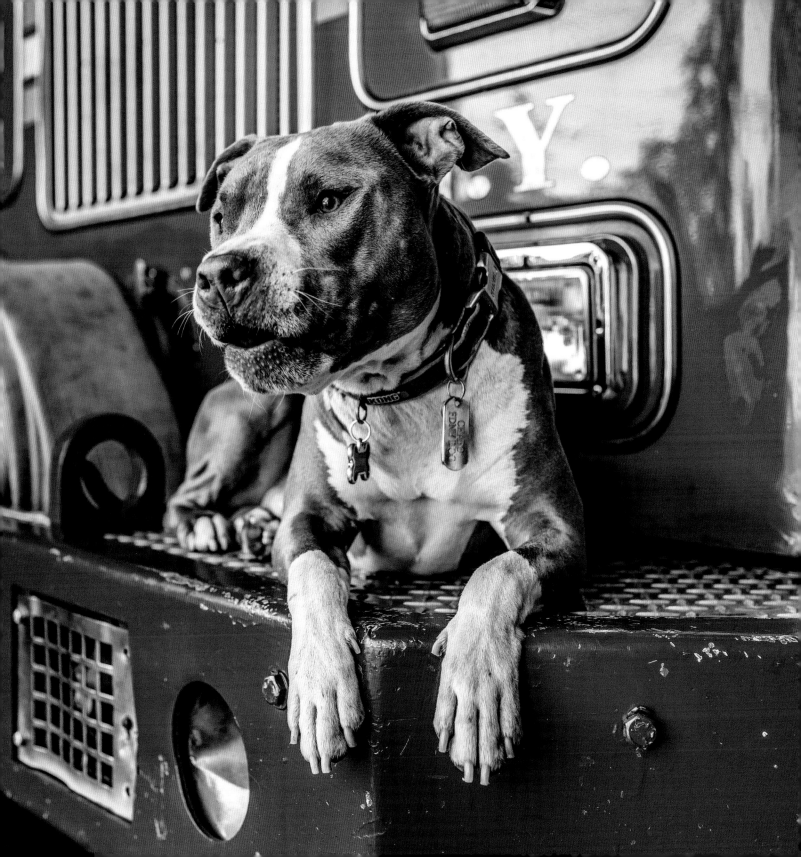

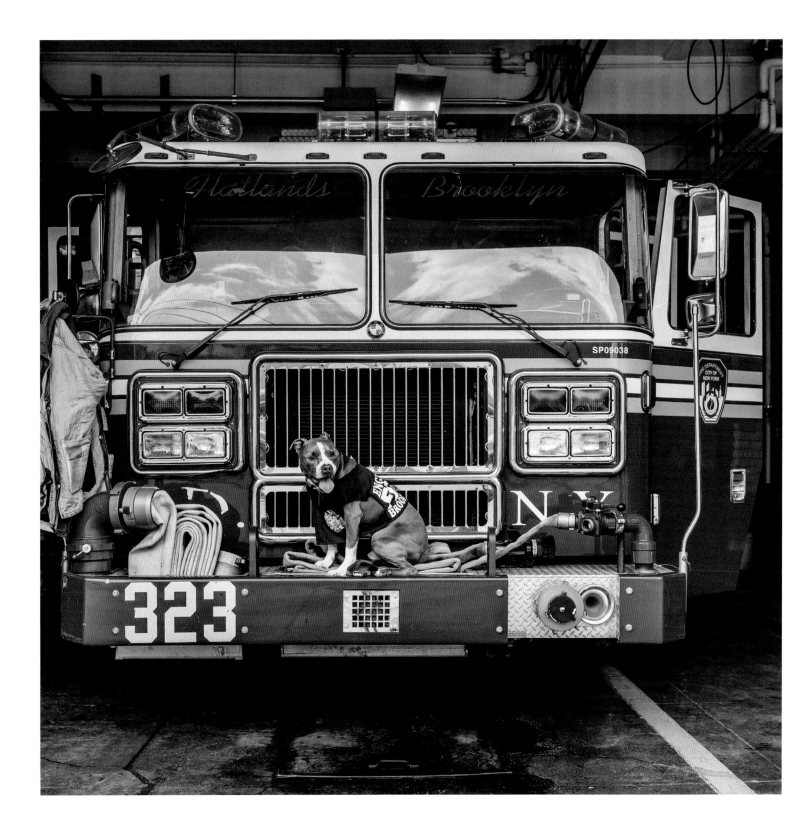

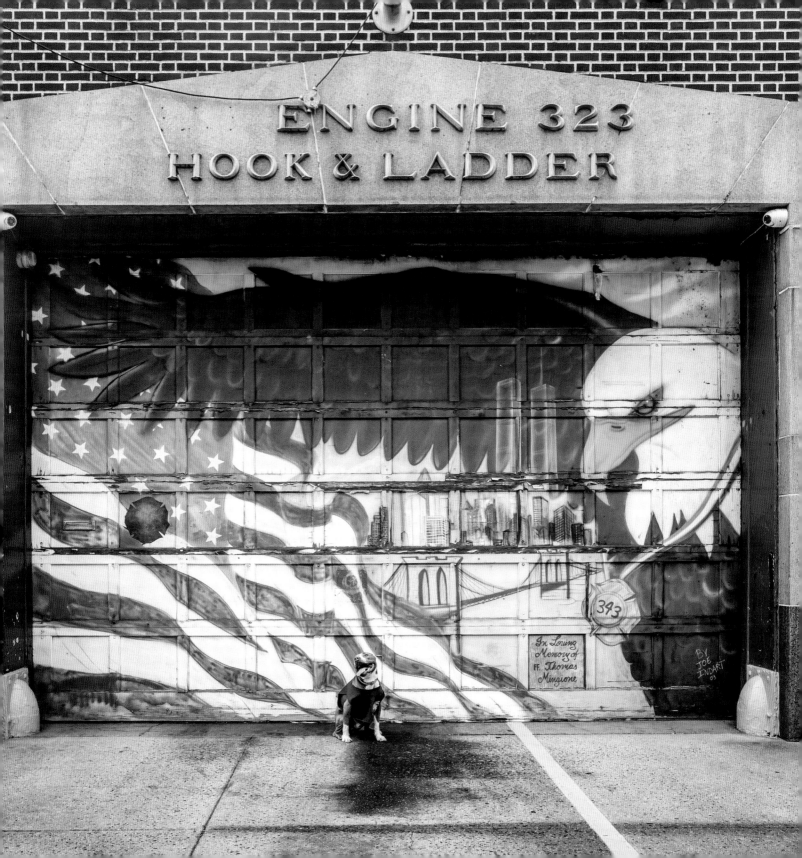

I became a proud member of "The Lost World," Engine 74, on the Upper West Side on September 11, 2020. I was donated to the firehouse after the loss of their beloved mascot of fifteen years, a dalmatian named Yogi. The Trainor family trained me from being a recruit puppy to being a serious firehouse dog. They donated me and named me after and in memory of FDNY battalion chief James Trainor, "JT," who served with the department for almost forty years.

You will see me each day making friends in the community as I greet all those who pass by on West 83rd Street. I am very sociable and friendly. You will also see me eager to go on runs with the firefighters. The firefighters take really good care of me. They made me a special seat on the engine, so I am comfortable riding with them while they go on runs. You will also see me enjoying the wind in my face, since I often ride with my head out of the window of the engine. I am quite smart, and I know when the firehouse members are going off duty. That's when they often bring me to the park, throw my treasured tennis balls for me to fetch, and take me for walks in the neighborhood. At night, I rest in my own firehouse bed right next to the kitchen, to ensure that I don't miss any treats.

Naturally, the main role I have taken on in the firehouse is that of comforting the members. I am tight with the members of my crew, so if they are having a tough day, I provide a calming presence to them, just as my ancestors did to the horses in the 1800s who often became nervous at the fire scene.

If you are ever out and about on West 83rd street, you can easily spot my firehouse by the fire hydrant out front that is painted like a dalmatian. It is highly likely that I will be nearby with my tail wagging happily, ready to say hello and ready to play!

JT
E74
MANHATTAN

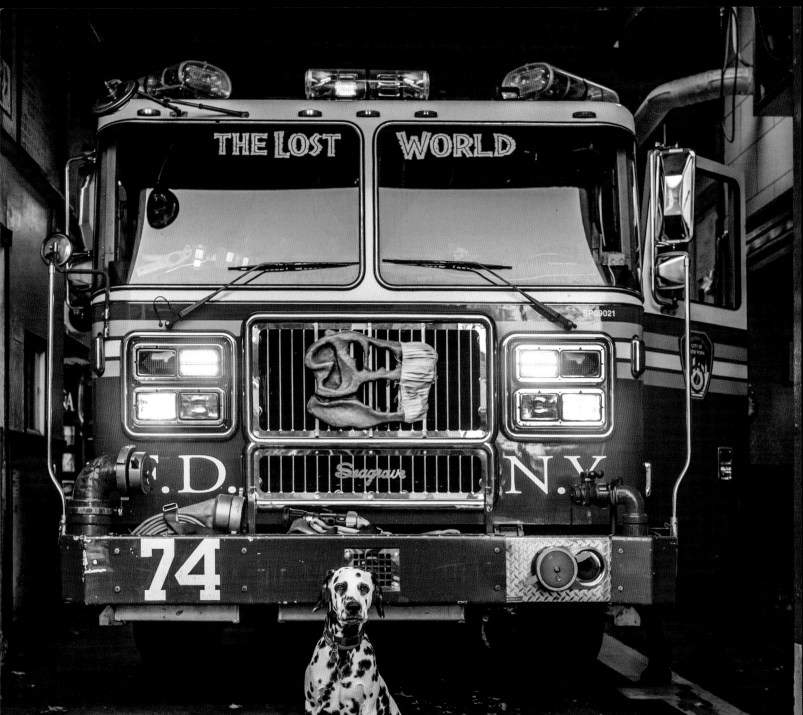

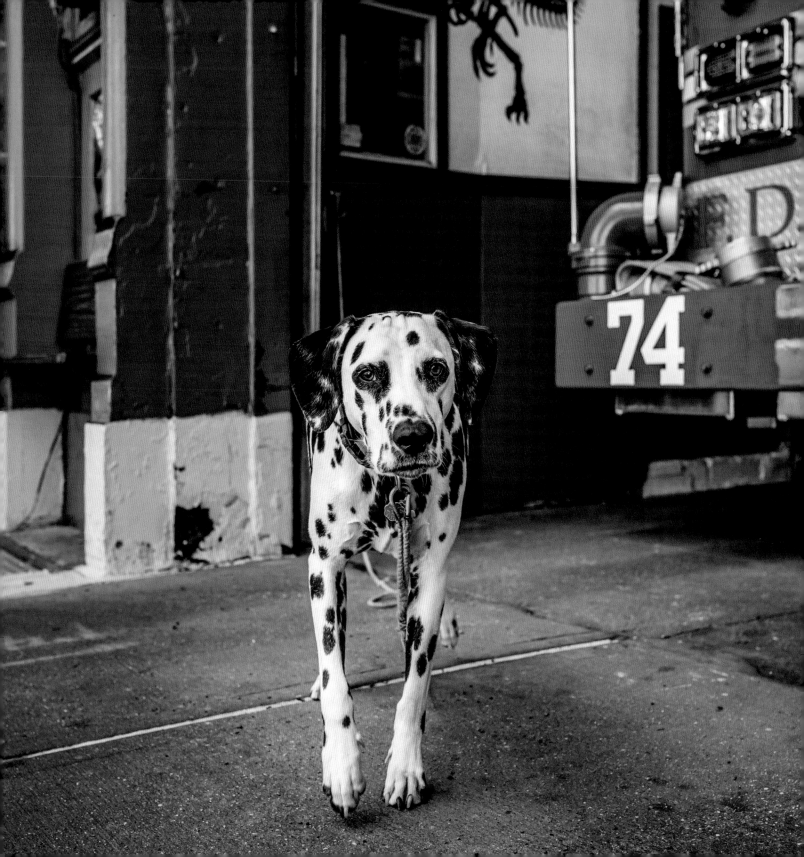

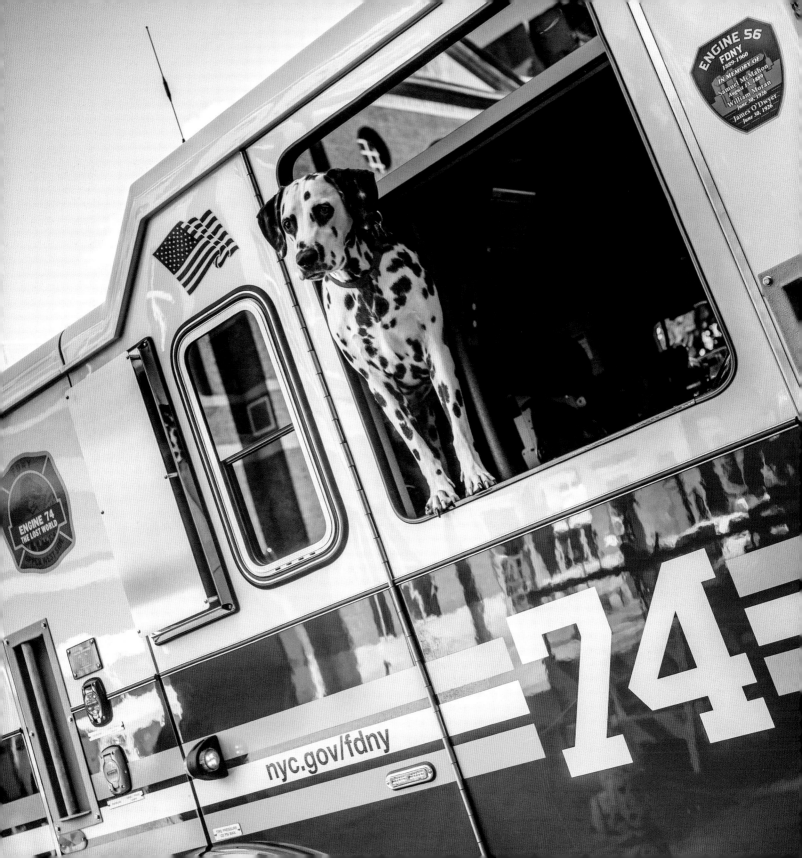

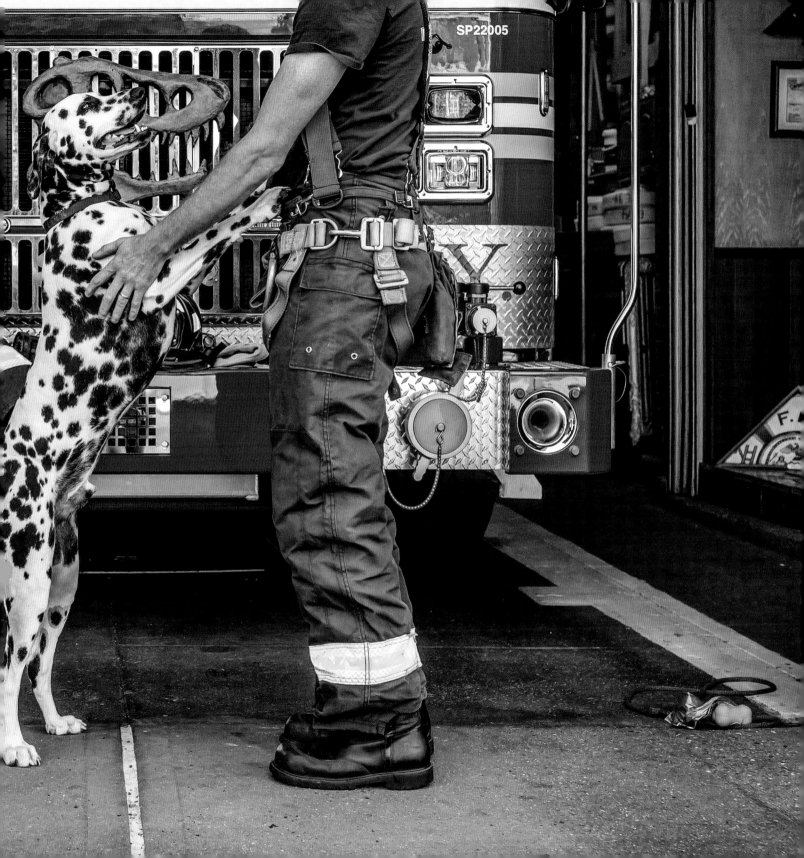

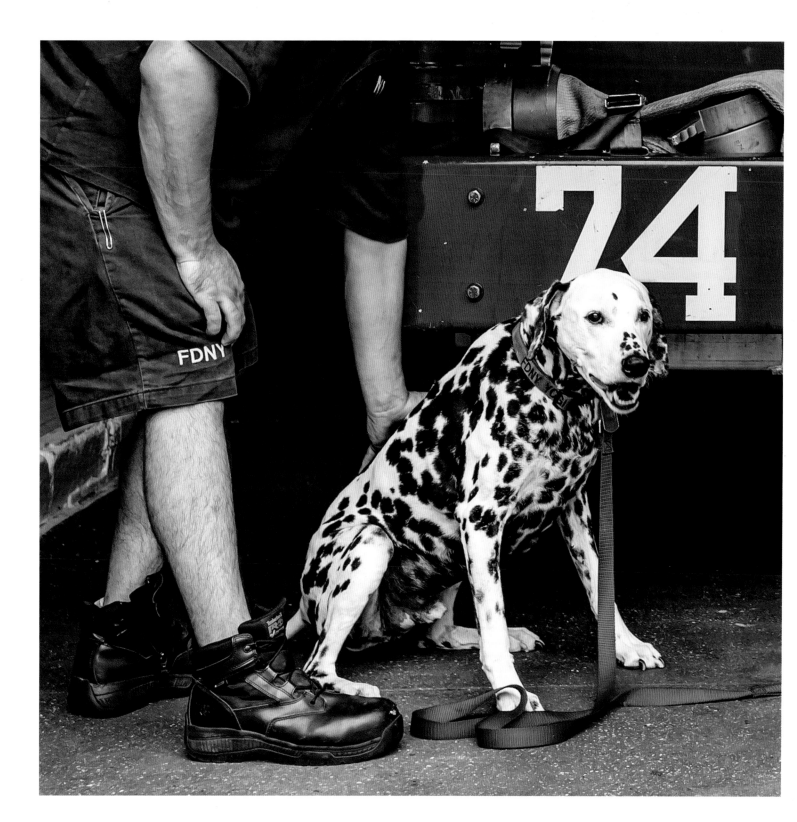

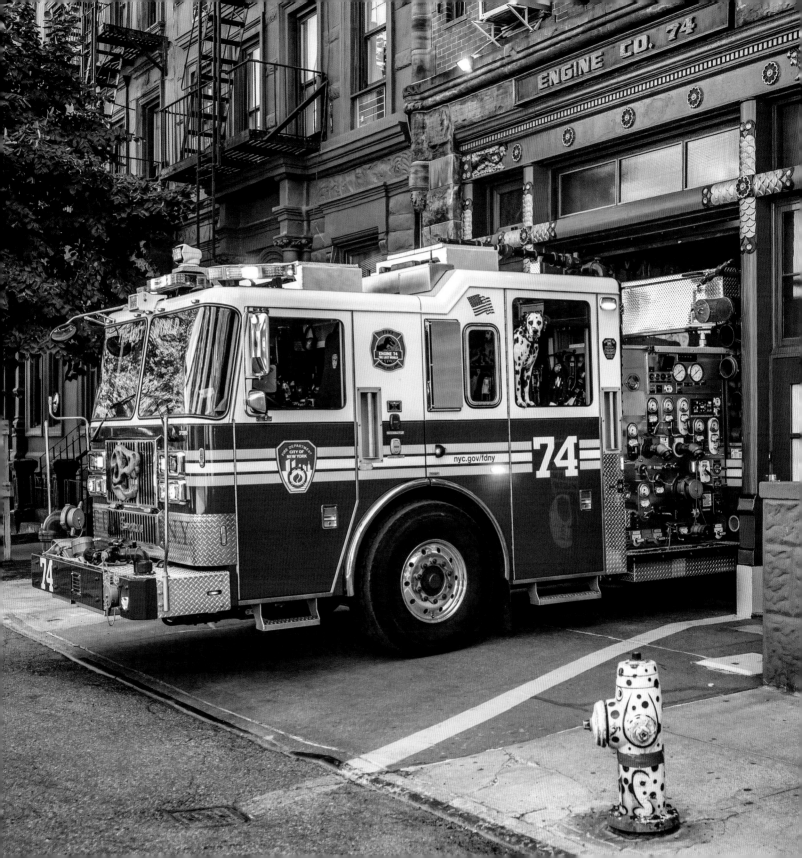

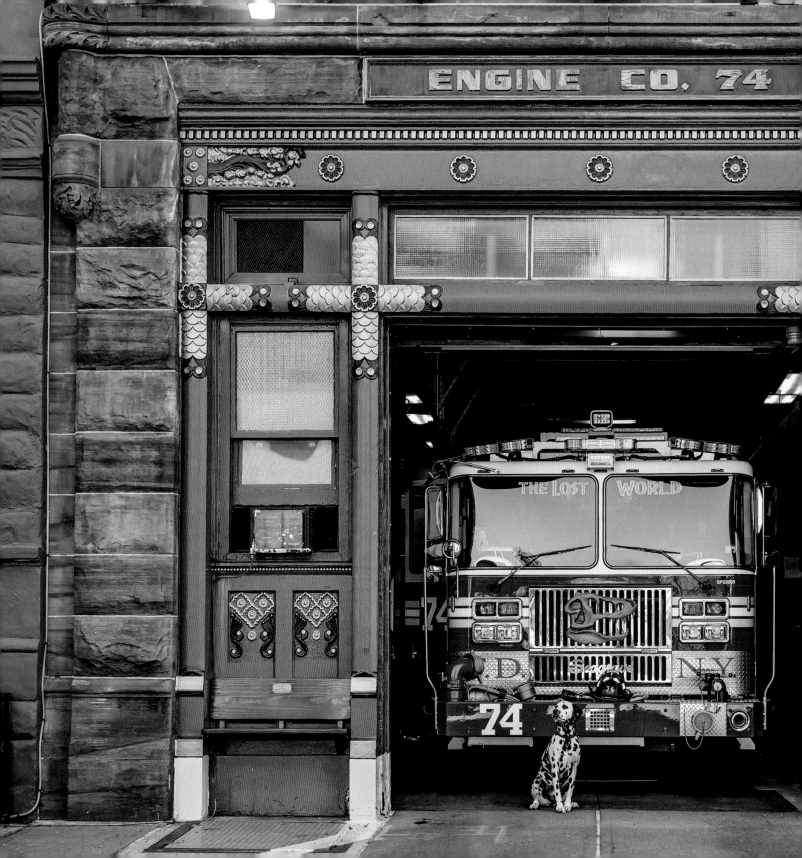

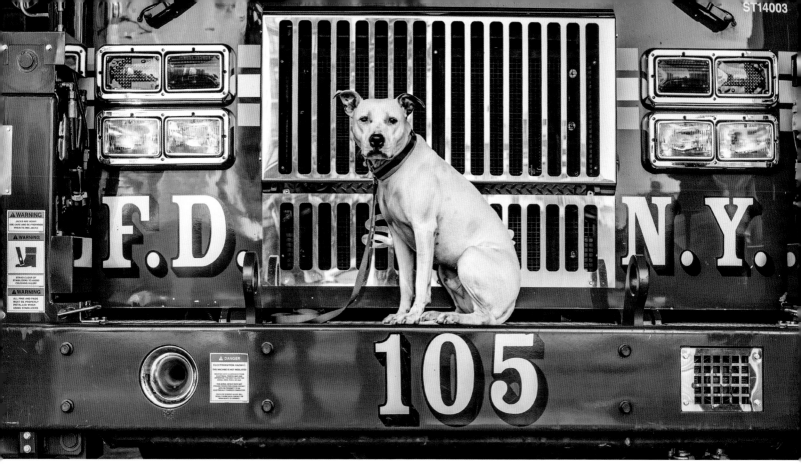

Retired firehouse dogs are similar to the firefighters who served before them: all good things must come to a well-deserved end. A life dedicated to serving others is something that I possess in common with the firefighters I served with. My name is Deano, and I am a retired firehouse dog out of Engine 219 and Ladder 105. I arrived at the firehouse on Dean Street in Brooklyn when our friends from the NYPD found me wandering around Prospect Park. The members of the firehouse helped me make myself right at home and kept me busy by throwing tennis balls and playing fetch, and I became a long-serving member of the companies. I also provided joy and comfort to the members of the firehouse after long and difficult days. I am currently enjoying my retirement with one of the members from the firehouse and his family. I now have another dog whom I can play and run around with on the beach. Now I know the true meaning of "dog days," since these are the finest days after a dedicated career as a firehouse dog.

DEANO (retired)
E219/L105
BROOKLYN

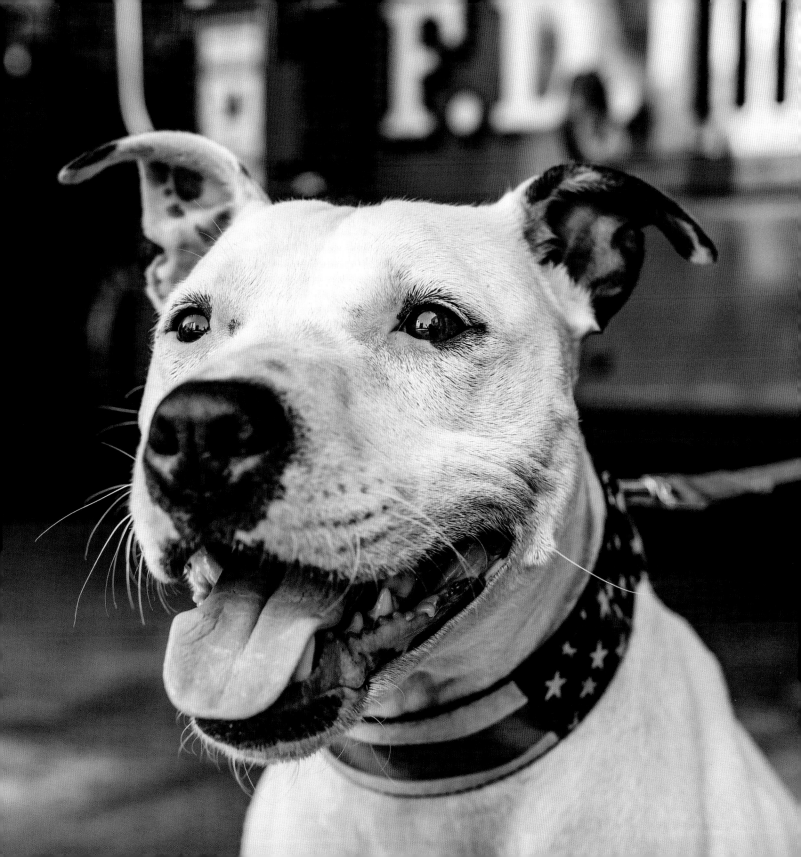

Fire scares me. That may make you think that I am not equipped to be a firehouse dog. That is simply not the case. Just as the firefighters have different jobs when assigned to the engine that don't involve putting out fires, such as technical rescue calls, firehouse dogs can have assignments that don't involve fire. My assignments are an important part of the tour here at the firehouse with Engine 228. My name is Duke, and I am the official firehouse taste tester. Just as the members of E228 in Sunset Park Brooklyn are "All In" in their duties of keeping the community of Sunset Park, Brooklyn, safe, I am "All In" by ensuring all their food is safe to eat.

I am currently ten years old, and I came to the firehouse because I suffered from anxiety and could not spend time by myself. Moving here provided the best comfort to me, since a firehouse is always busy. It also provided comfort to the firefighters to be able to count on me to keep the bagels and broccoli safe at the house while they go on runs. I do not join them on the runs, but I stand guard and protect the house while they help others. As you can see, I am a gentle giant who likes the simple things in life, such as swimming, playing catch (a.k.a. rescue rope training), chasing squirrels (department-required physical fitness), and playing with pillows.

Sometimes people get scared and run away from me. They don't know I am a kind soul, and I am there to give them a sweet cuddle to get them back on their feet. If you are looking for me and don't see me sitting out in front of the firehouse, I may be nose deep in the fridge on a search-and-rescue assignment to grab the tub of butter and make sure it gets into my belly safely.

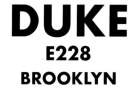

DUKE
E228
BROOKLYN

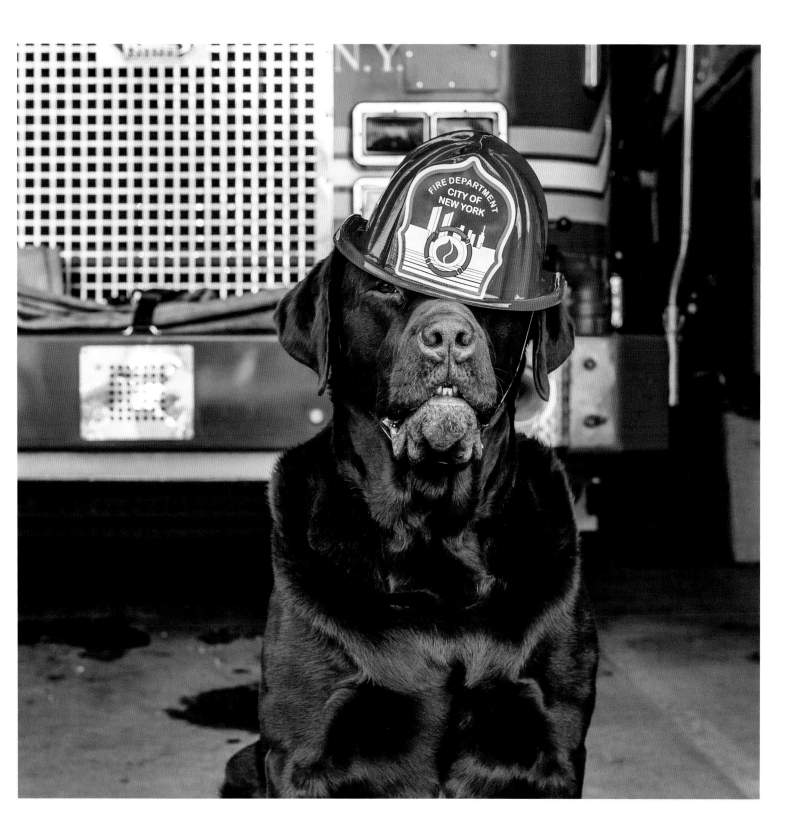

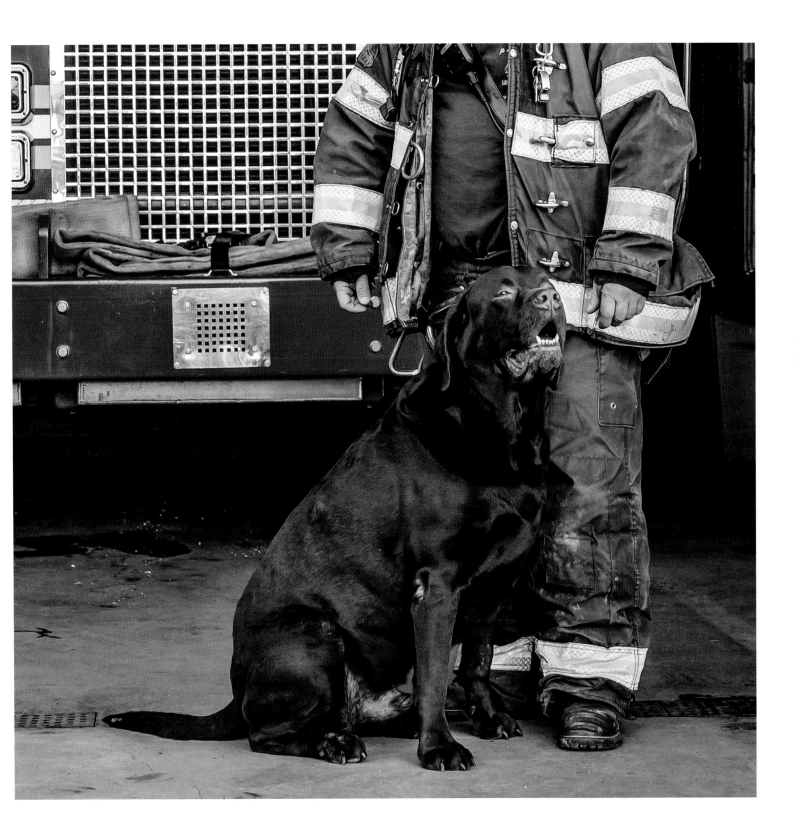

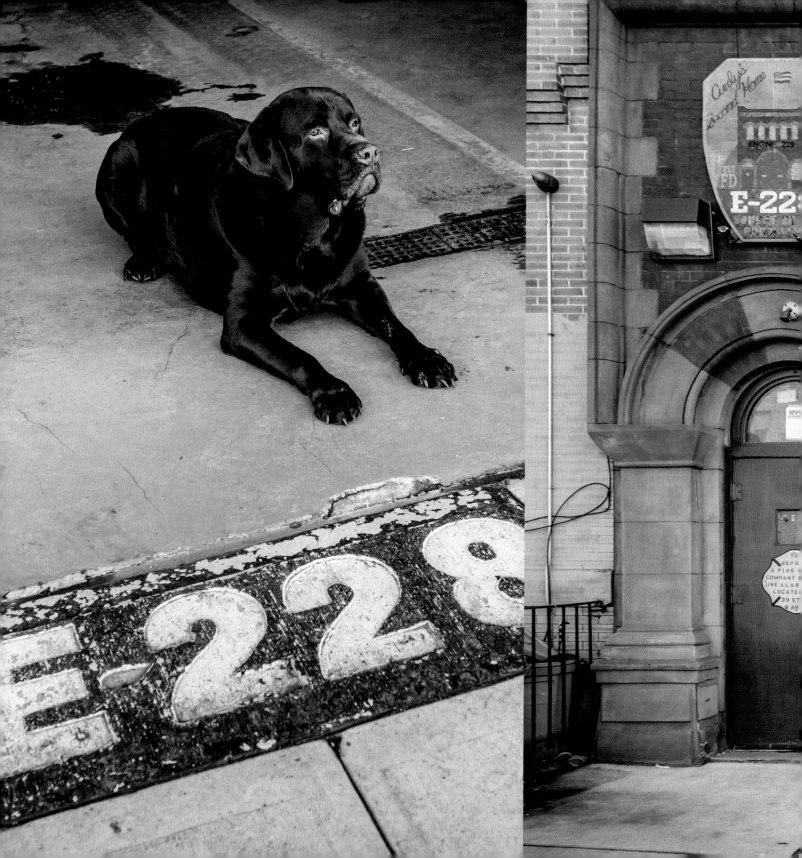

ENGINE CO 228

GOD BLESS AMERICA

F.D. N.Y.

228

FIRE. DEPARTMENT
CITY OF
NEW YORK

CAUTION
WHEN ALARM BELL SOUNDS
TANK FILLED TO CAPACITY
DO NOT OVERFILL

E 228

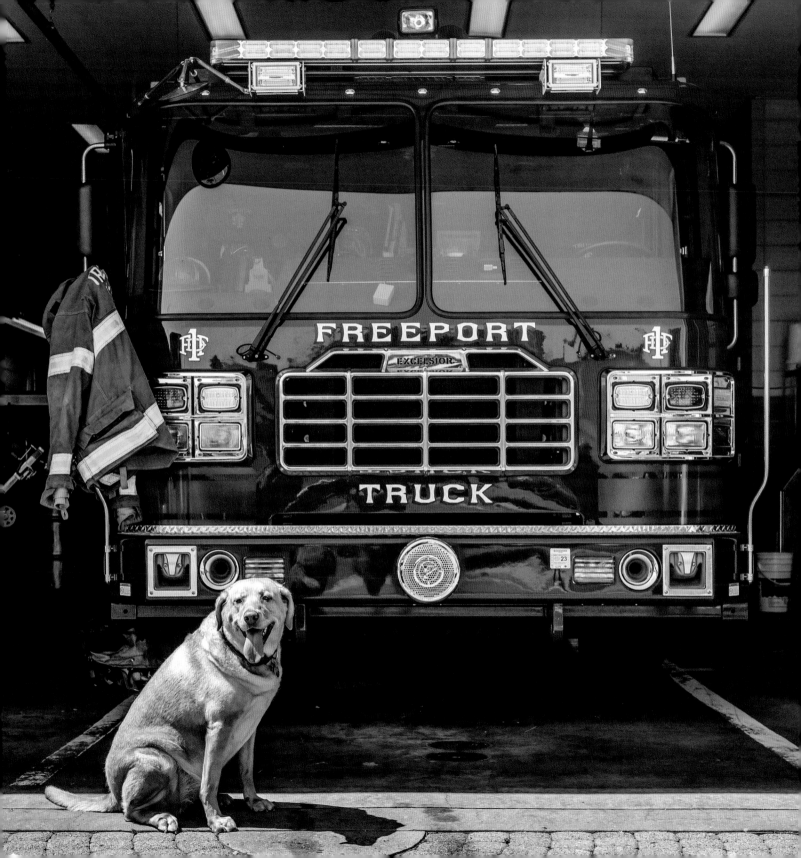

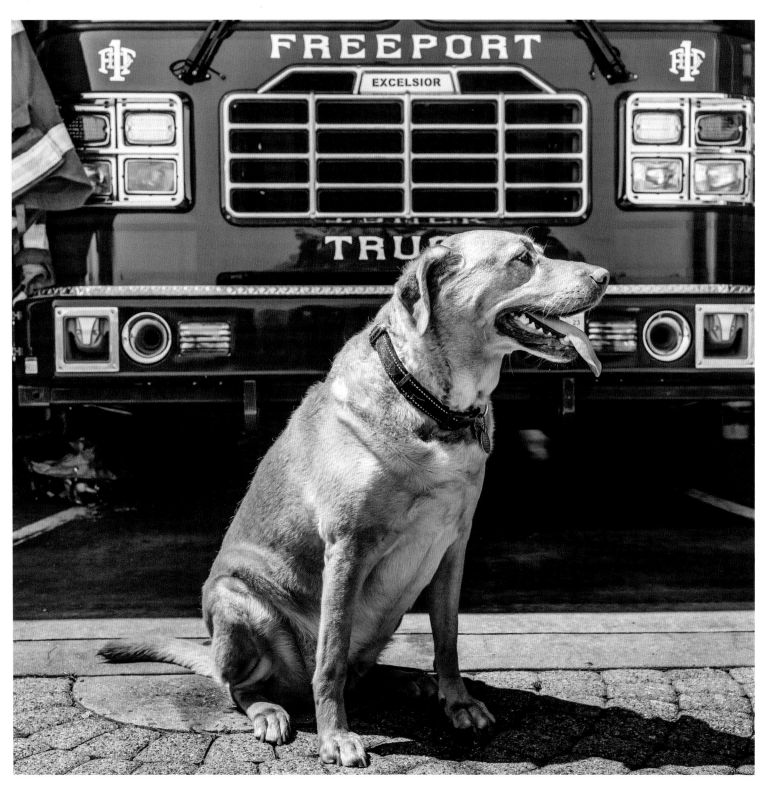

TILLIE, T1, FREEPORT, LONG ISLAND

On October 29, 2018, the members of Engine 153 and Ladder 77 on Broad Street in Staten Island found me tied to their firehouse door. They took me to the vet, and they estimated me to be about six months old. Well, the members fell in love with me, and who can blame them. I was a pretty cute puppy, and now I've grown to be a handsome boy. The firehouse is nicknamed the "Broad Street Bullies," and that's how I got my name, Bully. I fit right in!

When I am not on duty, I love to play fetch and go on walks. Because I am so well behaved on my leash, I have been known to assist with company rope-rescue drills. Bully to the rescue! When I was a little puppy, I rode the door seat on E153. However, I don't go on runs anymore. Instead, I prefer to stay in my comfort place: the kitchen, of course. When the firefighters go on runs, I like to sit on the stairs and watch them pull out of the firehouse. I have my own bed with my name on it in the bunk room at the firehouse, so no one else will claim it. When the firefighters are away, it is my job to keep watch over the firehouse. I double as a guard dog. No one messes with Bully. When the firefighters return to the house, I give them lots of love and they give it right back to me. I am a lucky dog; this house is the perfect place for me, and my humans are the best and the Bravest.

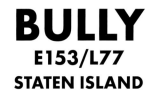

BULLY
E153/L77
STATEN ISLAND

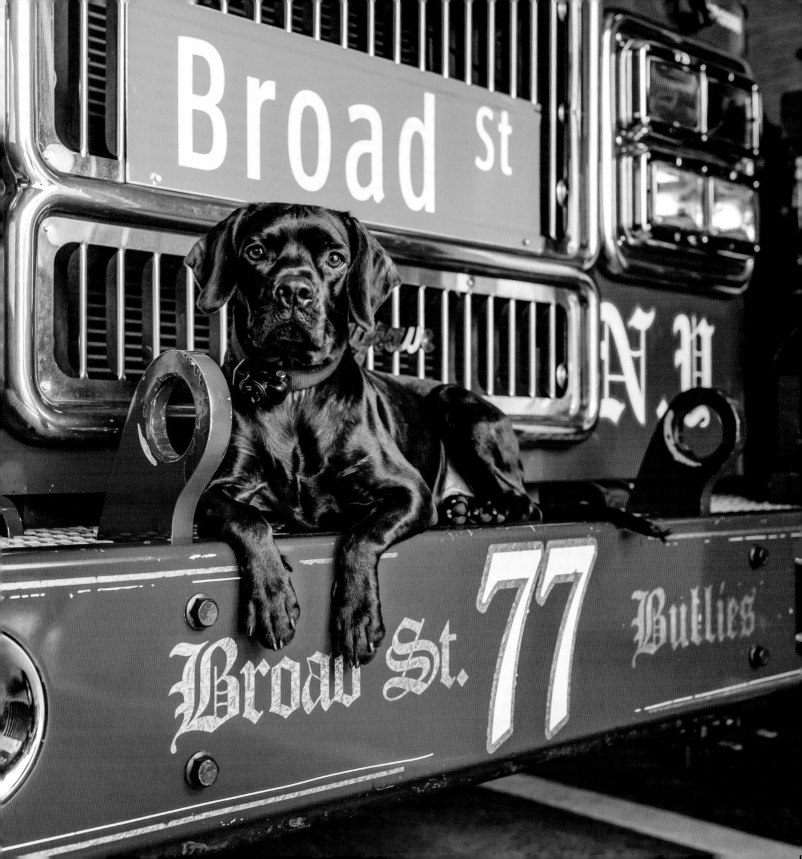

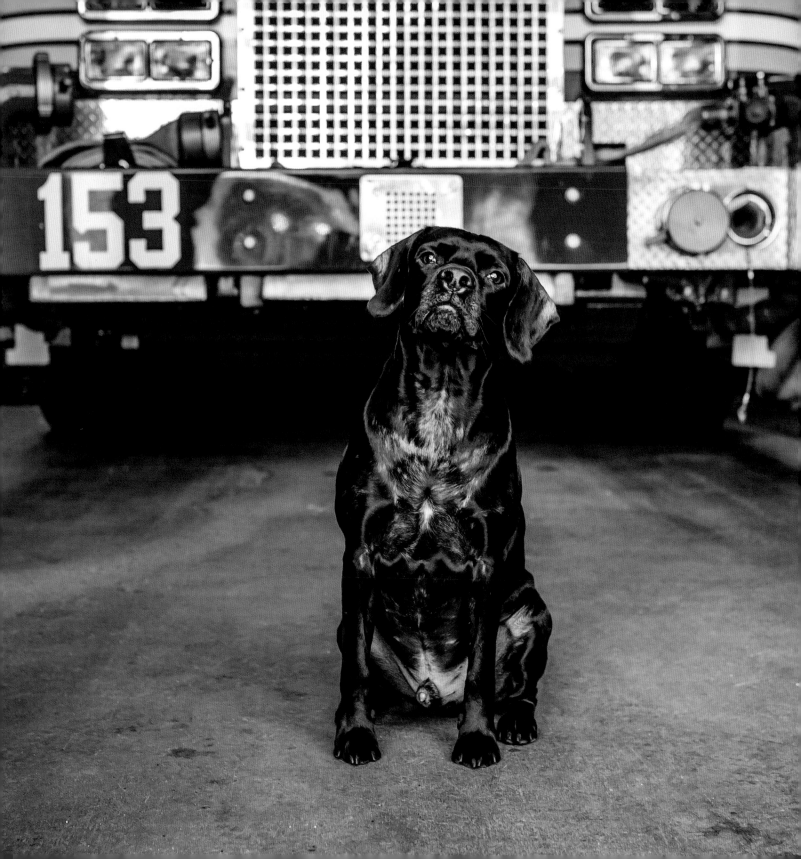

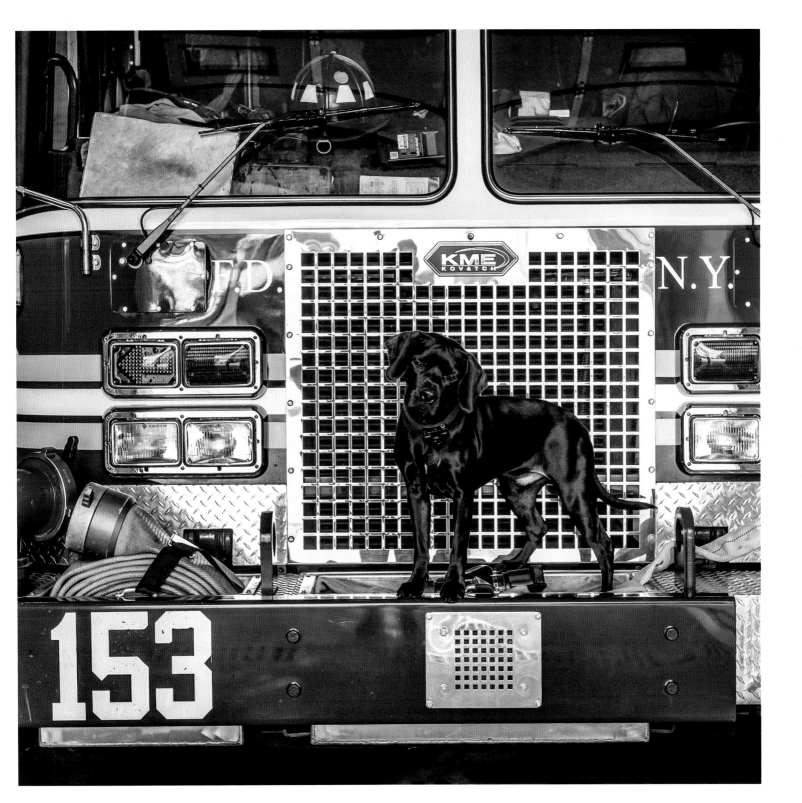

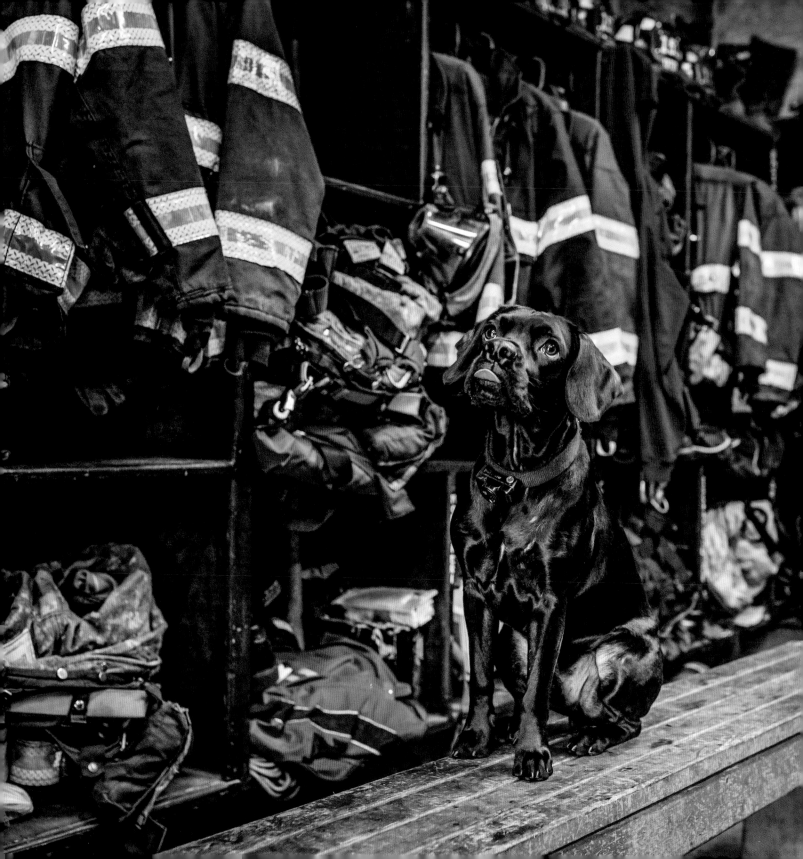

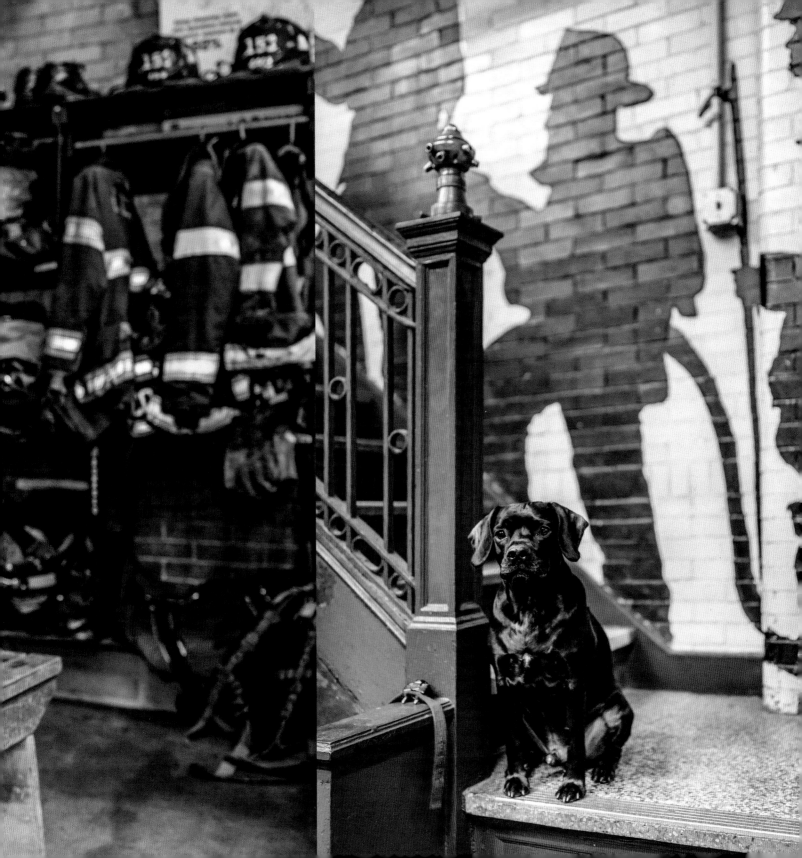

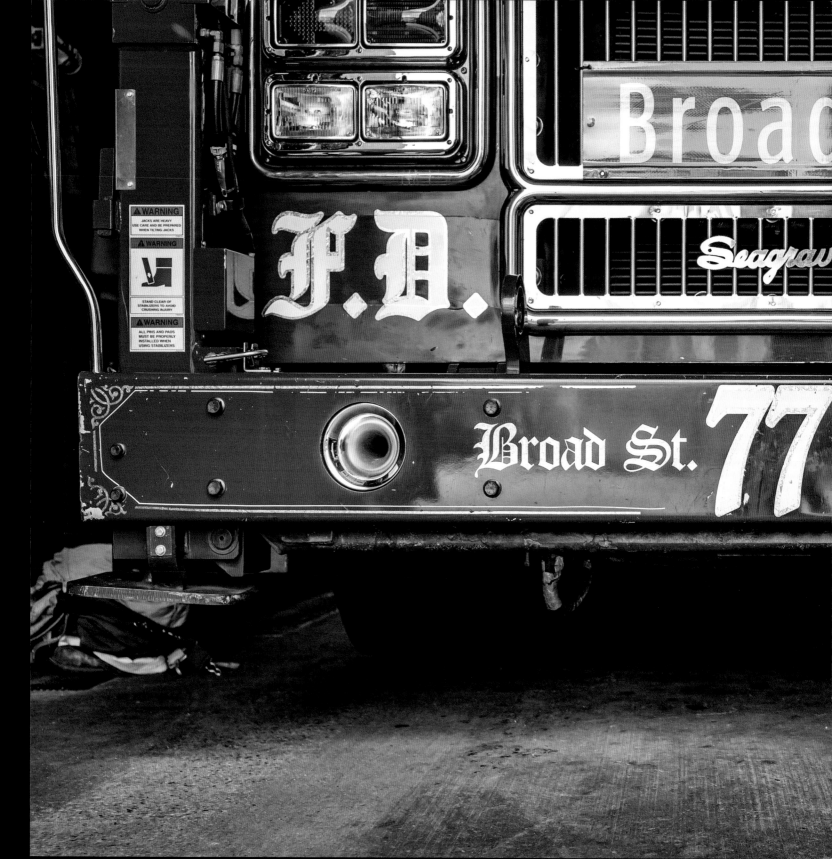

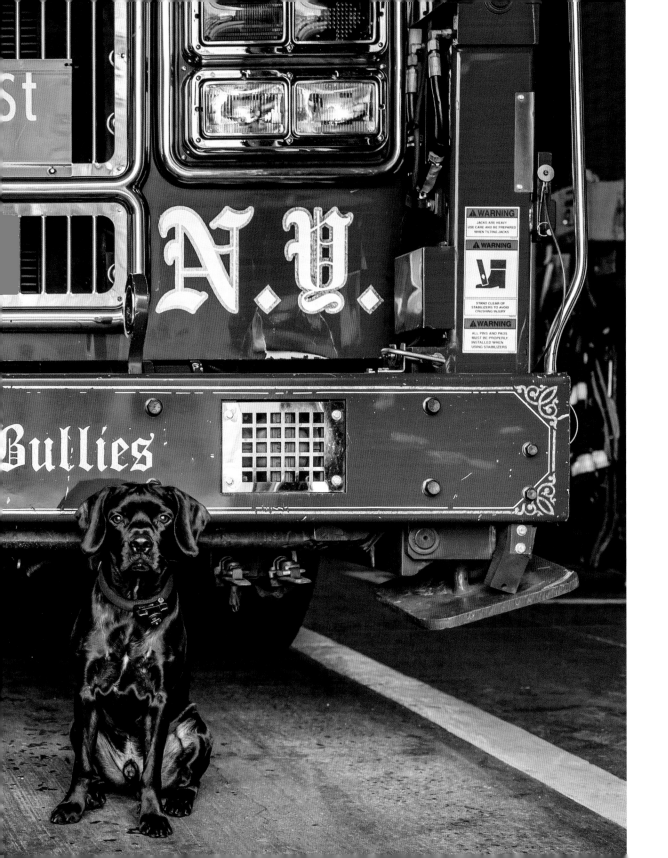

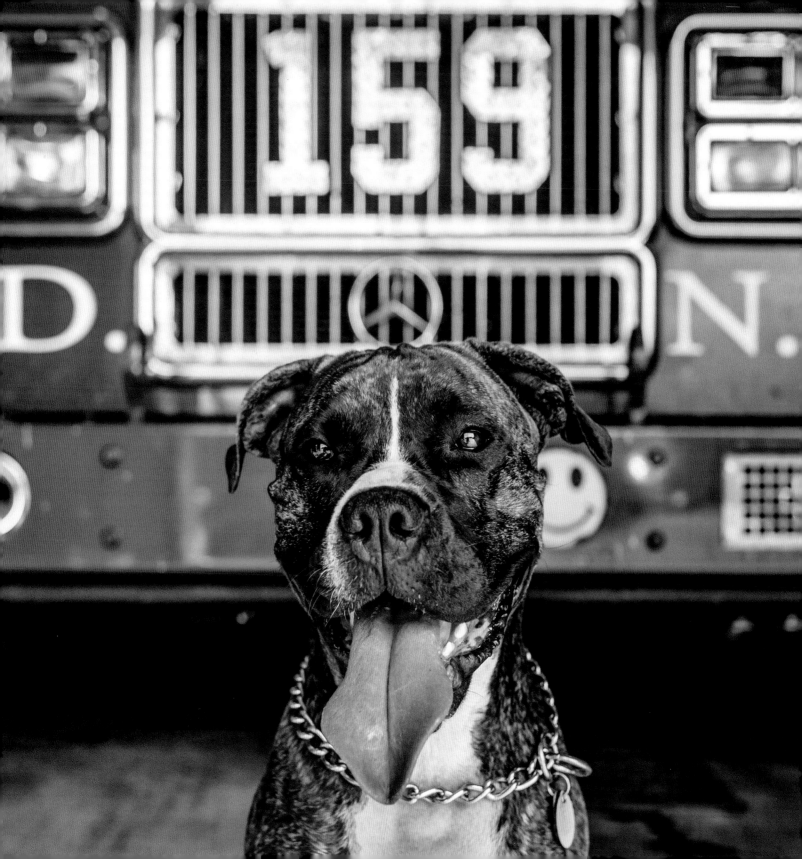

On the opening day of New York Mets baseball in March 2018, the members of Engine 309 and Ladder 159 responded to a call for a fire. After extinguishing the fire in a nearby home, the members returned and found me tied to the gate outside the firehouse. There was a note stating that my previous owner could no longer take care of me.

I was lucky, and the members of "The Friendly Firehouse" decided to keep me! The Friendly Firehouse has a long-standing tradition of great firehouse dogs. Before me was Stewie, a dalmatian who at one point was named the best firehouse dog in the city. He set the bar high for what was to be expected of a firehouse dog. Much respect for him, but now back to me. At first, I was simply referred to as "the dog." My coat is of a beautiful brindle color, so you may think that is why I was named Rusty. However, I am named after and in memory of Rusty Staub, a former New York Mets player. Since I was found on the New York Mets' opening day and Rusty Staub had just passed away, it was considered a sign, and my name was official.

I spend most of my days handling the house-watch duties at the firehouse. I have my own recliner, but I do not hesitate to spring into action when my firefighters get a run. I am always the first firehouse member to get on the truck, because I very much enjoy joining the firefighters on runs. My assignment is to the door seat, which allows me to stick my head out of the window when we are responding. Sometimes I catch a few days off from the firehouse with the rest of the crew. I always start my tour by checking on my chair and then into the kitchen to say hello.

The Friendly Firehouse has been in service for almost 100 years, and, like many of the firefighters who have passed through it, it did not need me to exist, but it will not be the same after I am gone. I am one happy pupper to have placed my paws throughout the same halls as New York's Bravest.

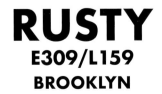

RUSTY
E309/L159
BROOKLYN

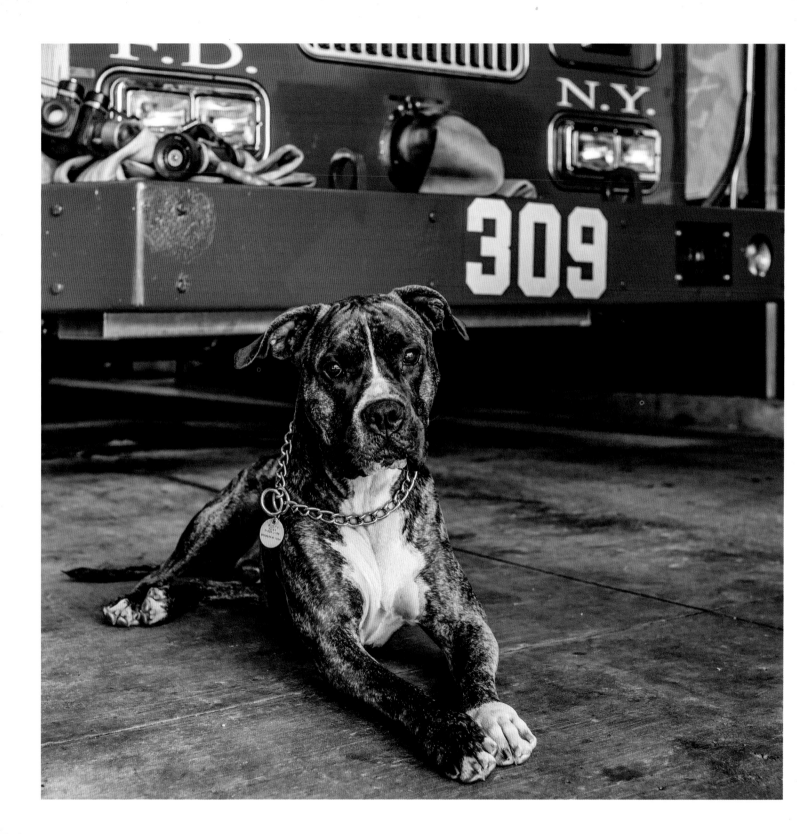

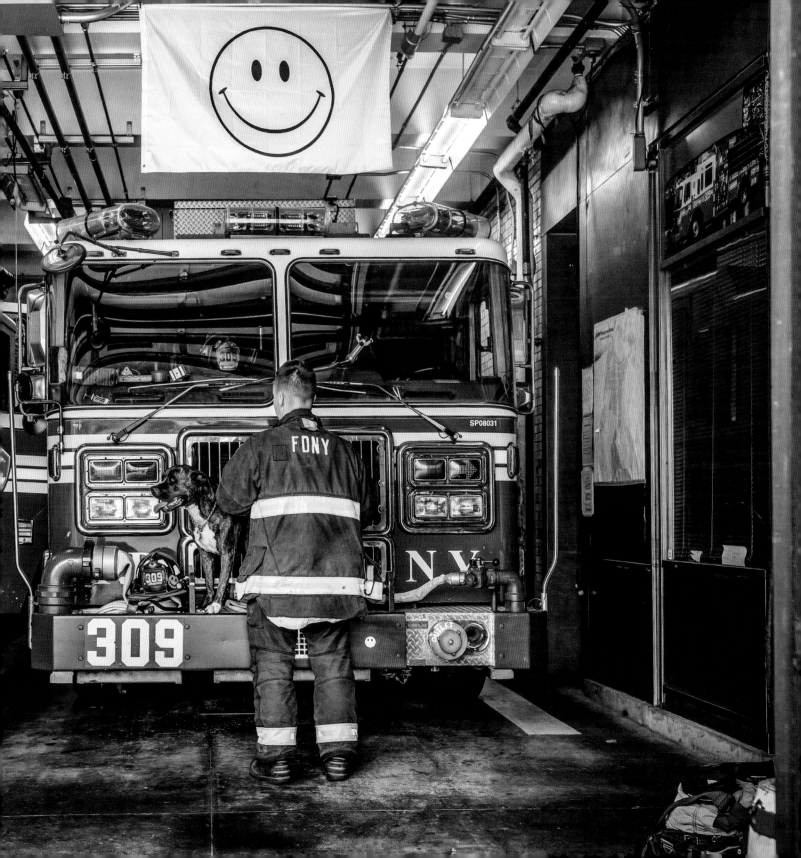

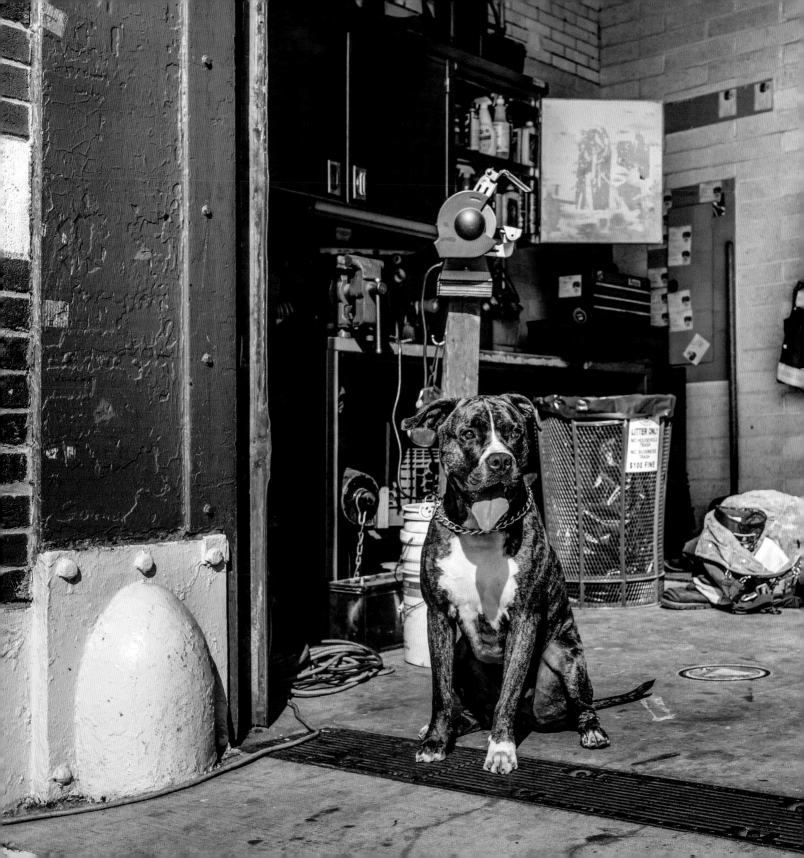

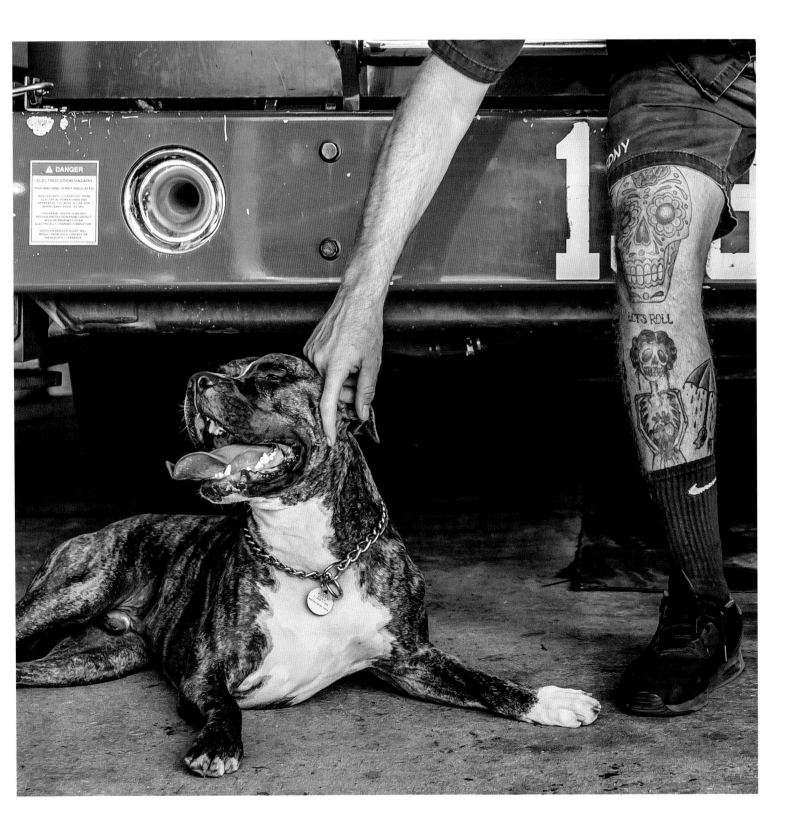

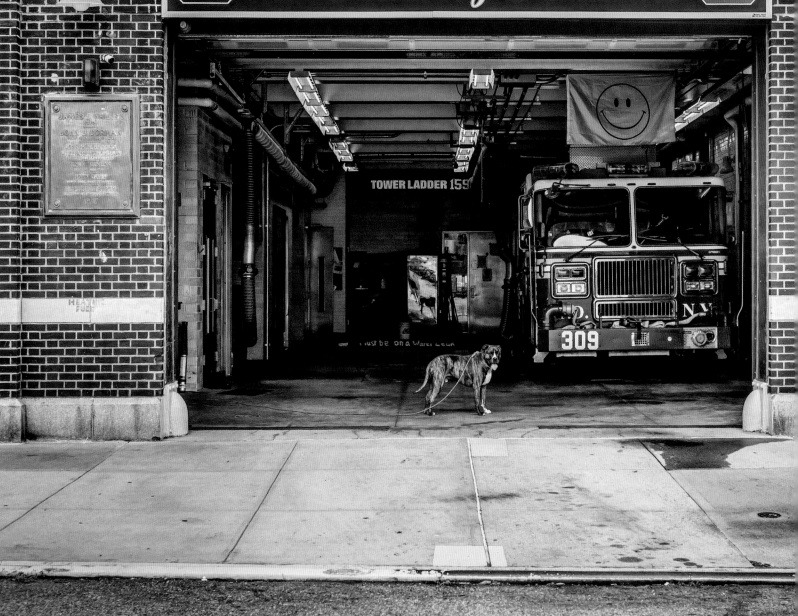

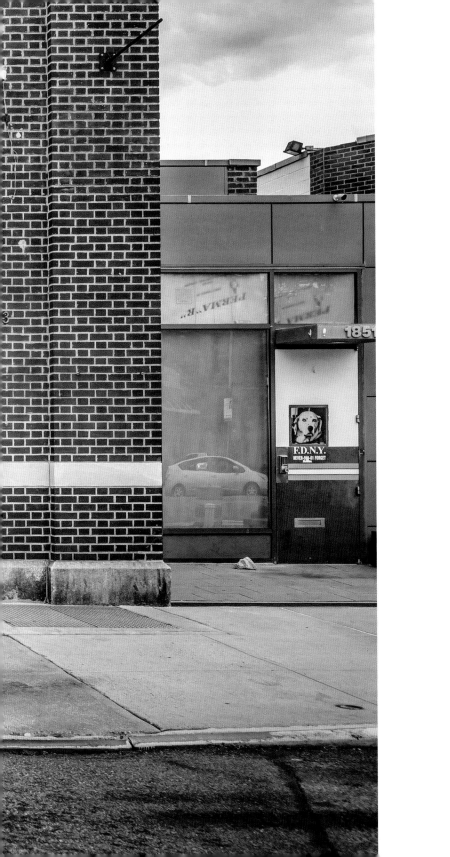

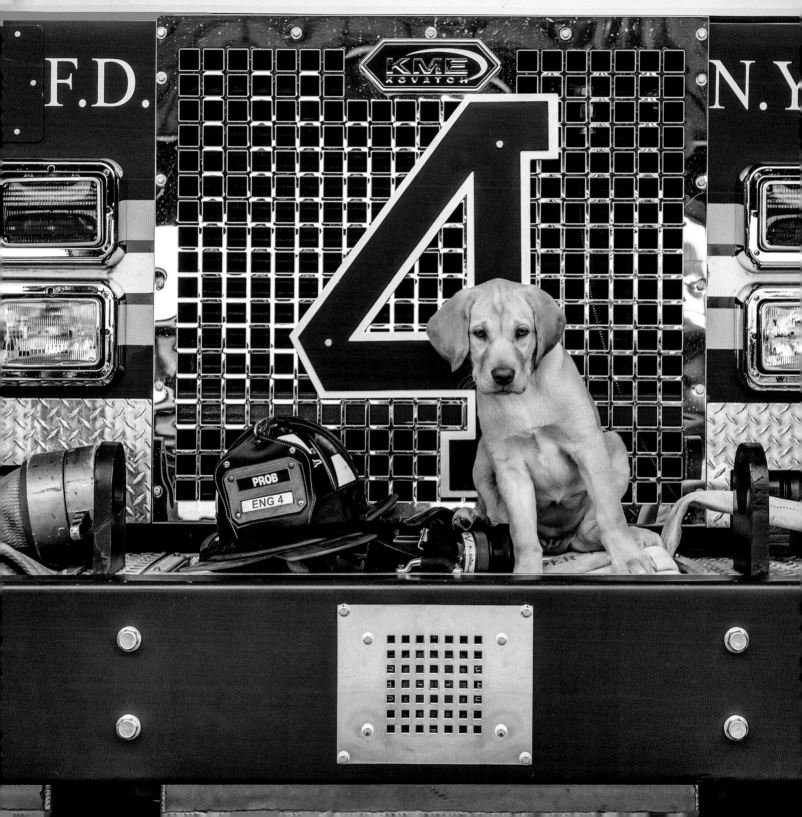

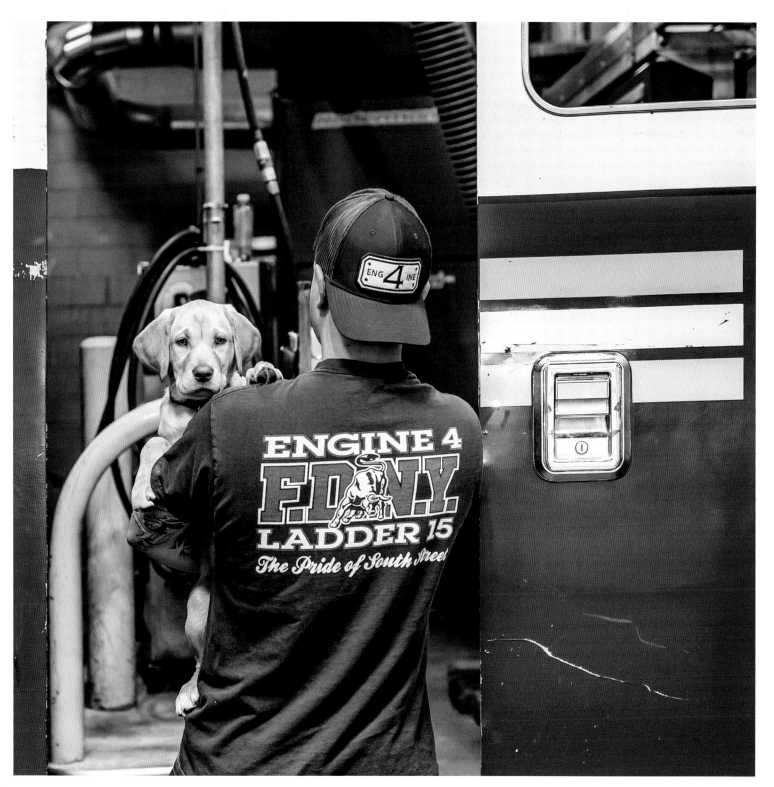

SIREN, E4, MANHATTAN

It is quite fitting that, being a dog with a white coat and the name of Casper, I am friendly, sociable, and personable, and I like to help people. Also, being named after a ghost, I can be quite sneaky. What did the firefighters think would happen to their steaks left out on the table when they went out on a run, and I was left behind? I snuck right up onto that table and ate every single last one of them! Yum, my favorite.

I made my way to the firehouse and joined "Bradford Street," home to Engine 332 and Ladder 175 by way of North Carolina. A member at the firehouse had a friend who rescues stray dogs there, and I was brought to the firehouse and adopted. It is a good thing that I was brought in by this firehouse, because I have been able to serenade the members at all hours of the day and night with my singing. They may call it "howling," but now that I am a New Yorker, I have learned how to carry a tune. You will definitely hear it when you approach the firehouse gate. The combination of my singing and the way I gallop and shake my booty makes me a showstopper that should probably be right at home on Broadway. But my home is the firehouse, and the only lights I want to sing and shake under are the red and white lights of the engine and ladder as they leave the firehouse to go on runs and help others.

CASPER
E332/L175
BROOKLYN

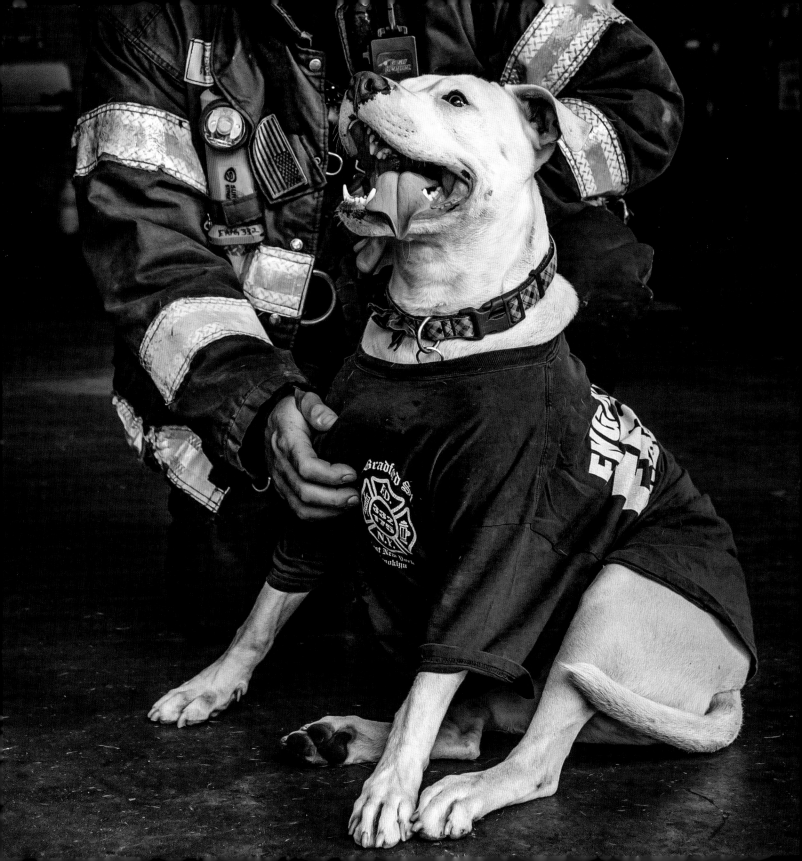

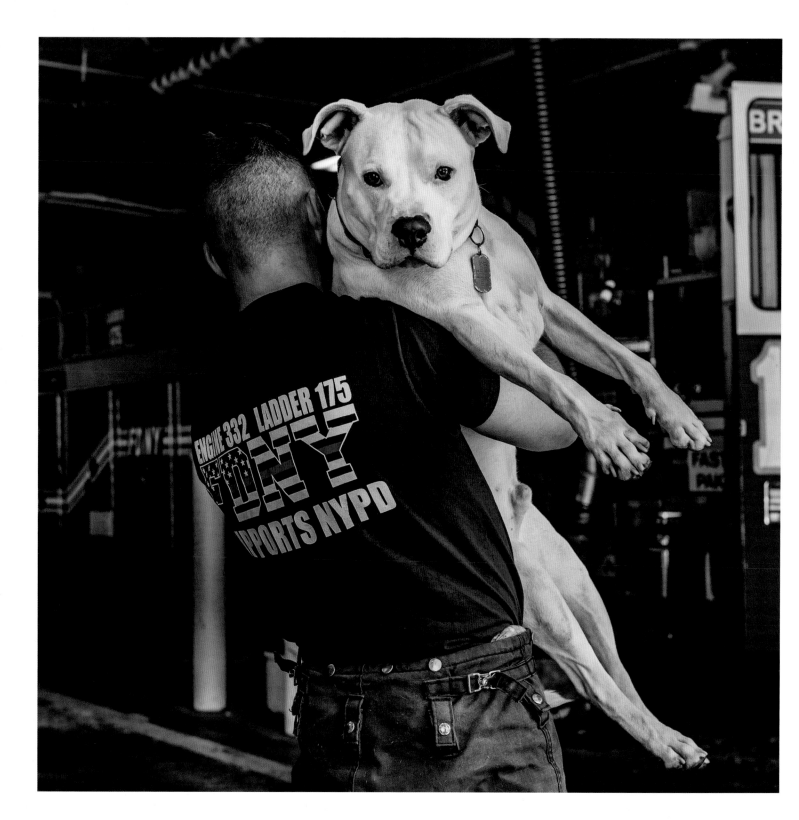

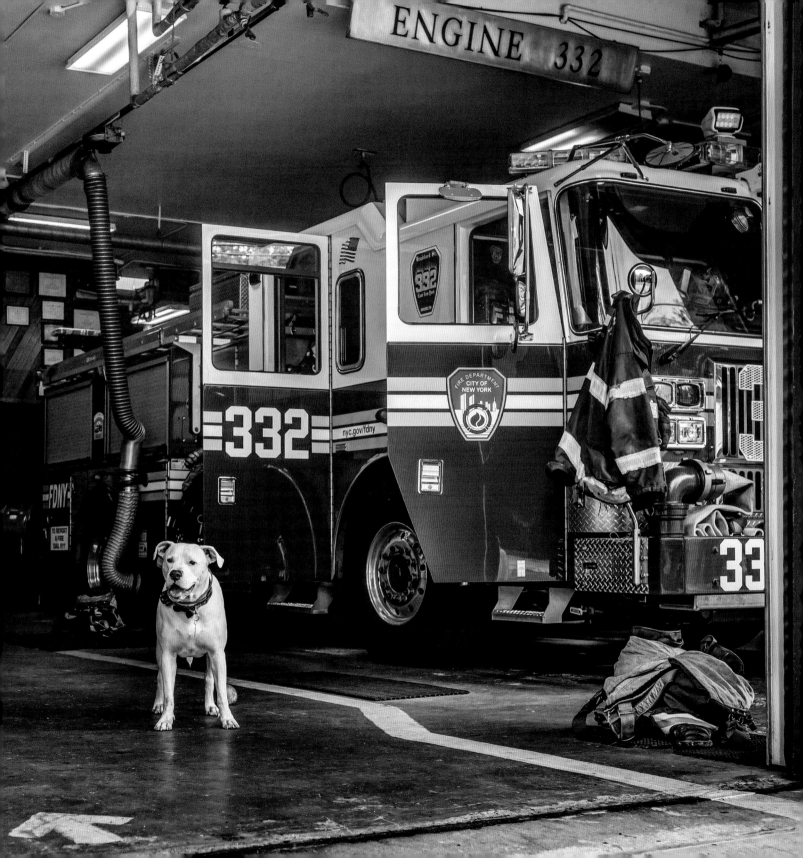

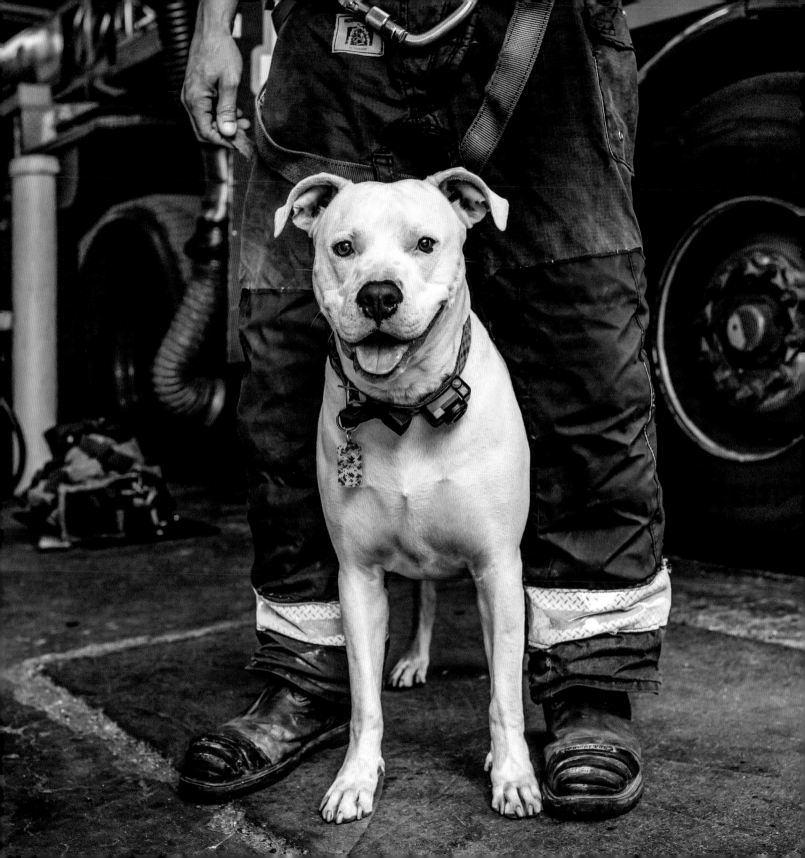

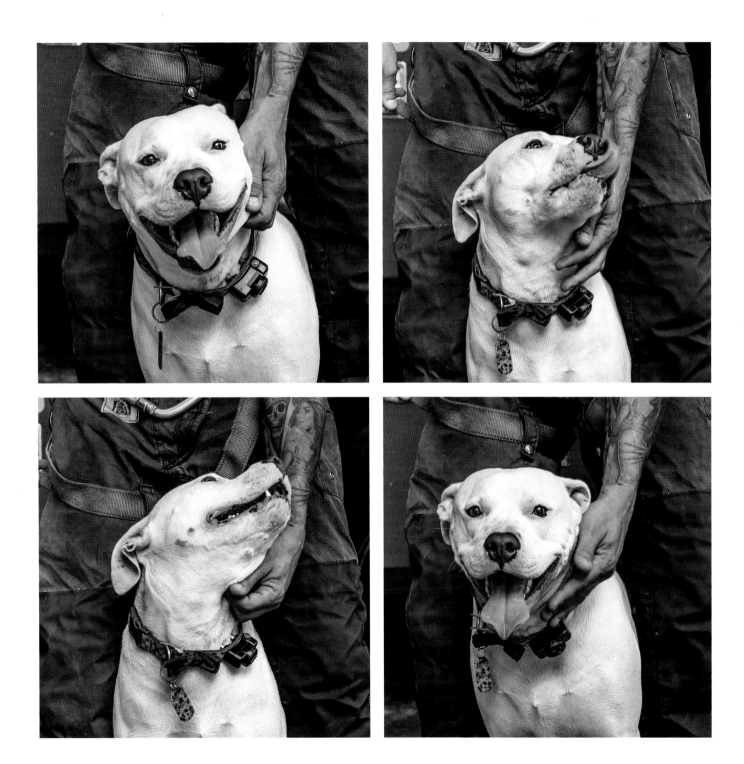

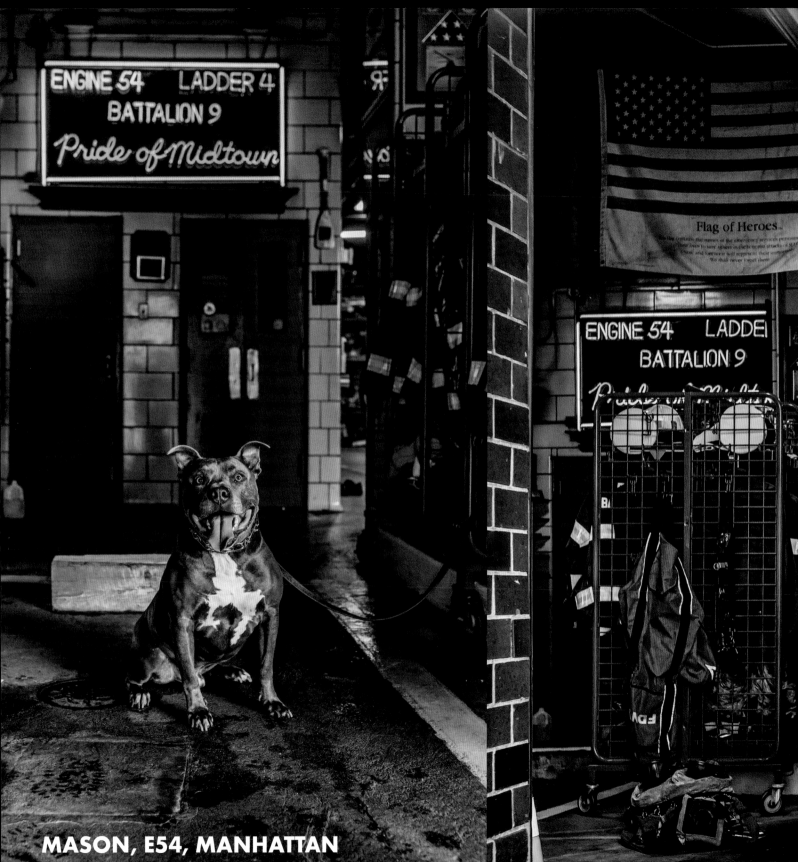

MASON, E54, MANHATTAN

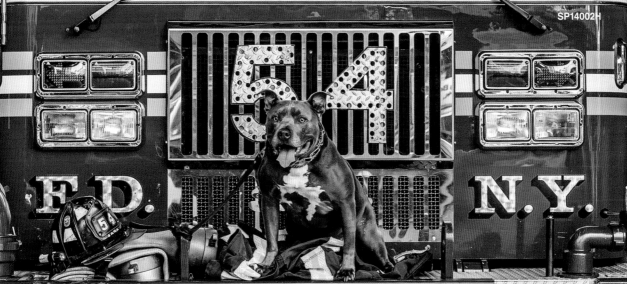

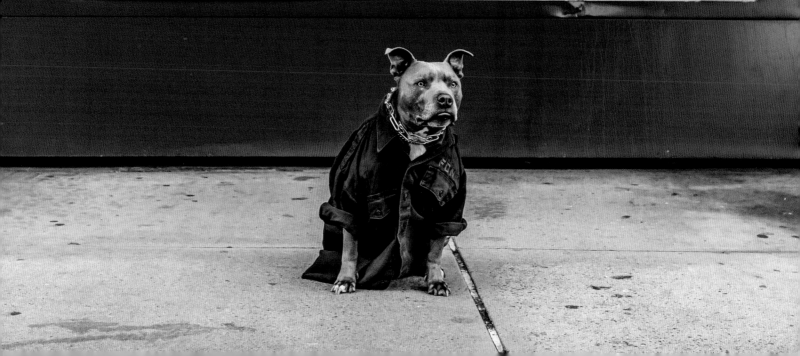

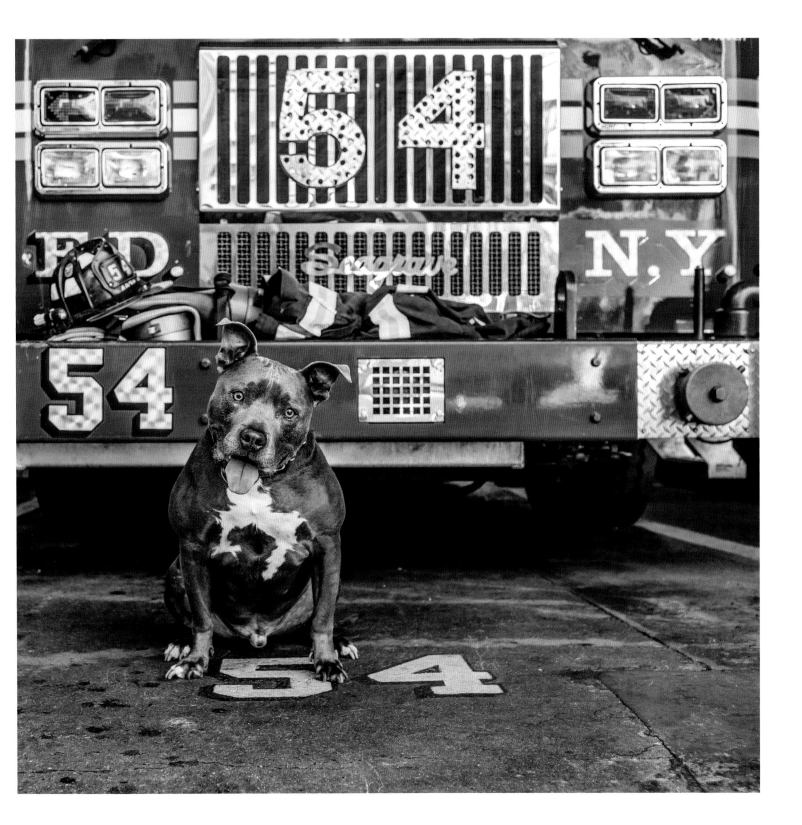

ISBN: 978-0-7643-6734-2
Printed in India

Published by Schiffer Publishing, Ltd.
4880 Lower Valley Road
Atglen, PA 19310
Phone: (610) 593-1777; Fax: (610) 593-2002
Email: info@schifferbooks.com
Web: www.schifferbooks.com

For our complete selection of fine books on this and related subjects, please visit our website at www.schifferbooks.com. You may also write for a free catalog.

Schiffer Publishing's titles are available at special discounts for bulk purchases for sales promotions or premiums. Special editions, including personalized covers, corporate imprints, and excerpts, can be created in large quantities for special needs. For more information, contact the publisher.

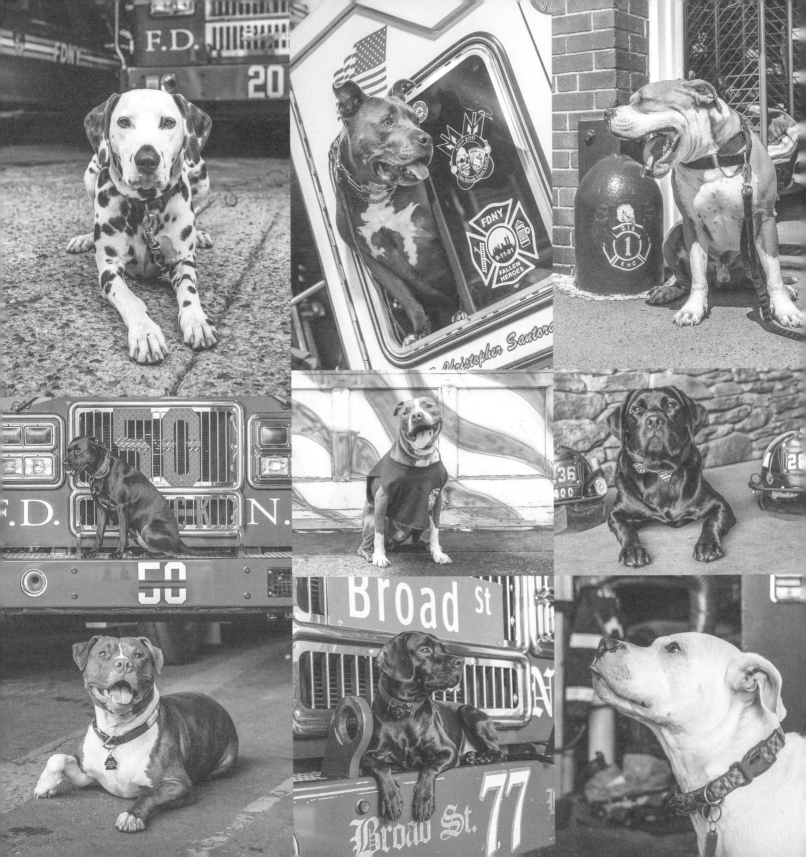